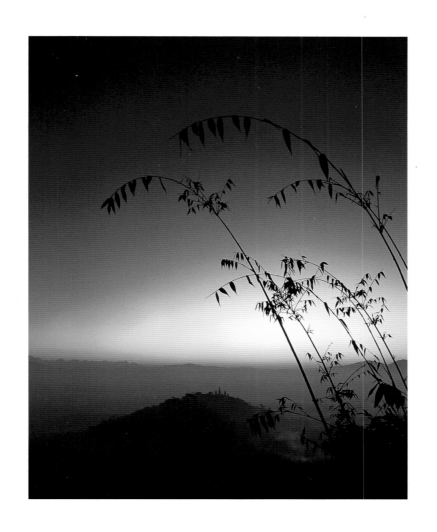

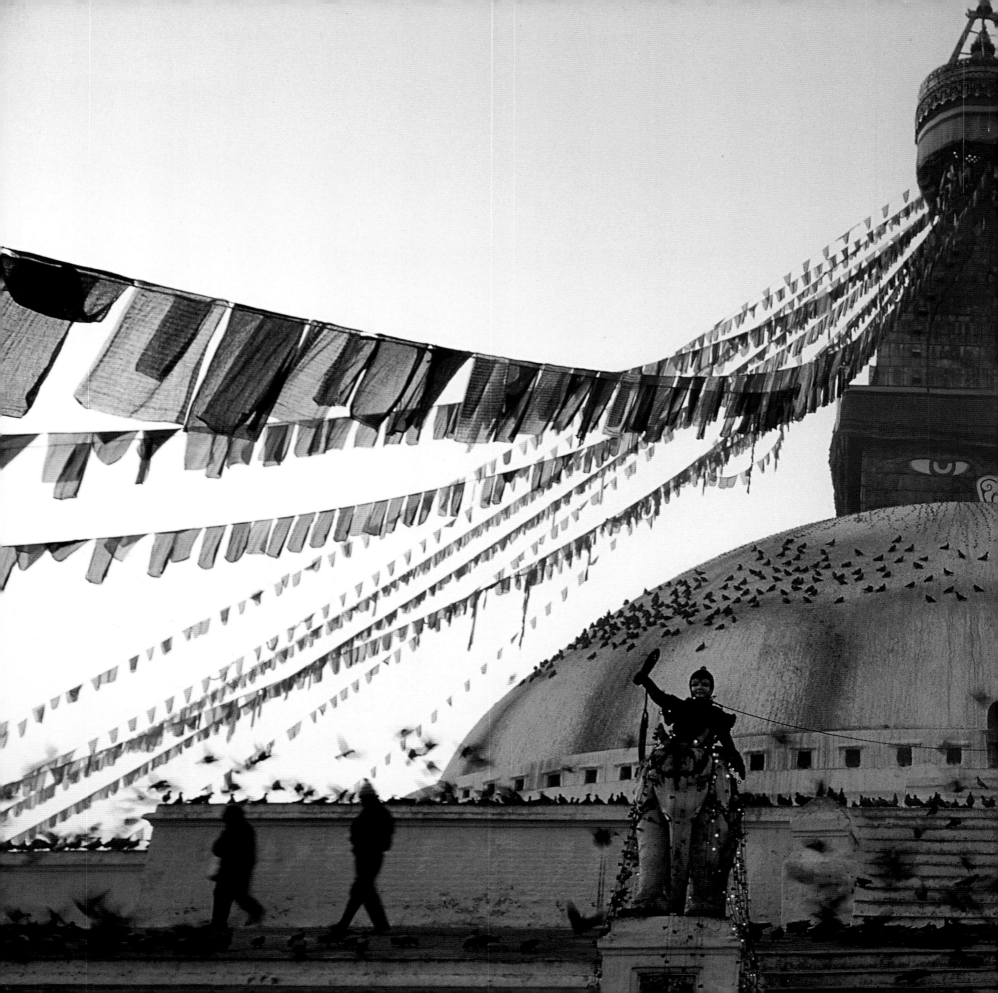

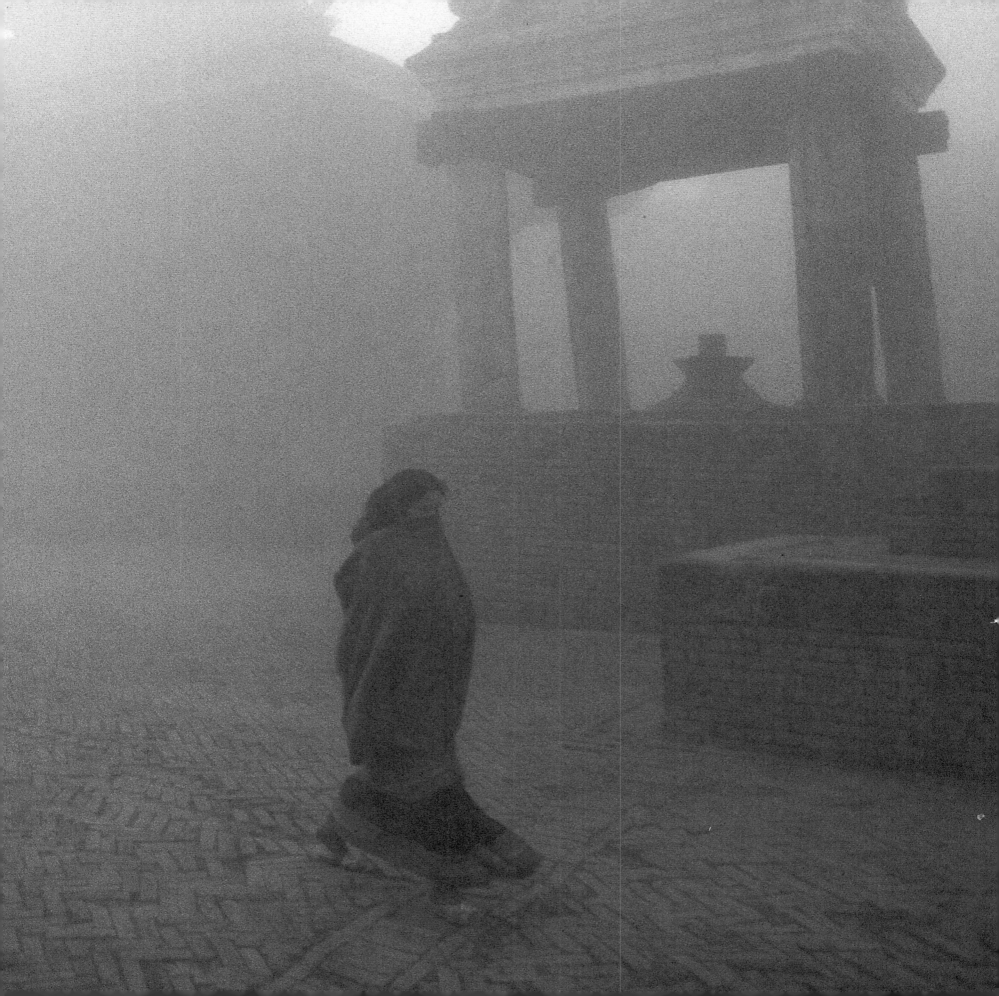

THE KATHMANDU VALLEY

Photography by Fredrik Ardvisson
Introduction by Kerry Moran

SHAMBHALA

Boston

1998

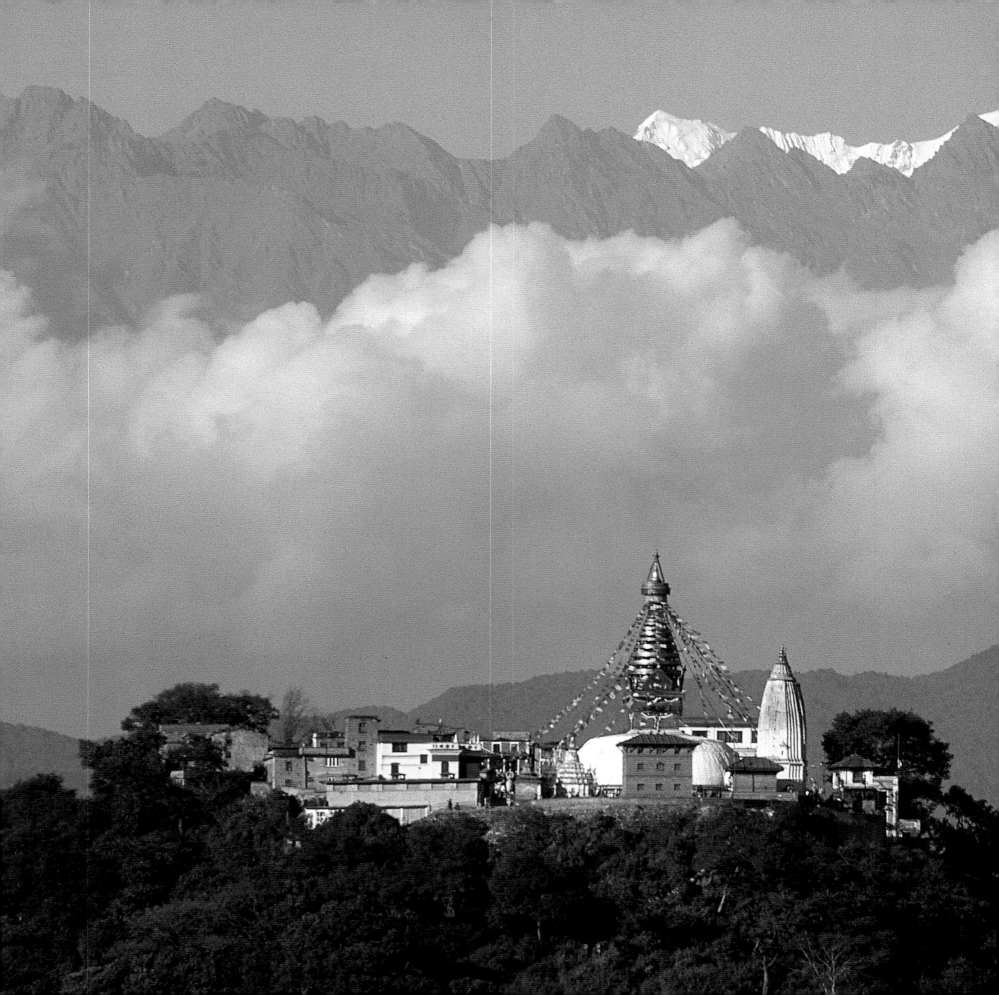

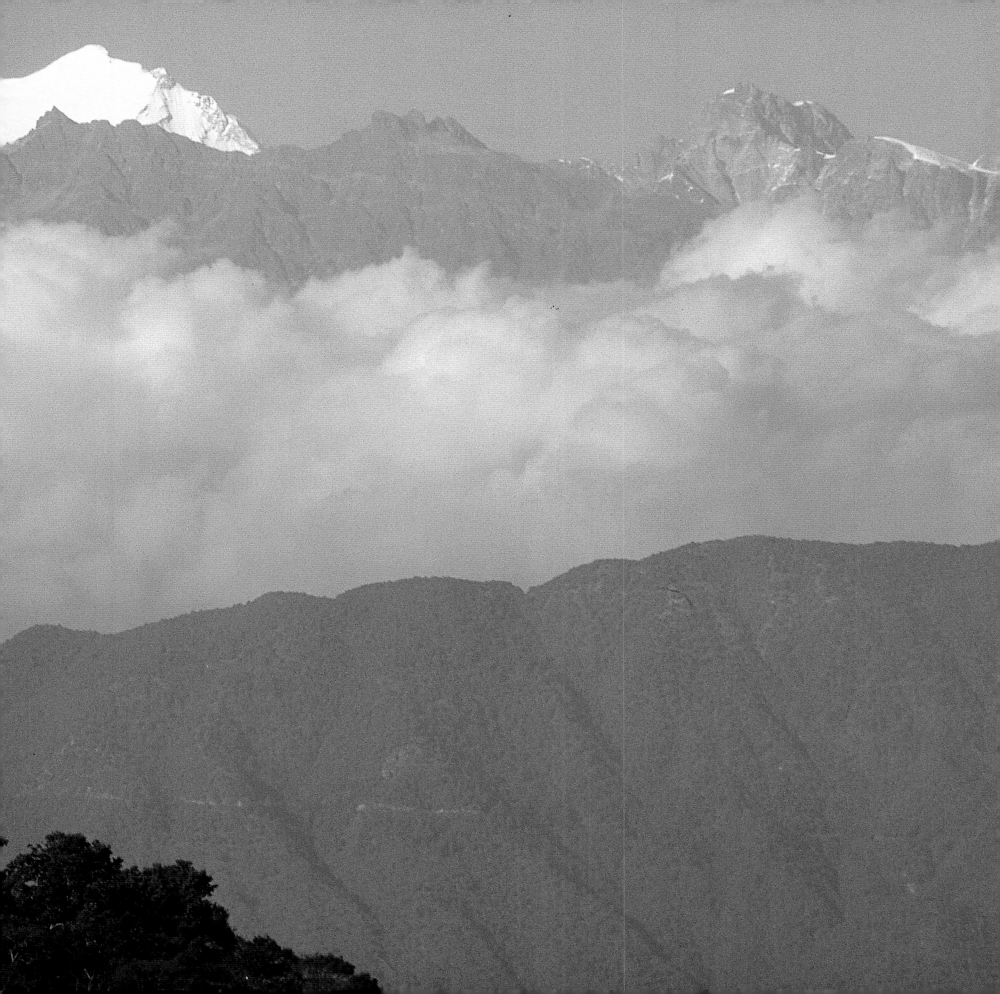

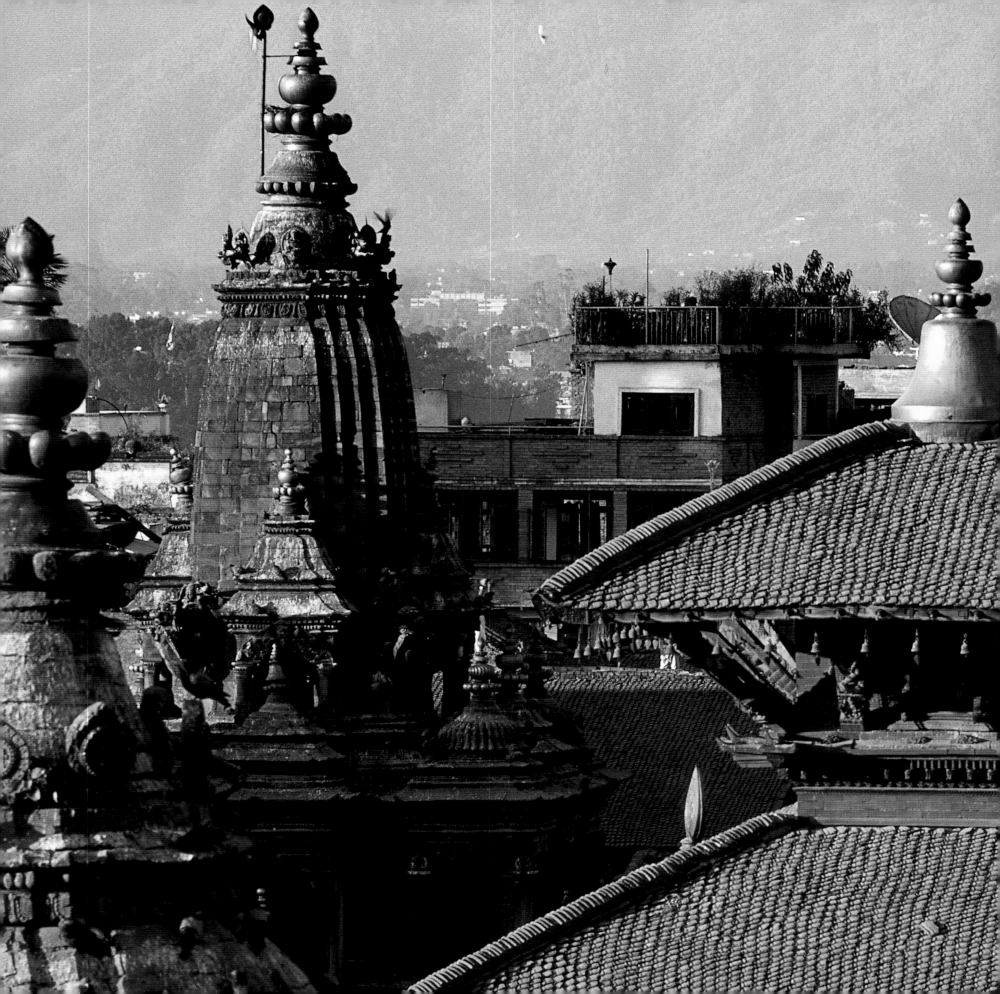

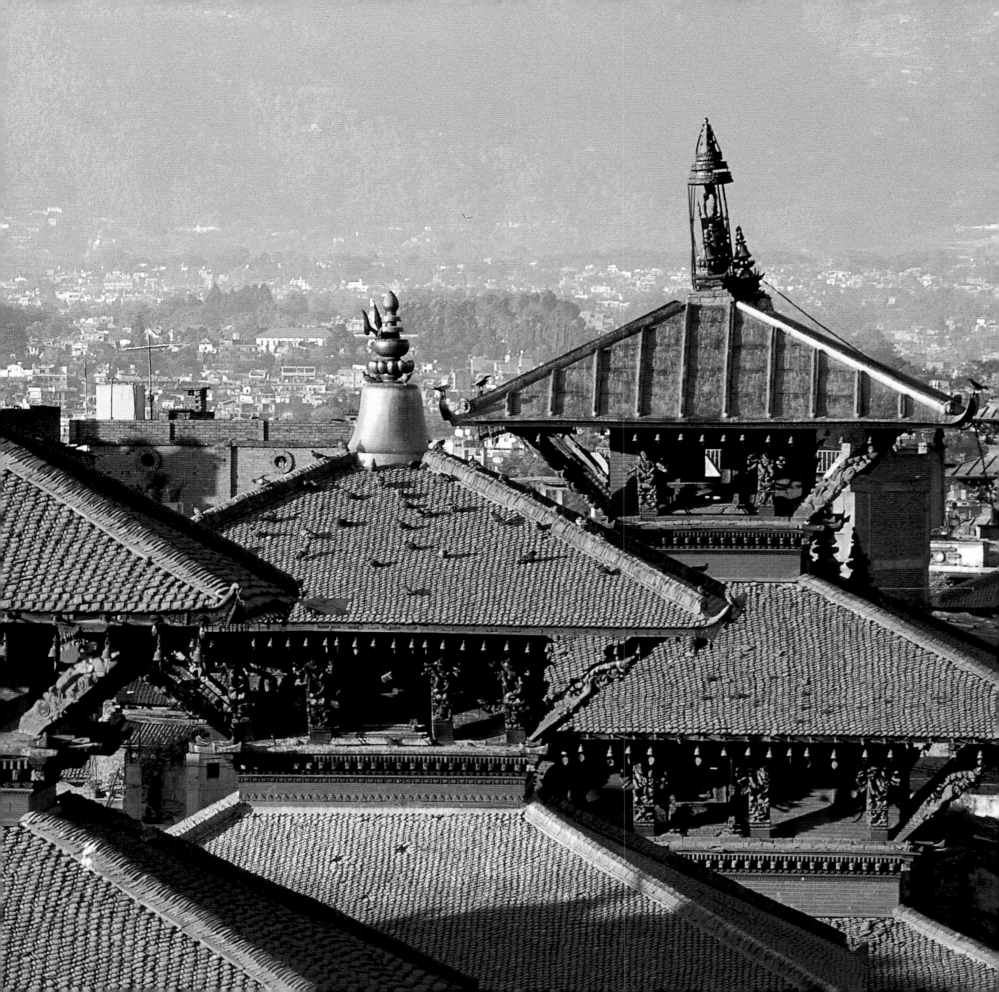

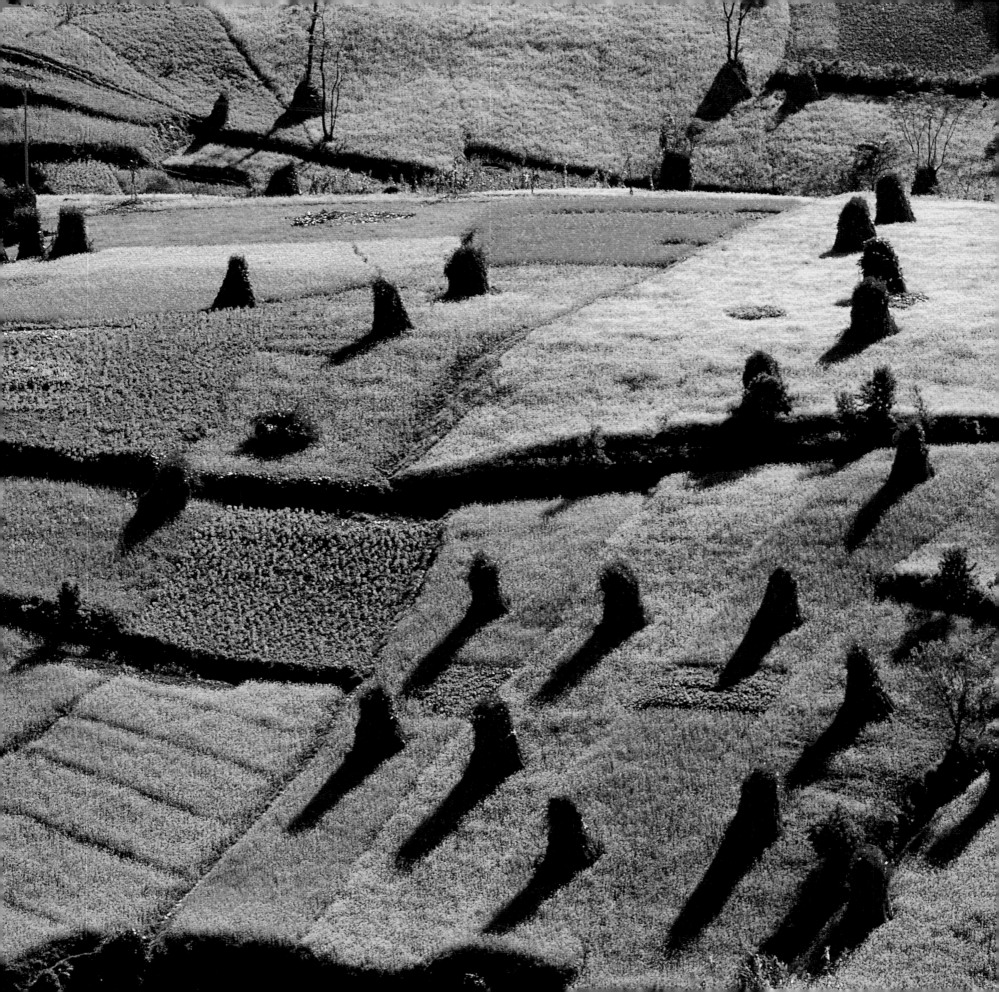

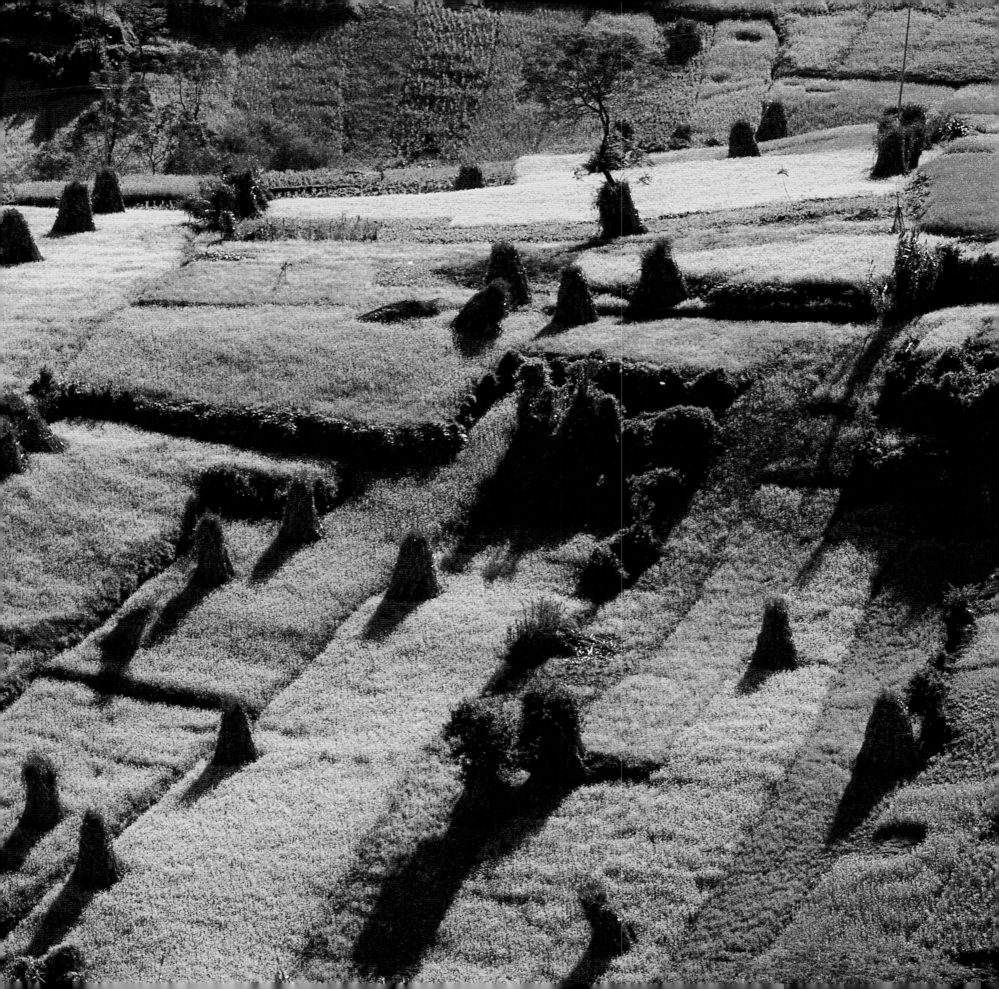

Shambhala Publications, Inc.
Horticultural Hall
300 Massachusetts Avenue
Boston, Massachusetts 02115
http://www.shambhala.com

9 8 7 6 5 4 3 2 1

First Edition

Printed in Hong Kong

Distributed in the United States by Random House, Inc.,
and in Canada by Random House Canada Ltd

Design: Philip Choi, Geoff Cloke

Editor: Peter Tom Le Bas

Map: Peter Tom Le Bas

Library of Congress Cataloging-in-Publication Data

Moran, Kerry.
 The Kathmandu Valley/by Kerry Moran.
 p. cm.
 ISBN 1-57062-404-6
 1. Kathmandu Valley (Nepal)—Civilization. 2. Kathmandu
(Nepal)—History. 3. Pātan (Nepal)—History. 4. Bhaktapur
(Nepal)—History.
DS495.8.K3M67 1998 98-7451
954.96—dc21 CIP

(Endpapers)
A chilly morning mist veils passers-by at Bhaktapur's Durbar Square. In the winter months, the temperature differential transforms early-morning dew into a thick, soft mist that blankets the Valley. Farmers refer to it as "milk" because it nurtures their crops.

(Half-title)
Sunrise highlights a stand of silhouetted bamboo against the distant hillock of Swayambhunath Stupa. Ancient legend maintains that the Valley was once a lake – a myth firmly grounded in historical fact.

(Title spread)
The all-seeing eyes of Boudhanath Stupa survey the four directions from its location in the eastern Valley. The stupa is an important holy site for Tibetan Buddhists, as well as a roosting site for early-morning flocks of pigeons, which generous devotees feed with grain. The monument is said to hold the relics of Kasyapa, a Buddha of a previous age. With a diameter exceeding 100 metres (330 feet), Boudha is among the largest stupas in the world.

(Pages 4-5)
The origins of the sacred hilltop shrine of Swayambhunath Stupa predate written history. Legend says, and geological evidence confirms, that the Valley was once a lake, placid and enormous and deep. A Buddha meditating atop a nearby hill tossed in a seed which aeons later blossomed into a thousand-petalled lotus radiant with a self-manifesting light. That self-born (swayambhu) light is now covered by the sacred stupa. Massive Himalayan peaks rise clear and clean behind the Valley's northern rim, the closest less than 50 kilometres (30 miles) distant.

(Pages 6–7)
Stacked temple roofs are adorned with a delicate fringing of bells and capped with gilded ornaments in Patan's Durbar Square. Historically the Kathmandu Valley contained three kingdoms or city-states, each with its royal palace or durbar. The bricked plazas facing these palaces are packed with shrines, temples, bells, fountains, and statues. An early visitor described Patan's Durbar Square as "the most picturesque collection of buildings that has been set up in so small a place by the piety and pride of Oriental man."

(Pages 8-9)
The Valley's rich irrigated fields give forth two or even three crops a year. These plots, near the village of Chobhar in the south Valley, are farmed by Jyapu peasants, a Newari subcaste skilled at tilling the land.

Contents

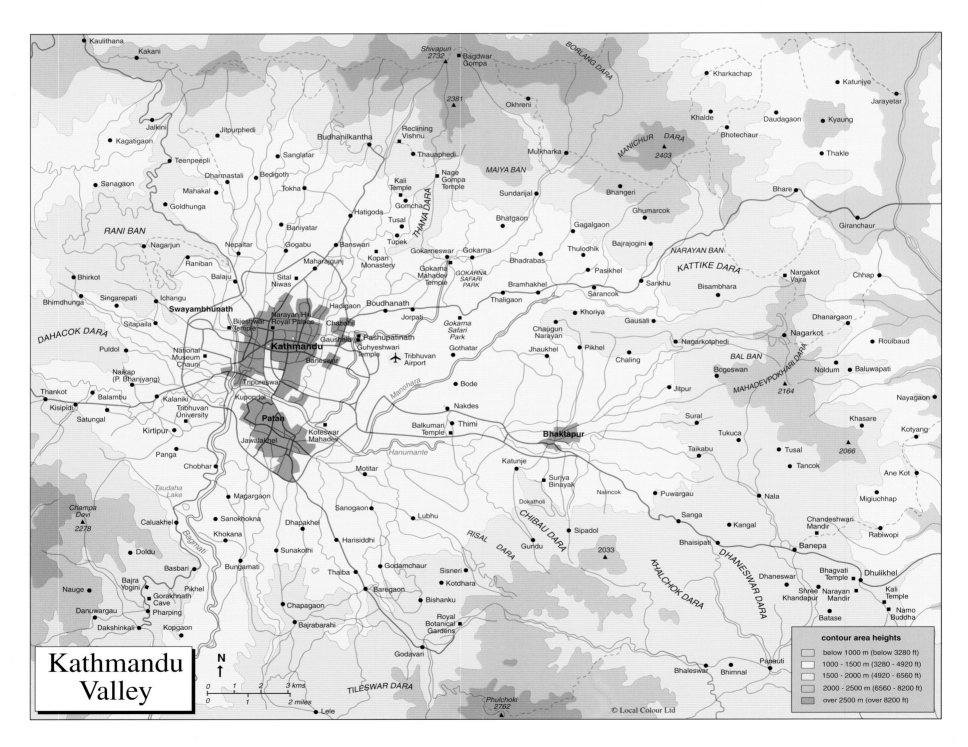

Kaulithana
Kakani
Jalkini
Kagatigaon
Teenpeepli
Sanagaon
Mahakal
Goldhunga
Jitpurphedi
Sanglatar
Dharmastali
Bedigoth
Tokha

RANI BAN
Nagarjun
Nepaltar
Gogabu
Baniyatar
Raniban
Balaju
Bhirkot
Singarepati
Ichangu
Sital
Niwas
Swayambhunath
Bhimdhunga
Nagarjun
Hadigaon

DAHACOK DARA
Sitapaila
Bijeshwar
Temple
Narayan Hiti
Royal Palace
Chabahil
Puldol
National
Museum
Chauni
Kathmandu
Gaushala
Pashupatinath
Guhyeshwari
Temple
Baneswar

Naikap
(P. Bhanjyang)
Tripureswar
Thankot
Balambu
Kalaniki
Tribhuvan
University
Kupondol
Kisipidi
Satungal
Patan
Kirtipur
Jawalakhel
Koteswar
Mahadev
Panga
Chobhar

Taudaha
Lake
Magargaon
Sanokhokna
Dhapakhel
Champa
Devi
2278
Caluakhel
Khokana
Sunakothi
Doldu
Basbari
Bungamati
Nauge
Bajra
Yogini
Pikhel
Gorakhnath
Cave
Pharping
Chapagaon
Dakshinkali
Kopgaon
Bajrabarahi

Danuwargau

Budhanilkantha
Reclining
Vishnu
Thauaphedi
Kali
Temple
Nage
Gompa
Temple
Gomcha
Tusal
Tupek
Hatigoda
Banswari
Maharajgunj
Kopan
Monastery
Boudhanath
Jorpati
Gokarneswar
Gokarna
Gokarna
Mahadev
Temple
GOKARNA
SAFARI
PARK
Gokarna
Safari
Park
Gothatar
Tribhuvan
Airport
Bode
Nakdes
Thimi
Balkumari
Temple
Motitar
Sanogaon
Lubhu
Harisiddhi
Thaiba
Baregaon
Sunakothi
Godamchaur
Bishanku
Kotdhara
Sisneri
Royal
Botanical
Gardens
Godavari
Lele

Shivapuri
2732
Bagdwar
Gompa
2381
Okhreni
MAIYA BAN
Sundarijal
Bhatgaon
Thulodhik
Pasikhel
Bramhakhel
Thaligaon
Sarancok
Khoriya
Gausali
Chaugun
Narayan
Jhaukhel
Pikhel
Chaling
THANA DARA
Mulkharka
Bhangeri
Ghumarcok
Gagalgaon
Bajrajogini
Bhadrabas
Sankhu
Bisambhara

BORLANG DARA
Kharkachap
Katunjye
Jarayetar
Khalde
Daudagaon
Kyaung
Bhotechaur
Thakle
MANICHUR DARA
2403
Bhare
Giranchaur
NARAYAN BAN
KATTIKE DARA
Nargakot
Vajra
Chhap
Dhanargaon
Nagarkot
Rouibaud
Nagarkotphedi
BAL BAN
Bogeswan
2164
Noldum
Baluwapati
MAHADEVPOKHARI DARA
Nayagaon
Khasare
Sural
Kotyang
Tukuca
2066
Ane Kot
Taikabu
Tusal
Tancok
Migiuchhap
Katunje
Suriya
Binayak
Nalincok
Puwargau
Nala
Dokatholi
Sanga
Chandeshwari
Mandir
Gundu
Sipadol
Kangal
Rabiwopi
CHIBAU DARA
2033
Bhaisipati
Banepa
RISAL
DARA
KHALCHOK DARA
DHANESWAR DARA
Dhaneswar
Bhagvati
Temple
Dhulikhel
Shree
Narayan
Khandapur
Mandir
Kali
Temple
Batase
Namo
Buddha
TILESWAR DARA
Phulchoki
2762
Bhaleswar
Bhimnal
Panauti

© Local Colour Ltd

contour area heights

	below 1000 m (below 3280 ft)
	1000 - 1500 m (3280 - 4920 ft)
	1500 - 2000 m (4920 - 6560 ft)
	2000 - 2500 m (6560 - 8200 ft)
	over 2500 m (over 8200 ft)

Kathmandu Valley

N

0 1 2 3 kms
0 1 2 miles

INTRODUCTION

Life in the Kathmandu Valley provides so many daily provocations to open the heart: the flash of white on the northern horizon that signals the post-monsoon appearance of mountains unexpectedly, absurdly high…the devotion of a Buddhist monk prostrating full-length in front of the Boudhanath Stupa…the delight of children soaring up in great arcs on bamboo swings… the wild freshness the monsoon rains bring to the green rice-fields…the piercing low tones of a conch shell blown by an itinerant ascetic wandering late at night…the golden light cast by butter lamps on serene faces intent on worship…the face of enormous beauty carved by some nameless long-ago craftsman, discovered on a cobwebbed and shadowy temple strut.

Traditionally speaking, the Kathmandu Valley *was* Nepal, and to this day it is called Nepal by hill dwellers living as little as a day's walk distant. It remains an outpost of civilisation, both traditional and modern, in the midst of a thoroughly rural country. Kathmandu is the capital of Nepal in every sense: political, economic, cultural, spiritual. The Valley is home to some 1.5 million people, a figure which increases yearly with the continuing arrival of virtually every Nepali with dreams of getting ahead.

The window seat of a plane gliding in for a landing at Tribhuvan International Airport reveals the Valley's geography and geology spread out below like the pages of an opened book. Its strategic positioning – a gently rounded bowl set amidst rugged Himalayan foothills – is best appreciated from above. To the early migrants who settled here, it must have been a welcome respite from the relentless up-and-down landscape that characterises so much of Nepal.

The Valley's fertile bottomland is patterned with a patchwork of fields displaying the changing colours of the seasons. More and more, farmland is being replaced by buildings, large and small, constructed of brick formed from the deep red soil. The former kingdoms, now cities, of Kathmandu, Patan and Bhaktapur sprawl larger each year. Small farming villages dot the landscape as well, some inhabited by indigenous Newari people, others populated by Hindu caste groups or Tamangs. Ascending the sides of the surrounding hills are terraced fields, and a few remnants of the lush forests which only a few generations ago swept all the way down to the Valley floor. Kathmandu's subtropical latitude combines with an altitude of 1,300 metres (4,300 feet) to generate tremendous bio-diversity: 400 species of birds are found here, and over 1,000 species of plants. Leopards still roam the higher hills, as do deer and wild boar, and, rumour has it, a lone tiger on Shivapuri. Backing the entire vista are the soaring Himalayan peaks, the closest less than 50 kilometres (30 miles) distant. The eye rises to green hills topped by clouds, only to be startled by the mammoth white bulk of snow-covered mountains towering *above* the clouds.

Protected by its great geographic barriers – the Himalayas to the north, the fever-ridden jungles of the Terai to the south – Kathmandu tantalised the West with its reputation as a hidden Shangri-La. Until a mountaineering reconnaissance expedition arrived in 1948, it remained the largest inhabited country unexplored by Europeans. The Valley was, however, long open to a diverse array of cultural influences. An entrepôt for trans-Himalayan trade, it linked the Indian culture of the Gangetic basin with that of Tibet, and by extension, China. Monks, traders, ambassadors, scholars, pilgrims and artisans all passed through here, leaving their mark. And Valley residents made their way to foreign lands as well: it was Valley craftsmen and artists who built and decorated the great monasteries of Tibet to the north. A particularly skilled artisan named Arniko was summoned by Kublai Khan to Beijing, where he became Controller of Imperial Manufacturers.

This cross-cultural fertilisation, combined with the enormous wealth reaped from trade, fostered a highly developed civilisation.

Architecture, art, dance, drama and literature all flourished in the Malla courts of the Three Kingdoms era. The Valley's sophisticated traditional civilisation is not, properly speaking, Nepali, but Newari, the creation of an indigenous ethnic group which inter-wove cultural influences from India, the Himalayas and Central Asia into a rich tapestry all their own.

Newari culture dates back an extraordinarily long period, to around the first century AD. Its Golden Age was the Malla Dynasty, which ruled the Valley for more than half a millennium – first as a unified entity; later as the three separate kingdoms of Kathmandu, Patan and Bhaktapur. Over the centuries the little city-states became increasingly cut off from reality, torn by constant bickering and political rivalries. In the late 18th century the Valley fell, as introverted societies are wont to do – straight into the lap of Prithvi Narayan Shah, the bold and tenacious ruler of nearby Gorkha. The Valley's decline was a crucial factor in a drive that was to conclude with the unification of all Nepal. From that point on, the Newars were no longer rulers in their own right, but merely part of the complex mosaic of ethnic groups that is modern Nepal.

PEOPLE

Nepal's steep hills and deep valleys, and its extreme variations of altitude and climate have fostered tremendous bio-diversity, and great ethnic diversity as well. The national census lists 60 major groups, but there are many, many more tucked away in remote mountain valleys, each with their own language, traditions, customs and costumes. And inevitably, it seems, people from all these groups make their way to Kathmandu, where they converge at the trading crossroads of Asan Tol. A few hours spent observing faces here will convince you of Guiseppe Tucci's description of Nepal as "the ethnic turntable of Asia". Prithvi Narayan Shah waxed more poetic when he proclaimed, "My country is a garden for all types of people."

The Newars (see above) make up less than four percent of the national ethnic potpourri, but exert an inordinate amount of influence in their Valley homeland, where they constitute more than 40 percent of the population. The old quarters of the three towns remain predominately Newar, especially in Patan and Bhaktapur. Newars are easily distinguished by unique touches, like the scarlet-bordered black skirts of Jyapu women, carefully draped to show off their blue-tattooed calves, the short-handled ko men use to break up the hardened earth, or the carrying device of double baskets suspended from a shoulder pole.

Shrewd traders and superb farmers, the Newars are a highly successful group, but their real talent is artistic, expressed through metal, stone, wood, clay, and paint. Their fascinating culture is markedly different from that of the dominant Hindu caste groups. The Tibeto-Burman Newari language, with its own script and a rich classical literary tradition, bears little resemblance to any other tongue and comes in many different dialects – so many that a resident of Kathmandu has difficulty understanding a Bhaktapur dweller. Originally Buddhist, Newars are now predominantly Hindu, or to be precise, they practice an amalgamation of both religions, supplemented by age-old beliefs in powerful natural forces. Their old traditions and customs live on, in the communal festivals and in the elaborate ceremonies for coming of age, marriage, and old age which can be seen on city streets.

For the past two centuries, the Valley has been ruled by Hindu caste groups, Brahmins and Chhetris whose ancestors fled from Western India to Nepal following the Muslim invasions of the 13th and 14th centuries. Their language, Nepali, has become the lingua franca linking a polyglot country. Originally Brahmins were priests while Chhetris were warriors; today these traditional occupations are less likely to be followed, but the two groups together constitute Nepal's ruling class (both the ruling Shahs and the influential Ranas are of Chhetri stock). The Hindu caste system also encompasses poorer and less powerful subgroups, namely the occupational castes who wash clothes, make shoes, sweep streets, and perform other types of labour considered degrading.

Tamangs are another prominent feature of the urban landscape. These sturdy people are natives of the hilly regions surrounding the Kathmandu Valley, where they work as farmers and porters. In the city they may paint ritual Tibetan thangkas for the tourist trade, pedal brightly painted cycle rickshaws or drive the noisy little three-wheeled tempos which clog the streets. Traditionally they portered goods into the Valley, including motorcars for the Rana rulers, which were strapped to bamboo litters and lugged by teams of men over the hills from India. Buddhist by tradition, the Tamangs speak a Tibeto-Burman language and trace their ethnic roots back to Tibet.

The Valley's ethnic mix contains many more: almond-eyed Rai

and Limbu from Eastern Nepal, whose Kiranti ancestors some historians believed ruled the Valley 2,000 years ago, stalwart Magars and Gurungs from the Central Hills; the famous Sherpas of Eastern Nepal, many of whom base lucrative trekking and tour businesses in Kathmandu; assorted Bhotia people from the northern mountains and the slender, dark-skinned peoples of the southern Terai. Nepal is still not as much of a melting pot as the government would have one think. Despite Radio Nepal's pervasive influence, there are plenty of Newari women on the streets of Bhaktapur who understand not a bit of Nepali, and this 14 kilometres from the nation's capital.

THE URBAN LANDSCAPE

Centuries of Newari culture have created a cityscape that is a rich melange of cultural and religious influences. Tightly packed conglomerations of houses line the narrow brick-paved lanes of the old cities. Low doorways afford glimpses of peaceful courtyards centred around delicately carved stone *chaityas* or gilded family temples. Tiny shrines of red-daubed sacred stones or gilt-roofed temples appear every few steps, as do sunken water taps (*hiti*) and old open-sided resthouses (*pati*). At the centre of each city are the Royal Palaces or Durbars, each facing a temple-strewn plaza or Durbar Square, which serves as a ceremonial centre and – more recently – a major tourist attraction. Narrow lanes and alleys, hopelessly unsuitable for the traffic which increasingly clogs them, channel the flow of pedestrians throughout the towns.

The political fragmentation of the Three Kingdoms era had its problems, but it proved a boon for the development of art and architecture. Kings competed with one another to see who could raise the finest palace and the most lavish temples, seeking to glorify both themselves and their gods. The Malla rulers were public-spirited as well, sponsoring the construction of water tanks, taps, and resthouses, and providing endowments of land to fund their maintenance in perpetuity.

But the Newars' true genius lies in their skilful shaping of urban space. The real achievement is all around, in the intrinsic harmony and rhythm built up through centuries of organic growth. It is an aesthetic based on subtle curves and undulating waves, rather than straight lines and rigid angles. Rhythm is a pal-pable phenomenon, in the placement of buildings or the winding of streets. The subtle blending of materials adds its share – the harmony created by weathered brick, mellow stone and old wood, relieved by the occasional flash of a brass pinnacle or bronze temple guardian.

Against this serene backdrop are held the daily performances of life, enlivened by the seamless merging of public and private space. Streets and courtyards reveal people drying grain, spinning wool, bathing, enjoying an oil massage in the sun, scolding errant children, worshipping a deity, shouting imprecations at a cheating trader, nursing babies, hunting for lice (a favourite pastime), flirting, telling stories, smoking cigarettes, or shouting complicated instructions from a rooftop in full earshot of the entire neighbourhood. Despite the enormous population density, the Valley's urban space feels not crowded, but vital. Perhaps the tightly packed population serves as a seedbed for the unmatched cultural flowering that occurred here.

Some scholars believe the stacked-roof temple found from China to Bali has its origins in the Kathmandu Valley. A seventh-century visitor marvelled at "multi-storeyed temples so tall one would take them for a crown of clouds." The modern Valley retains numerous examples of this basic graceful form, which is infused with elaborate symbolism not apparent to the naked eye. A temple's carefully measured ground plan is designed as a *yantra*, a mystic diagram of the cosmos; in this way, each embodies a bit of eternity in physical form. Constructed of warm red brick and carved *sal* wood, temples are lavished with elaborate metal ornamentation as intricate as jewellery. The beaten borders, the tinkling bells trimming the roof, the banners streaming stiffly out and the assorted forms of fierce and mythical guardians all combine to create an exuberant yet deeply harmonious impression.

Master woodcarvers, the Newars have skilfully shaped the dark, heavy wood of the *sal* tree into delicately latticed screens and doorways lavished with rows of different motifs. Most dramatic are the slanted wooden struts which support the stacked roofs of temples. Carved into the form of the resident deity, they serve as a sort of divine billboard advertising the presence of a particular sacred manifestation. The largest corner struts sport winged griffons with horned heads and erect phalli. Small vignettes at the base of the struts may feature graphic caricatures of couples in various contortions, assisted by animals and helpful

servants. Some depict gentle couples or half-naked *yakshas,* nymphs of divine grace and perfectly proportioned beauty – erotic in the best sense of the word.

Due to the Valley's pervasive syncretism, temples may be Hindu or Buddhist, or quite commonly worshipped by followers of both. Take the prettily decorated little gilt-roofed shrine adjoining Swayambhunath Stupa, one of the busiest in the Valley. Buddhists revere its resident deity as Harati; Hindus know her as Sitala. For both, she is the fearsome goddess of smallpox, a dread disease which swept the Valley well into this century. The recent eradication of smallpox has not deterred the steady stream of devotees who continue to supplicate the goddess with offerings of duck eggs, grain, and yoghurt, toting their children inside for a blessing from the black stone image.

A uniquely Buddhist monument is the hemispherical stupa or the smaller, more elaborately carved stone *chaitya.* Both stupas and *chaitya* have their origins in the ancient Indian burial tumuli, but the eyes painted along the square base of stupa spires are a uniquely Nepali touch. Generally these eyes manage to convey the desired impression of wisdom and compassion, but there are also squinting stupas, sleepy stupas, farsighted stupas – even (in the case of Chabahil) a stupa with a light bulb dangling down over its third eye. The protective pairs of eyes painted on old doors – a tradition that lingers especially in Bhaktapur – add yet another dimension to the urban landscape.

A final aspect: temples are not sacrosanct shrines to be entered only on Holy Days, but are interwoven into the fabric of urban life. Fruit and vegetable sellers spread their wares on the lower steps of Durbar Square's temples, while children fly kites from the higher levels and cavort across the stone guardians. The more active shrines, like that of the powerful goddess Nara Devi, are visited by a stream of worshippers throughout the day: women bearing their daily offerings, men touching their caps in a brief gesture of respect, supplicants seeking special favours. It's all part of the daily scenery, and the ease with which religion and daily life blend constitute one of the many charms of Kathmandu.

RELIGION

The majority of Nepalis are Hindu (the country proudly calls itself "the world's only Hindu kingdom"), but religious syncretism and a generally mellower take on life gentles the orthodox Hinduism of neighbouring India into a rich and fascinating blend influenced by Buddhism and ancient animistic beliefs. Day in the Valley's old towns begins with the clanging of temple bells and the sight of women scurrying between neighbourhood temples with brass trays of flower petals, red *tika* powder and uncooked rice, which provide the basis of worship for peaceful deities. Other divinities, like the terrifying Bhairab, a form of Shiva, and the fearsome goddess Durga, demand more significant gifts. At the forest temple of Dakshinkali on the southern fringes of the Valley, Tuesdays and Saturdays are orgies of blood sacrifice. Hapless chickens or goats are dragged before the black stone image of the hideous, grinning goddess, where they are sprinkled with water to make them shake. Once this signal of assent is given, their throats are neatly cut. The blood is offered to the image, while the carcass is cooked to make a family feast a few hours later. Impoverished families may offer an egg or pumpkin as a substitute.

Worship, or *puja,* is carried out to propitiate the gods. To ignore them risks illness, misfortune, and possibly death; to cultivate their favour can bring happiness and prosperity. This is the most common approach, but a handful of devotees cultivate their connection to divinity in an esoteric sense, using them as stepping stones to an inner vision.

The gods are found everywhere in the Valley, not just in temples but in rivers, rocks and stones, in the hearth of homes and even buried in the household trash dump. Like humans, they have their own characters, playful or sly or fearsome or gentle. Ultimately all are considered expressions of the supreme and formless reality called Brahman. Deities manifest in larger-than-life forms, their multiple limbs and heads symbolising their complex powers. Each is easily identified by his or her own attributes, implements, emblems and animal vehicles. The mainstays of the Hindu pantheon include Shiva the Transformer, who embodies the powerful energies of birth and death; Vishnu the Preserver, a gentler manifestation who appears in 10 main forms, and the sly trickster Ganesh, the elephant-headed Lord of Luck. Brahman, for some reason, is largely ignored in Nepal – one explanation is that his work ended with the creation of the universe, and he's maintained a hands-off role ever since.

Beneficent goddesses are propitiated as well: the lovely lotus-eyed Lakshmi for wealth, or Brahma's consort Saraswati for the knowledge obtained from study. But the Nepali imagination

seems to be most captivated by the fiercer manifestations of feminine energy – black-faced Kali, who squats atop a corpse with her tongue lolling, or the regal and courageous Durga, whose slaying of the buffalo-demon is celebrated in the great annual festival of Dasain each autumn.

Hinduism and Buddhism exist side by side in the Valley, and have done so peaceably for centuries. Seventh-century Chinese visitors marvelled at the way "Buddhist convents and the temples of Hindu gods touch each other". In the modern Valley there is hardly an orthodox temple to be found – shrines serve visitors from both religions and diverse cults, while Buddhist *chaitya* and Shivaite *linga* stand side by side in courtyards.

Buddhism manifests in two forms in the Valley, both of them belonging to the highly complex Vajrayana school based on ancient tantric practices. The Newari form of Buddhism is the last living remnant of the long-vanished Buddhism of India. Characterised by elaborate rituals performed by *barey*, a hereditary caste of priests, it lingers in the temples and *bahals* of Patan, and to a lesser extent Kathmandu.

Tibetan Buddhism is the other form, an iconographically rich and complex series of practices involving deities, both fierce and gentle, who embody the entire range of human capacities. The Valley's Tibetan Buddhist population swelled following the Chinese invasion of Tibet in the late 1950s, when thousands fled across the Himalayas to a refuge in Nepal. Major Tibetan communities are now centred around the Buddhist stupas of Boudhanath and Swayambhunath, as well as the old refugee camp of Jawalakhel, south of Patan. It was Tibetan skills that started Nepal's important export industry of hand-knotted woollen carpets. Over the years, traditional Tibetan patterns and hues have been adapted to Western tastes, and nowadays the looms are likely to be worked by Nepali women. Tibetans themselves have moved up into management, channelling their new-found wealth into the new *gompas* or Buddhist monasteries which now ring Boudhanath and Swayambhunath.

Apart from, or rather, in addition to, the many Hindu and Buddhist deities, Nepalis live in a world of invisible forces: the *naga* or serpent deity which guards underground wealth; *deutaa* or local spirits which can bring good fortune or suffering, and the Newari Mai and Ajima, ancient "mother" and "grandmother" goddesses who must be propitiated with blood sacrifice. After dark,

the city is prowled by malevolent *pisaachs* and *pretas*, and the crossroads ghosts called *bhut* – perhaps one reason why city streets are virtually empty after 9 pm. And practically every community has its suspected *boksi* or witch, who may be male or female, and who serves as a convenient scapegoat for misfortune and illness.

To deal with this often malevolent universe, people rely on *jhankris* or shamans, who mediate between them and the many invisible forces. *Jhankri*-ism is so pervasive it's been called "Nepal's third religion". Rather than an organized faith, it relies on special individuals with the capacity to enter trances and gain contact with invisible spirits. In this state they diagnose and sometimes even cure illnesses, and serve as oracles foretelling the future. Dressed in pleated white skirts and peacock-feather head-dresses, the Valley's *jhankris* congregate on special occasions, most notably the Janaai Purnima festival each August, when dozens of them can be seen performing their whirling, hopping dance at the Khumbeswar Mahadev Temple in Patan.

FESTIVALS

With so many gods, it is only natural that "every other building is a temple, every other day a festival," as an 18th-century English visitor to Kathmandu observed. The annual cycle of festivals shapes the year, bringing colour and magic to daily routine. Celebrations may centre around a particular temple or shrine, or spill out onto the streets in boisterous processions. They are among the Valley's greatest sights for visitors – who are as likely to be a group of Tamang peasants down from the surrounding hills as a camera-toting tour group.

Festivals invariably involve *puja*, offerings of flowers, rice and red *tika* powder lavished on the particular deity of the day. Great feasts of curried this and fried that, accompanied by mountains of rice, are dished out onto disposable plates fashioned of stitched leaves (100 percent organic and biodegradable). Special bathing festivals allow crowds of shivering devotees to purify themselves in sacred rivers; or sometimes it is the holy image of a deity which is laved with mixtures of symbolic liquids. *Yatra* or processions march through the streets, accompanied by the drums, flutes and cymbals of Newar musicians, or by palanquins bearing images of deities. Particularly impressive are the great chariot festivals (*rath yatra*) of the three cities, in which images of the gods

are paraded in towering wooden chariots pulled by sweating, shouting crowds of devotees – a tradition which dates back to the eighth century.

The yearly festival cycle has its highlights: the oil lamps flickering on Patan's Krishna Mandir for Krishna Jayanti; the gay masquerades of Gai Jatra; Teej's gorgeous display of singing, dancing, clapping women in brilliantly coloured saris; the Hindu ascetics of various bizarre descriptions who descend upon Pashupatinath for Shiva Ratri; and the cheerful crowds that ring Boudhanath Stupa at Tibetan New Year. For Valley residents, the greatest of all festivals is Indra Jatra, a week-long celebration held in old Kathmandu on the full moon following the monsoon's end. The air has turned fresh and clear, and the moon pours its silver light onto streets stalked by troupes of masked and costumed dancers. Old images of the god Bhairab are put out on display, temples are illuminated, wild crowds tug the Kumari's great wooden-wheeled chariot, and magic is most definitely in the air.

LOCATIONS

A pity that some visitors never see this aspect of Kathmandu. For many, Kathmandu is synonymous with Thamel, the busy tourist district north of the old town where one can buy every conceivable type of hat, map, turquoise bracelet, or embroidered t-shirt, to name only a few specialities. Thamel incarnates the opposite of the maxim "Do a few things, but do them well." On the contrary, you can get virtually everything here, but little is well-done, and even less is really Nepali.

Just a kilometre or so south is another world entirely – old Kathmandu, a warren of interlinked lanes and courtyards and bazaars selling items both necessary and delightful. An endless stream of pedestrians sweeps through these, shopping for saris or soap or nails or any of the hundreds of other objects glimpsed through the wooden doorways. The ground floor of city dwellings serve as shops, or sometimes as workshops for artisans, bronze casters or silversmiths who skilfully anchor the piece they are working on with their toes.

It is absolutely essential to spend a morning, afternoon or evening wandering the old city, exploring its little markets specialising in little things. The Bead Bazaar, for example, tucked behind Indra Chowk, where Muslim traders preside over shimmering strands of glass beads and village women spend hours picking out the perfect necklace. Down the road in Makhan Tol are the cloth vendors, each displaying a rainbow assortment of fabrics, indigo shading into violet into black, then a new row starting off with 18 different hues of green. Round another corner at Bedhasingh is the "pottery temple," its lower steps covered with an assortment of pots, urns, jugs, jars, and containers of unglazed terracotta. Across the way is a string of shops selling *kapas,* the fluffy cotton used to stuff pillows and mattresses. In front of them loiter the professional beaters of *kapas,* dark-skinned men from the Terai who lounge beside their single-stringed wooden instruments waiting to re-fluff a mattress or quilt.

Kel Tol, the short stretch of road between Asan and Indra Chowk, is particularly fascinating. Part of the old, old trade route linking India and Tibet, the street is a riot of colour – draped saris and shawls, rows of brilliant bangles, peacock-feather fans, tinsel decorations for celebrations and festivals (one or another is always impending), great sacks of turmeric and their yellow-dusted sellers, bundles of rope incense and huge brown cannonballs of soap, sticky brown heaps of *gur,* stacks of plates fashioned of green leaves stitched with bamboo fibres, garlands of marigolds, and the orange-tinted heads of very recently slaughtered goats.

The nexus of all this activity is the trading centre of Asan Tol. Its vegetable sellers were evicted several years ago to make more room for traffic in a horrendous municipal decision, but crowds still swirl around the little Annapurna Temple, a gem of elaborately wrought metalwork dedicated to the goddess of the harvest, represented here by an overflowing silver vessel.

Old Kathmandu is breathtaking, especially early in the morning, when invisible temple bells clang from the winter mist, or on a summer evening when everyone's out on the street. Find an out-of-the-way corner and watch the crowds swirl by: the sari-clad women, the uniformed schoolchildren released from bondage, the men with their *topi*. Sitting back and watching life flow by is the East's premier entertainment, more sensual and stimulating than any virtual reality game, far more intriguing than television.

Across the Bagmati River, the former kingdom of Patan is linked to Kathmandu by suburban sprawl, but it retains its old-fashioned, otherworldly air. Historically known as "City of Artists," it houses an active community of craftsmen who continue the tradition of skilled metalwork – everything from brass water jugs to fine bronzes crafted using the lost-wax process.

Patan's huddled buildings, linked by the mellow tones of weathered brick, wood and tile, share the harmonious patina lent by age. The city's spacious courtyards house scenes that could be from medieval times, and on ritually important full-moon nights the whole place is humming with men singing devotional hymns, accompanied by harmonium and tabla.

The city remains a stronghold of Buddhist Newars, as demonstrated by the stupas, *chaityas* and shrines which dot the urban landscape together with old *bahal*, former Buddhist monasteries now occupied by communities of married "monks" who live with their families in the quadrangular quarters built around a central temple. The gilt-plated facade of Kwa Bahal, popularly known as the "Golden Temple," is an extravaganza of the finest Newari metalwork. An even more important, though less lavish, site is the stately shrine of Raato Machhendranath, Patan's most beloved deity. The strange red image of the god resides here for only six months of the year. The other six months it is ensconced in Bungamati, a thoroughly Newar village some six kilometres south of Patan. Machhendranath commutes back and forth on a palanquin carried by devotees, and perambulates annually around Patan in a wooden-wheeled chariot topped with a 60-foot tall bamboo tower, in a tradition dating back centuries.

Patan's Durbar Square has been acclaimed the finest of all the Valley's royal plazas by generations of visitors. It is indeed an astonishing assemblage of temples constructed of stone, wood and brick, lightened by the bright flash of rooftop pinnacles. Among the most marvellous structures is the *naga*-rimmed royal bath of Tulsi Hiti in the palace courtyard of Sundari Chowk. Sinuous stone snakes writhe along the top of curved walls inset with niches where stand superb small sculptures of deities in stone and metal, over five dozen in all. The exquisitely detailed 17th-century palace compound consists of a series of linked courtyards adorned with woodcarvings of the highest order. One of the courtyards, Lumjyal Chowk, was recently restored with financial assistance from the Austrian government and now houses the Patan Museum. Most suitably for this City of Artists, its collection highlights metalwork.

Bhaktapur, on the other hand, embodies concentrated countryside. Fourteen kilometres east of Kathmandu, it remains surrounded by fertile fields that have long been considered the best farmland in the Valley. The third of the triumvirate of ancient

kingdoms, Bhaktapur remains the most authentically in touch with its rural heritage. Some ninety percent of its population is Newari – Hindu Newars this time – and over half belongs to the Jyapu subcaste of peasant farmers. This ethnic cohesiveness has done much to preserve a rich cultural life rooted in ancient traditions. Some of the credit for the city's harmonious appearance must also go to the German-sponsored Bhaktapur Development Project begun in the 1970s, which restored many crumbling buildings and established guidelines for future development.

Bhaktapur's tall red-brick houses are festooned with necklaces of drying corn, firecracker-red strings of chili peppers, and chains of fermented dried greens called *gundruk*. Few vehicles ply the city's red-brick streets, which are filled with people doing all sorts of interesting things – drying grain, making pottery, dyeing skeins of wool. The feeling is intensely busy yet deeply harmonious. It's difficult to believe that this is an urban environment with one of the highest population densities on earth. The tight concentration of people into a limited space conserves precious farmland, and is a characteristic of Newari cities. In the case of Bhaktapur, it seems to have had exceptional cultural results. One anthropologist has described Bhaktapur as "a climax community of Hinduism" – the full flowering of an extraordinarily rich and complex civilisation.

Bhaktapur's Durbar Square, while palatial in size, seems oddly empty. The devastating 1934 earthquake which shook the Valley left much of this city in ruins and wiped out fully half of the square's ornate monuments. The neighbouring plaza of Taumadhi Tol is much more integrated into the urban fabric. Here is the towering five-storied temple of Nyatapola, the tallest in Nepal, and another handsomely proportioned shrine to Bhairab.

Around the corner in the open-air atelier of Bolachha Tol, pottery of all shapes and sizes is in every stage of being formed, finished, or refined. Muscular men knead unyielding lumps of black clay into submission, while skilled potters slap a handful of earth on their whirling wheels and miraculously cause it to bloom into a vessel. After designs and decorations are etched in with the edge of a coin, the almost-finished products are carried out to the square to dry in the sun. The final step is firing, in giant temporary kilns formed of mounded straw.

As a stroll through the surrounding countryside soon reveals, life in the Valley follows a rhythm dictated by the seasons and the different kinds of fieldwork that accompany each. The advent of

the summer monsoon brings long lines of workers into the flooded ricefields to plant the green shoots in the warm mud. A month later the vibrantly coloured fields are set amid the floating mirrors of flooded terraces. The clear, sunlit skies of autumn arch over a golden harvest season, when everyone joins together to bring the ripened grain in on time. The coldest months see fallow fields of stubble grazed by livestock herded by shouting children, but nothing stays unplanted in the fertile Valley for long. The mist that swathes the Valley in a white blanket on winter mornings moistens fields of wheat and potatoes, soon followed by the bright yellow of flowering mustard.

Any visit to the countryside, however brief, also reveals that women are the workers of Nepal. They do their share of planting and harvest as well as most of the weeding and maintenance of crops, carry water, wood, and huge mountains of fodder to feed their livestock, bear the children and care for them, do the laundry (by hand), cook the meals (over a wood fire), and process the food they have grown. The men pitch in at the peak work seasons of planting and harvest, but otherwise the main responsibility for the smooth running of life seems to fall on women's shoulders, as it does the world over.

HOLY PLACES

The Valley's singular mix of religions is best sampled in situ, at three of its greatest shrines. Each is dedicated to a different religion, and each displays a distinctly different character.

The great stupa of Boudhanath in the eastern Valley is a superb site from which to observe the exceptional devoutness of Tibetan Buddhists, who can be seen performing the many sacred ceremonies their culture has refined: prostrating full-length, spinning prayer wheels, muttering sacred *mantra*, burning mounds of dried juniper to cleanse the air of evil influences. The crowd that endlessly circles the stupa moves clockwise, keeping the monument on its right as a sign of respect. This performance of *kora* or ritual circumambulation is a therapeutic combination of mild exercise, social stimulation and religious merit – a pleasant form of worship carried out early in the morning and again at dusk. Participants may finger prayer beads or spin the embossed copper prayer wheels, chat with a friend or take their Lhasa *apso* out for an airing as they stroll in circles – it all brings *sonam,* merit. On full-moon nights the number of worshippers increases, and little

stands are set up with butter lamps one can light for a few rupees to generate more merit. The flickering, glowing light casts its magic on faces, and always the crowds are turning round, caught up in the never-ending wheel of life.

Perhaps because it lies along the old Kathmandu–Lhasa trade route, Tibetans have always gravitated to Boudha. More recently, thousands of refugees settled here following the Chinese invasion of Tibet. In a classic refugee success story, they have transformed the local landscape with houses and monasteries built with wealth both old and newly-earned from shrewd business ventures. At least a half-dozen new monasteries are visible from the topmost level of the stupa, their ritual halls (*lhakhang*) hosting frequent prayer ceremonies of chanting monks accompanied by sonorous horns and thudding drums. Further in the distance is Kopan Monastery, where Western students gather each fall for a month-long meditation seminar. With its wide variety of teachers and practices, Boudha is the premier site for the study of Tibetan Buddhism.

The western side of the Valley is guarded by the ancient hill-top shrine of Swayambhunath, said to have been built over the site where the legendary lotus blossom first emerged from that long-ago lake. Certainly Swayambhu is among the most ancient sites in the Valley, its historical roots lost in the mists of time. It's a steep, steep climb up the 365 worn stone steps to the very top of the hill. The penetrating gaze of the stupa surveys all comers, as do the wary bands of thieving monkeys and the persistent Tibetan curio vendors who patrol the steps.

The stupa platform is enriched by centuries of royal gifts, including a giant gilded *vajra* and Buddha images constructed of carved and fitted stone blocks. Royal wealth was also lavished on the five little gilded shrines attached to the stupa's dome, one for each of the Pancha Buddhas who are associated with the five elements. Since the formless selfborn light of Swayambhu is a difficult entity to grasp, the Pancha Buddhas are worshipped as intermediaries by devotees. Swayambhu is at its finest on a spring evening. As the delicate pink sky of twilight outlines the hills, the full moon rises over a city in which lights flicker on one by one. The entire tableau seems suspended in a magical halfway realm that belongs to neither day nor night.

At the Hindu temple of Pashupatinath on the banks of the Bagmati River, Shiva is ruler. Pashupatinath, "Lord of the Beasts",

is one of his many guises, the focus of an ancient Indian cult who today serves as the official patron of Nepal. Three millennia of Hinduism are concentrated here, in temples and little stone *shivalayas* housing carved *linga*, the quintessential symbol of Shiva.

At once the destroyer and transformer of Hinduism, Shiva embodies all the powerful, dark and regenerative forces of nature. The deeply interwoven associations between his most holy shrine and death seem only appropriate. To die on the Bagmati's bank at Pashupatinath is said to bring the highest good fortune – release from the cycle of birth and death. The terminally ill are often carried down to pass their last moments with their feet in the water. Every day of the year, ritual cremations are conducted on the stone platforms along the river's western bank, a sight of immense dignity and poignancy too often unrespected by the crowds of camera-clicking tourists on the opposite shore.

The Bagmati is considered Nepal's spiritual equivalent of India's sacred Ganges. Despite the horrific pollution created by raw sewage and industrial wastes, crowds of devout Hindus still gather here for ritual bathing, particularly for the festival of Shiva Ratri each February. The same period sees the arrival of crowds of *sadhus*, Hindu ascetics who may be holy men or slightly crazed eccentrics – often a combination of both. Some are clad in orange robes; others in a loincloth or nothing at all, smearing their bodies with ashes gathered from cremation pyres. They may perform peculiar penances, standing up for years on end or subsisting on a diet of only milk. Many partake mightily of hashish, a substance sacred to Shiva, preceding each hit with the invocation *Bom Shiva Shankar.*

Its superb cultural wealth has led the Valley to be often called an "open-air museum." Its 570 square kilometres (220 square miles) are littered with temples and shrines and ancient stone sculptures that anywhere else would be safely encased behind glass, but here are still actively worshipped, or simply taken for granted. In actuality, the Valley is far better than a stuffy museum – it's a vibrant traditional culture that has somehow managed to survive into the last days of the 20th century.

The Modern Valley

What the next millennium will bring is less certain. Observers glumly predict the imminent demise of ancient traditions due to the pressures of modernisation – but then, the same refrain has been sung for years. It's similar to the long-term residents' lament: "If only you could have come before"…before the hippies came (in the early '60s)…before the hippies were kicked out (in the early '70s)…before the traffic became so terrible (in the early '80s)…and so on.

Such sentiments ignore large chunks of the inconvenient truth, such as the fact that a brown, smoky haze obscured Himalayan views during those supposedly halcyon '60s days, because most Kathmandu residents at the time cooked on wood fires. Yes, there is air pollution nowadays; and no, it is not the worst in Asia, no matter what some residents might complain. Caught up in the vortex of the admittedly ugly modern Asian city that is New Kathmandu, it's easy to forgot the Valley that lies beyond the smoke-belching tempos of Putali Sadak – the harvest scenes straight from a Breughel painting, the rice-planting songs, the ancient deities and the blood sacrifices and the long low growl of monastery horns.

The modern world has definitely come to the Valley, and still a certain cultural strength and resilience endures, living on in traditions like the worship of the Kumari, a living virgin goddess. A dozen villages and towns in the Valley follow this ancient custom, but the most sacred of all is the Raj Kumari of Kathmandu, a little Newari girl chosen for her uncanny self-possession and flawless appearance as described in an ancient text: "Thighs like a deer, chest like a lion, neck like a conch shell, eyelashes like a cow, and body like a banyan." Once the high priests have determined her to be a suitable vehicle for the goddess – she may be as tiny as two years old – she is initiated and enshrined in the 18th-century Kumari Bahal adjoining the old Royal Palace. Attendants care for her in a daily ritual, dressing her in bright red robes, painting her forehead with an elaborate third-eye design, and adorning her with gold and silver jewellery.

Though she is of the Sakya caste of Newars and therefore Buddhist, her devotees believe the Kumari incarnates Taleju Bhavani, a powerful form of the Hindu goddess Durga. Devotees come daily to worship her, women hoping for the boon of fertility or their children's health, and men seeking worldly power. The little Kumari reigns until the shedding of blood, through loss of a tooth or more commonly menarche, signals the goddess has left her body. Another young girl is chosen, and the former Kumari is free to lead an ordinary life.

Kathmandu is in some ways like this newly liberated Kumari – come of age and released from its traditional roles, freed into a less-romantic life which offers greater, if more uncertain, opportunities. Increasing modernisations have done much to demystify and expedite life, in a way that is both a gain and a loss. Or perhaps this is still the Valley's future, for the pull of tradition and the intricate network of kinship and culture are often stronger than we give them credit for.

Many forces encroach upon the Valley's traditional culture. Most apparent are the obvious modernisations brought by the internal combustion engine, television and tourism. Less visible, perhaps, but more pervasive is the "Sanskritisation" created by social pressures from other Nepali ethnic groups, particularly the dominant hierarchy of the Brahman and Chhetri ruling castes. The woes of modernisation can be summed up in the symbols of modern Kathmandu: traffic jams, air pollution, and blaring horns, cinema halls featuring Hindi films, the theft and sale of cultural artefacts and religious relics, and the multi-storied concrete houses erupting everywhere, like hideous blotches on a beautiful face.

Still, and somehow, the city retains its charm. A traffic snarl untangles to reveal its source, a caparisoned elephant bearing a regal red-and-gold-clad bride, and any impatience evaporates in a burst of pure pleasure. Another traffic jam is caused by a gaily-clad wedding band marching at leisurely pace down the street, its trumpeters blaring out a tuneless melody punctuated by the ear-splitting thump of a bass drum. Or sometimes it's just the resident elephant of the Jawalakhel Zoo, slowly plodding home in the left-hand lane with its daily fodder. Sacred cows do their part to snarl city traffic, and dogs take death-defying naps in the middle of the road. Snake charmers and itinerant sadhus play the crowds, and painted beggars lay on the sidewalks waving their stumps in search of *baksheesh*.

Contrast is the only thing one can take for granted in Kathmandu. Helmeted riders manoeuvre their motorcycles around the ancient shrine of Ashok Binayak, performing the traditional good-luck circumambulation made before departing on a journey with a new twist. Cable dishes sprout from tiled roofs, and giant neon signs block views of old domed temples. Flocks of ducks are driven down past the luxury shops lining Durbar Marg, and sweating porters push rattling wooden carts amidst traffic jams formed of sleek ministerial Hyundais and Land Cruisers.

What can one say about a place that produces at least seven major soft drinks and six types of beer, but can't come up with potable tap water? Or where an annual public holiday shuts everything down once a year so that gangs of young men can roam the streets, tossing buckets of water on passers-by and smearing them with red powder? What kind of comment can one make about a place where the Natural History Museum exhibits stuffed rats, where a revolution (the 1951 one) replaced an oligarchy with a monarchy, and where a Communist government periodically rules over the "world's only Hindu kingdom." How to understand a place that supports the Kumari and cable television with equal aplomb?

Faced with all this, one is forced to resort to Nepal's unofficial national slogan: *"Yo Nepal ho,"* "This is Nepal," accompanied by a slight heave of the shoulders that shrugs off its quirkiness as a matter of course. Truly the Kathmandu Valley *is* Nepal, complete in all its grime and glory.

The snarling, fanged mask of Seto Bhairab ("White" Bhairab) in Kathmandu's Durbar Square is revealed only once a year, during the week-long festival of Indra Jatra. At night, the pipe jammed between the image's teeth spouts forth jand or home-made barley beer to the crowds of revellers jostling below.

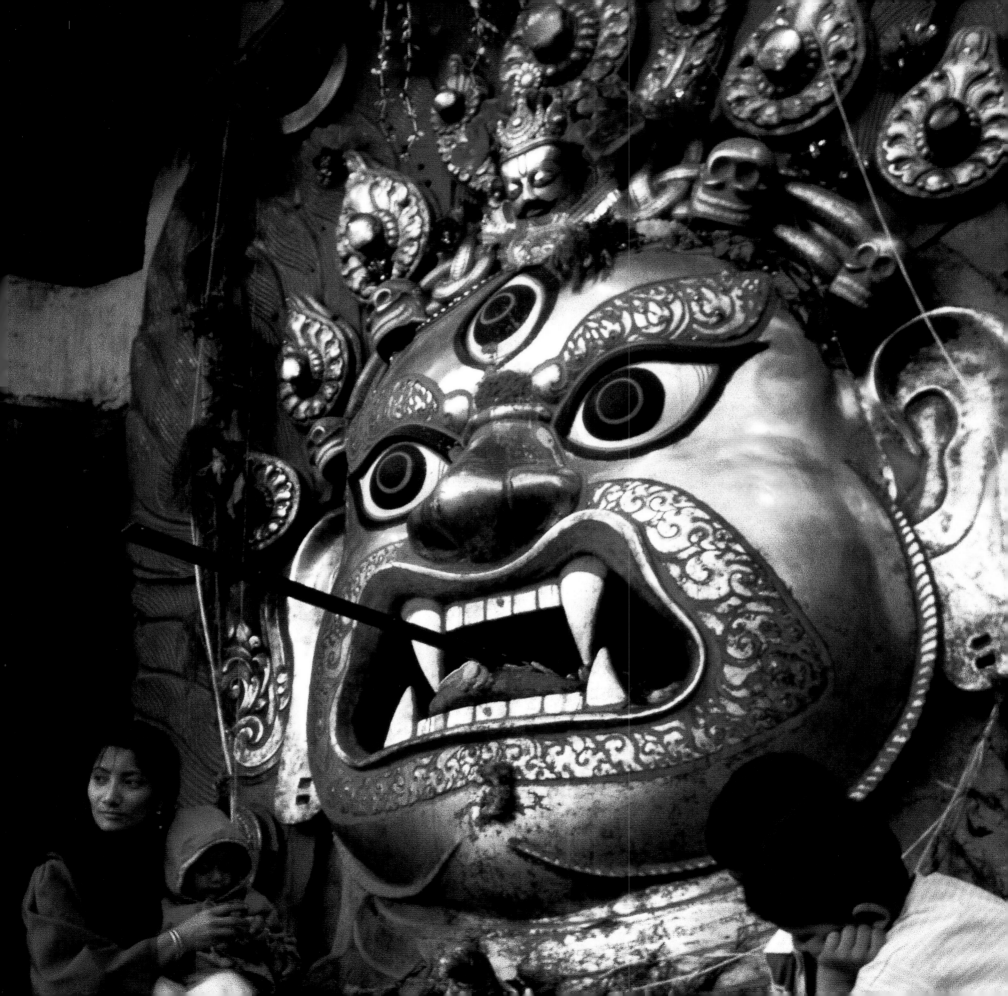

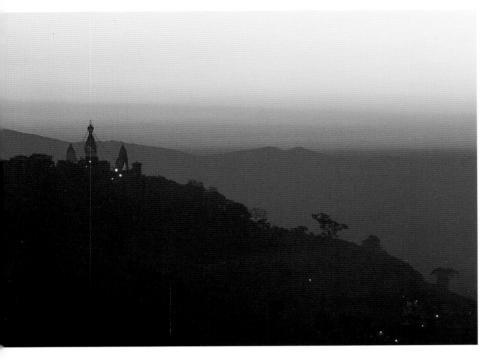

(Above)
Sunset tints the horizon with delicate yet rich colours, silhouetting the spire of Swayambhunath stupa. The Valley's creation legend maintains that the Buddha Manjushri was so moved by the marvellous sight of Swayambhu's light that he split the sheer wall of hills rimming the lake with his Sword of Wisdom. The waters rushed out, leaving behind a flat and fertile basin to which pilgrims could now come for worship. Manjushri's sword, or the series of earthquakes that split the rock cliffs of Chobhar Gorge, from where the Bagmati River winds its way out of the Valley – ancient texts and geological science are for once in perfect accord.

(Right)
Full-moon days are occasions for major puja or offering ceremonies at temples throughout the Valley. The full moon of May marks the triple anniversary of the Buddha's birth, death and enlightenment, and is an especially sacred time at Swayambhu. Crowds of worshippers come to make offerings of rice grains and flowers, light oil lamps, burn fragrant incense, and string up new prayer flags.

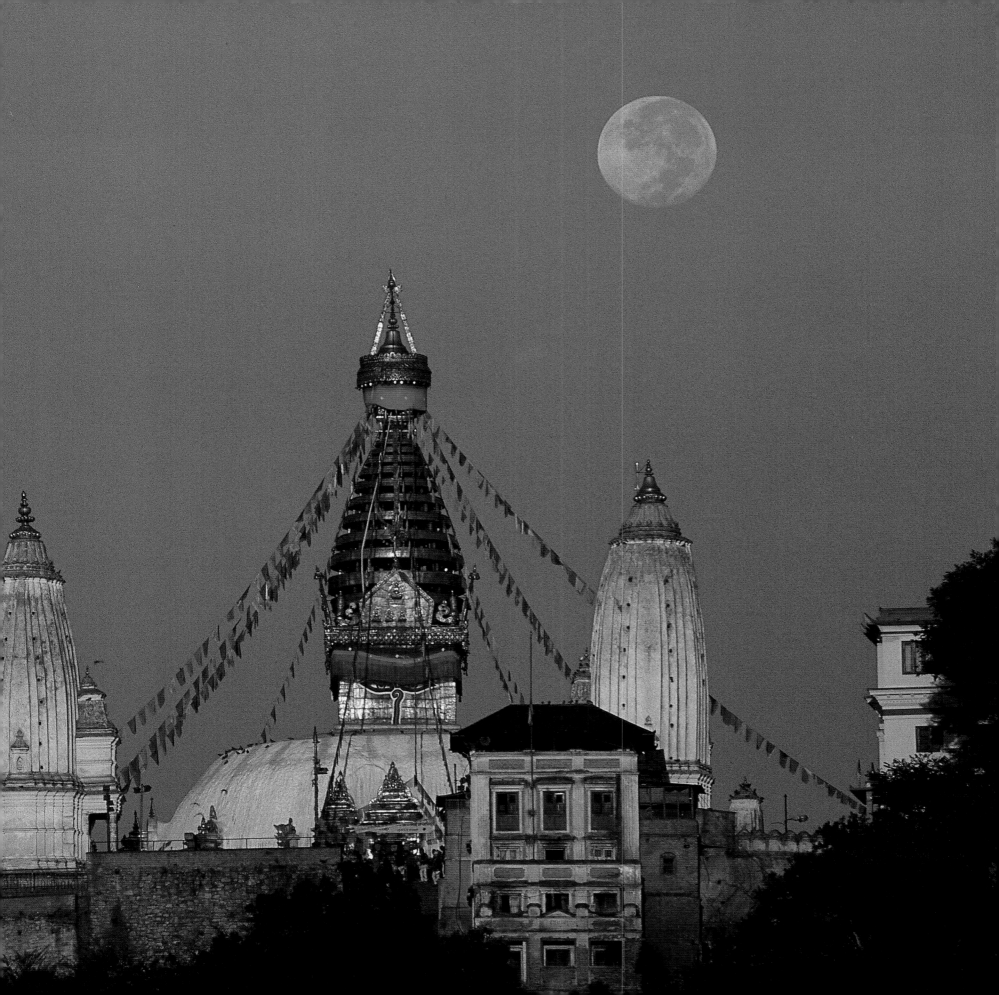

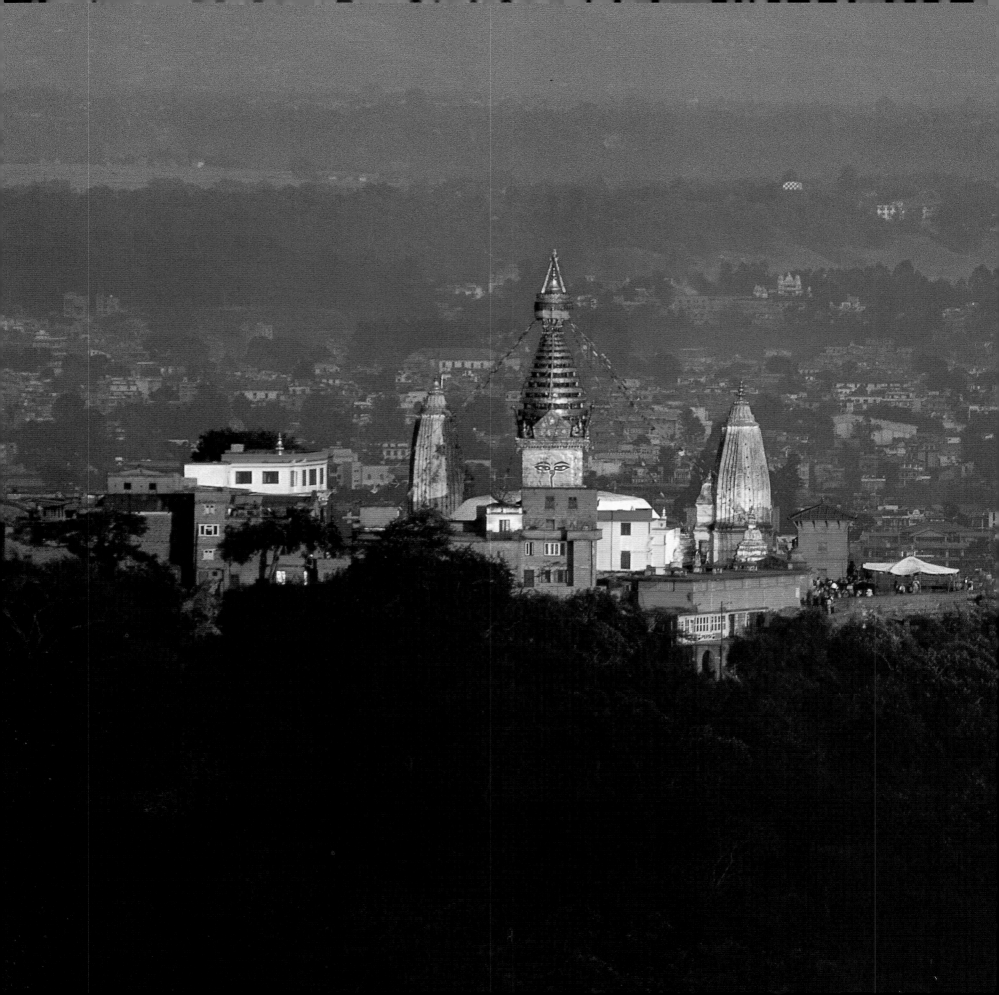

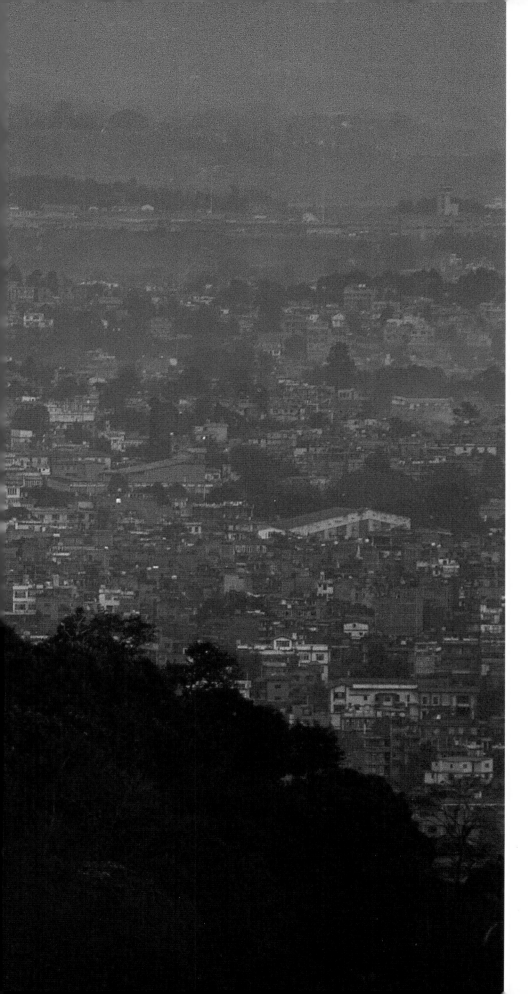

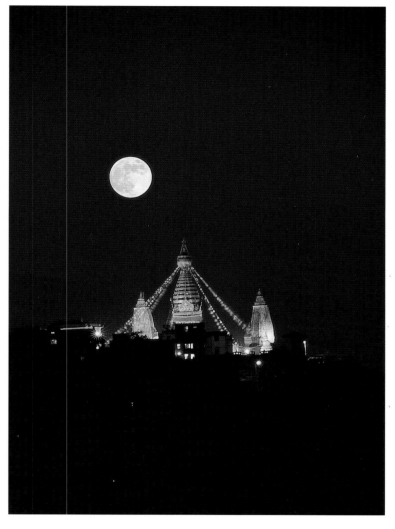

(Above)
The most mystical and enigmatic of all the Valley's shrines, Swayambhu's origins are lost in the mists of time, but historians have no doubt that it has been a sacred site since at least the fifth century.

(Left)
Swayambhunath is particularly sacred to Newar Buddhists, who flock here on festival days and for personal rituals conducted by family priests. During the sacred summer month of Gunla, hundreds assemble each morning before dawn in the old town and form processions to worship at the stupa. Swayambhunath has a sizeable Tibetan community as well, and many new Tibetan Buddhist monasteries have been built in the vicinity.

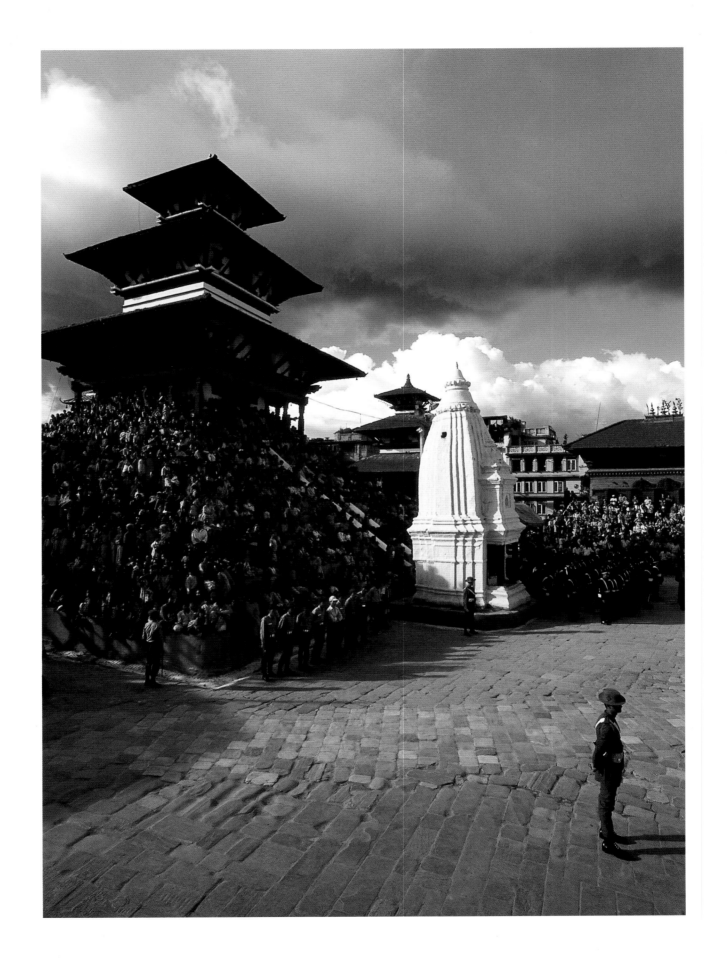

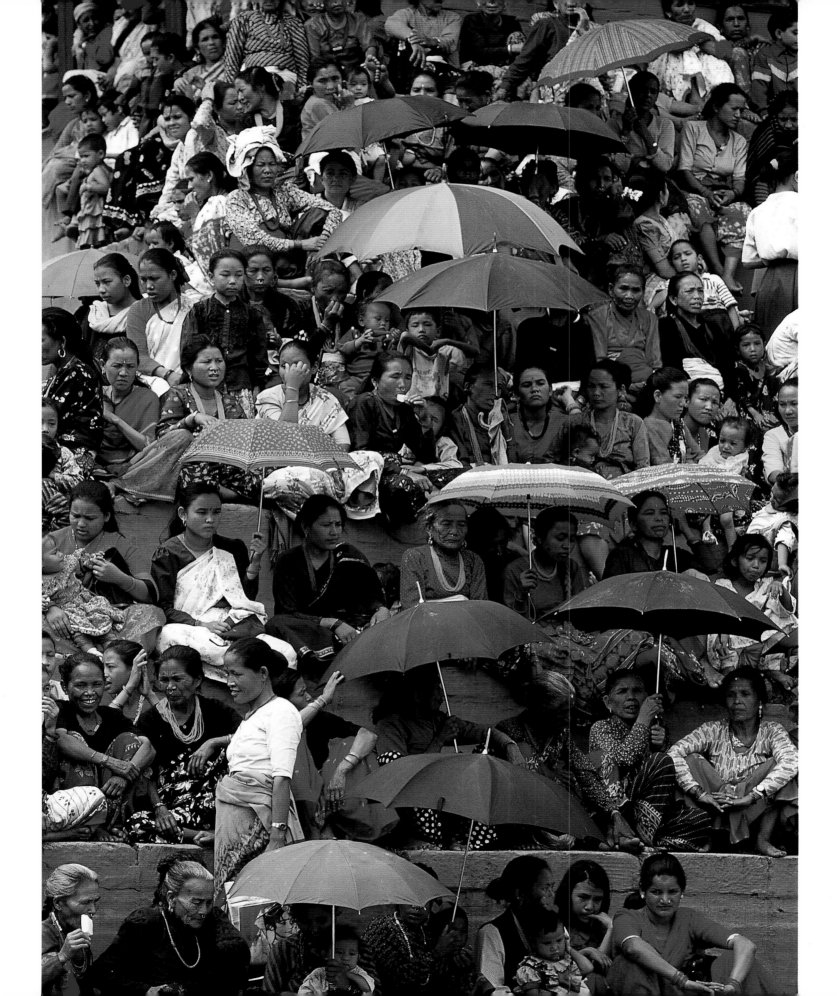

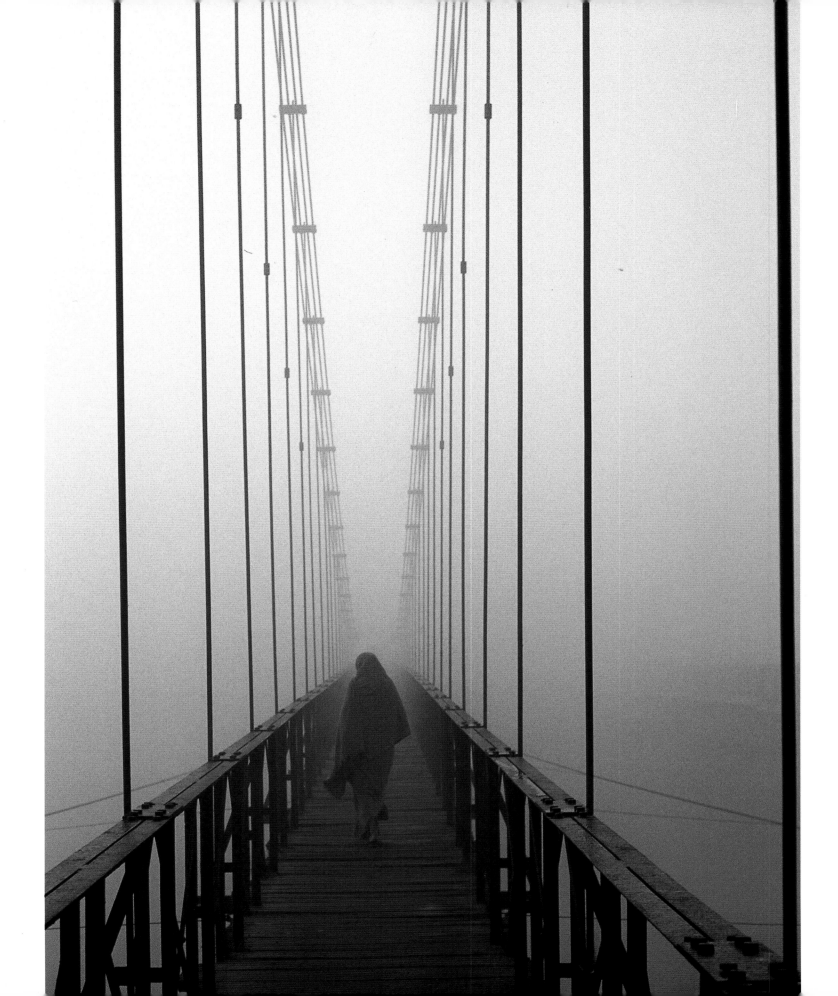

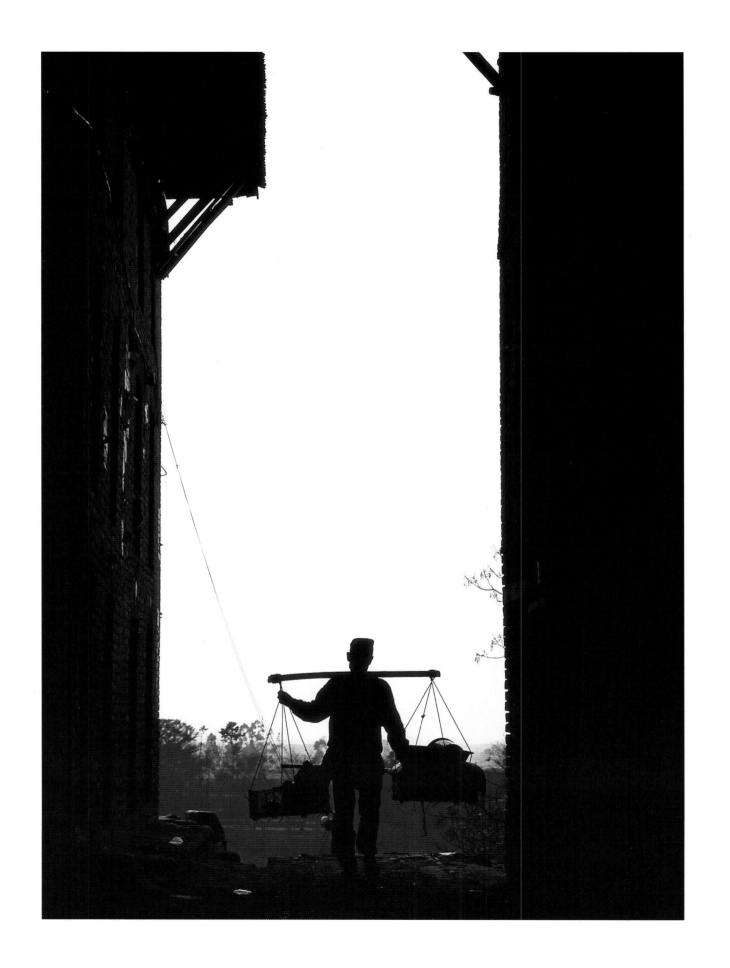

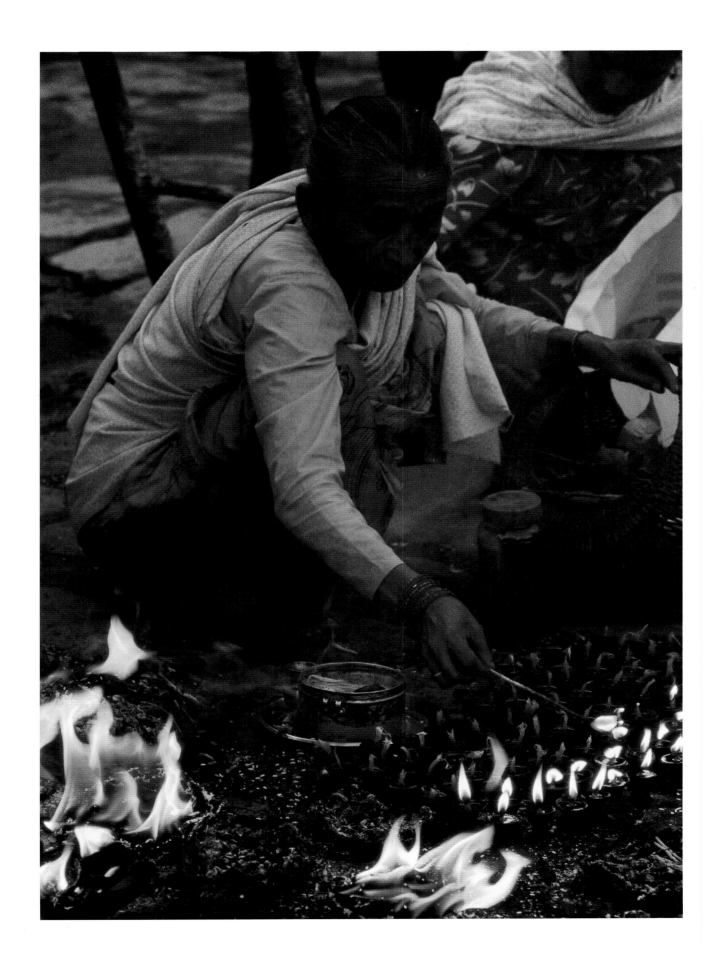

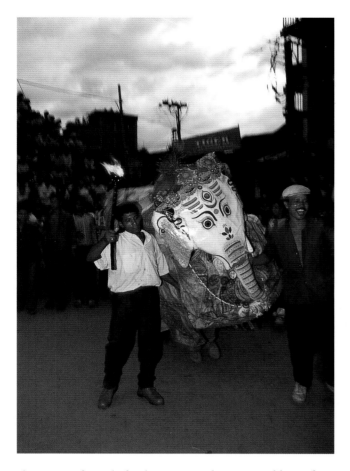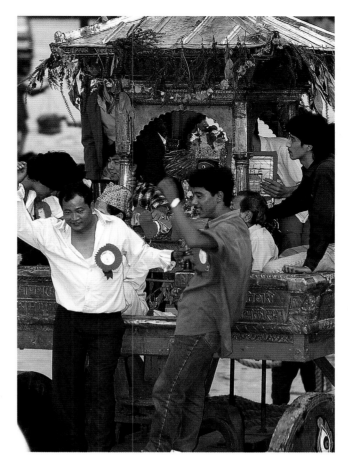

The autumn festival of Indra Jatra marks an annual bout of revelry and excitement for Valley residents. Ancient images of the fierce deity Bhairab (a form of Shiva) are displayed in public for the occasion, as are idols of Indra, the Lord of Heaven, whom, it is said, was once imprisoned by Kathmandu residents for attempting to steal flowers.

(Facing page)
An elderly woman lights oil lamps as a part of offerings presented in Kathmandu's Durbar Square.

(Top left)
A torchbearer accompanies a pair of costumed dancers embodying Indra's mount, an elephant, on a frantic rampage through the streets searching for its master.

(Top right)
The girl-goddess Kumari is pulled in her gilded chariot through the streets by crowds of devotees as part of Kumari Jatra, a festival within a festival.

(Page 28)
Crowds gather in Kathmandu Durbar Square during Indra Jatra to view the appearance of the Kumari, a little girl worshipped as the embodiment of a powerful goddess. On the final day of the festival she appears in public to give tika to the king of Nepal, thus confirming his right to rule for another year.

(Page 29)
With their brightly coloured blouses and saris, the crowds of women who pack the temple steps form a celebration in themselves. Many of them are Tamangs from the hill regions surrounding the Valley. Colourful umbrellas shade them from the blazing sun.

(Page 30)
A woman crosses an old suspension bridge swathed in winter mist. Around a dozen iron bridges were imported from Scotland at the turn of the century by Nepal's Rana rulers. As the country had no roads, the materials were carried in by teams of porters, then assembled and installed on site.

(Page 31)
Twin baskets suspended from a nol or bamboo shoulder pole are one of the many distinguishing characteristics of the Newars, the Valley's indigenous inhabitants. They are used to carry loads varying from fresh vegetables to pots and pans, and occasionally, small children.

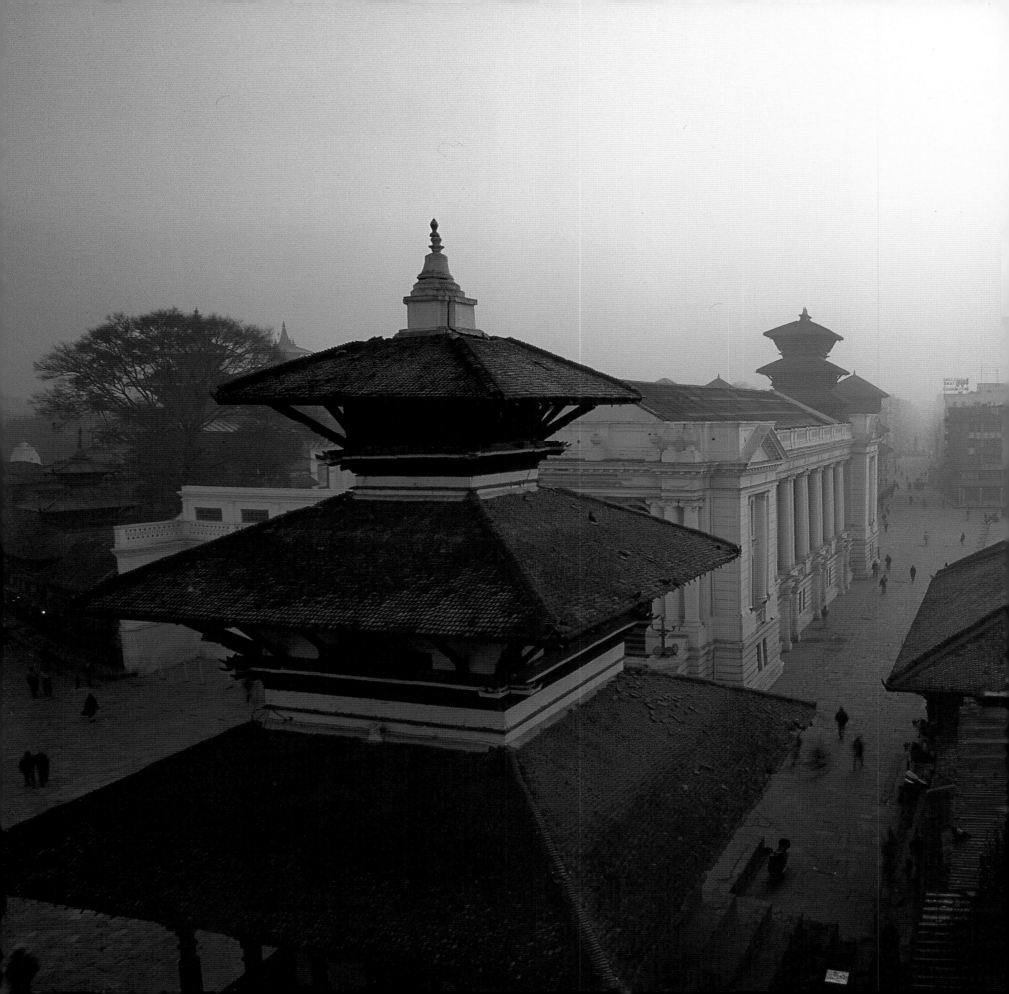

(Above)
Kathmandu is composed of layered centuries of development: the red-brick huddle of the old town fronts the white spire of the 1830 Dharahara, which a period historian reported was built to "amaze the populace". Behind are newer buildings, like the red-brick block of the Everest Hotel to the right, flanked by the massive white bulk of the new Convention Centre.

(Left)
Early morning light envelops Kathmandu's old Durbar and the adjoining Basantapur Square. The neo-classical facade of Gaddhi Baithak to the left, modelled on London's National Gallery, is a relatively recent Rana-era addition to the stacked temple roofs of the old palace. The entire complex represents an amalgamation of various styles and eras, from the 17th century to the present day.

(Page 36)
Garlands of marigolds strung up to bring blessings to a shuttered shop, and campaign posters exhorting "Vote for Tree" (the Congress Party symbol) serve as a backdrop for two friends chatting at a small urban version of Nepal's traditional trailside chautaara or shaded resting place.

(Page 37)
The backstreets of old Kathmandu, brick-paved or sometimes not paved at all, remain quiet, shady warrens of tightly packed buildings and shops. While the old cities of the Valley have some of the highest population densities on earth, they somehow manage to feel uncrowded. Local neighbourhoods are arranged by caste or subcaste into tol, groups of 100 or so houses clustered around temple-studded squares.

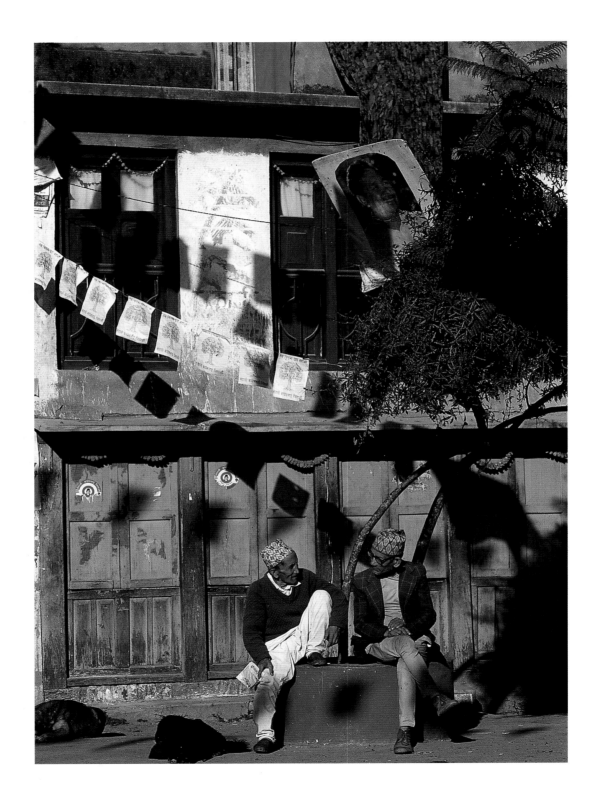

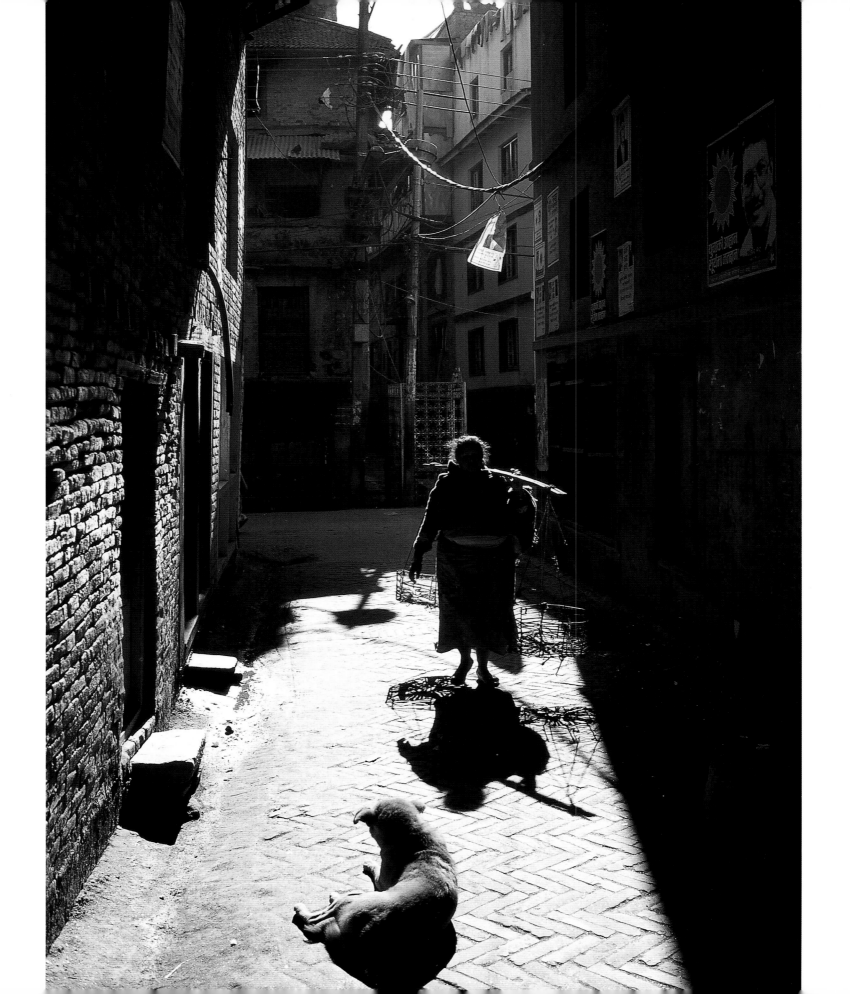

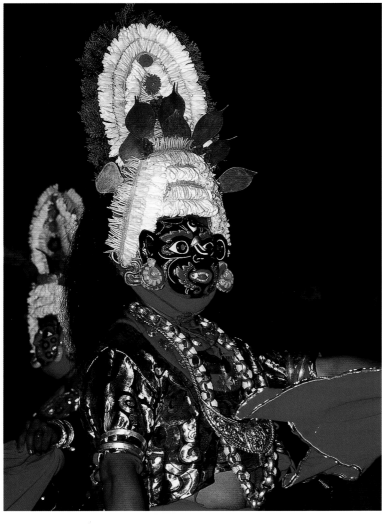

(Above)
A masked lakhey dancer with elaborate head-dress performs in front of Kathmandu's Ikhu Narayan temple during Indra Jatra. Troupes of costumed dancers, jingling bells strapped to their ankles, roam the streets during the eight nights of the festival, returning the city to its medieval past.

(Right)
Crowds gather to watch the street performance of lhakey dancers, who represent a certain type of demon. Only members of a particular Newar subcaste perform this dance. On other occasions, dancers don sacred masks for performances that serve as ritual worship. If the dancer's mind is perfectly centred, he is believed to enter a trance in which he embodies the god.

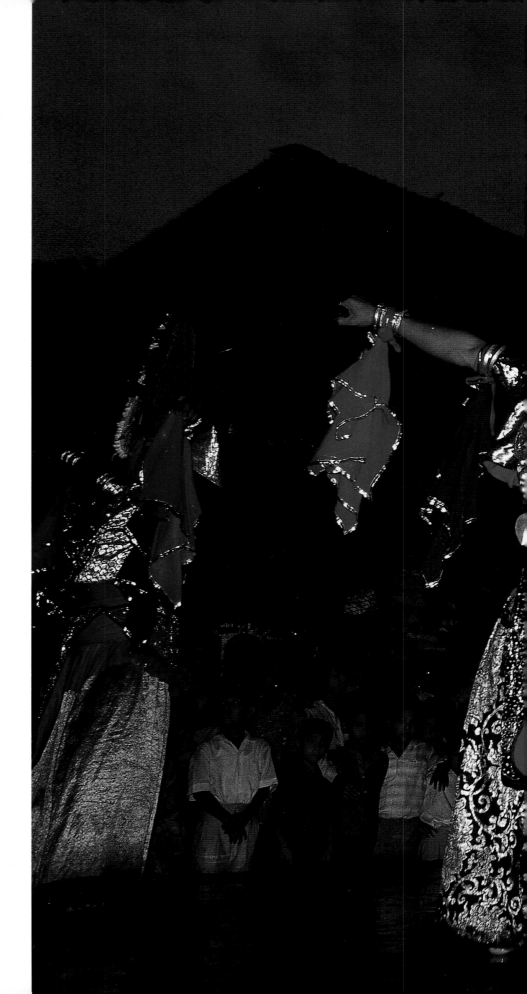

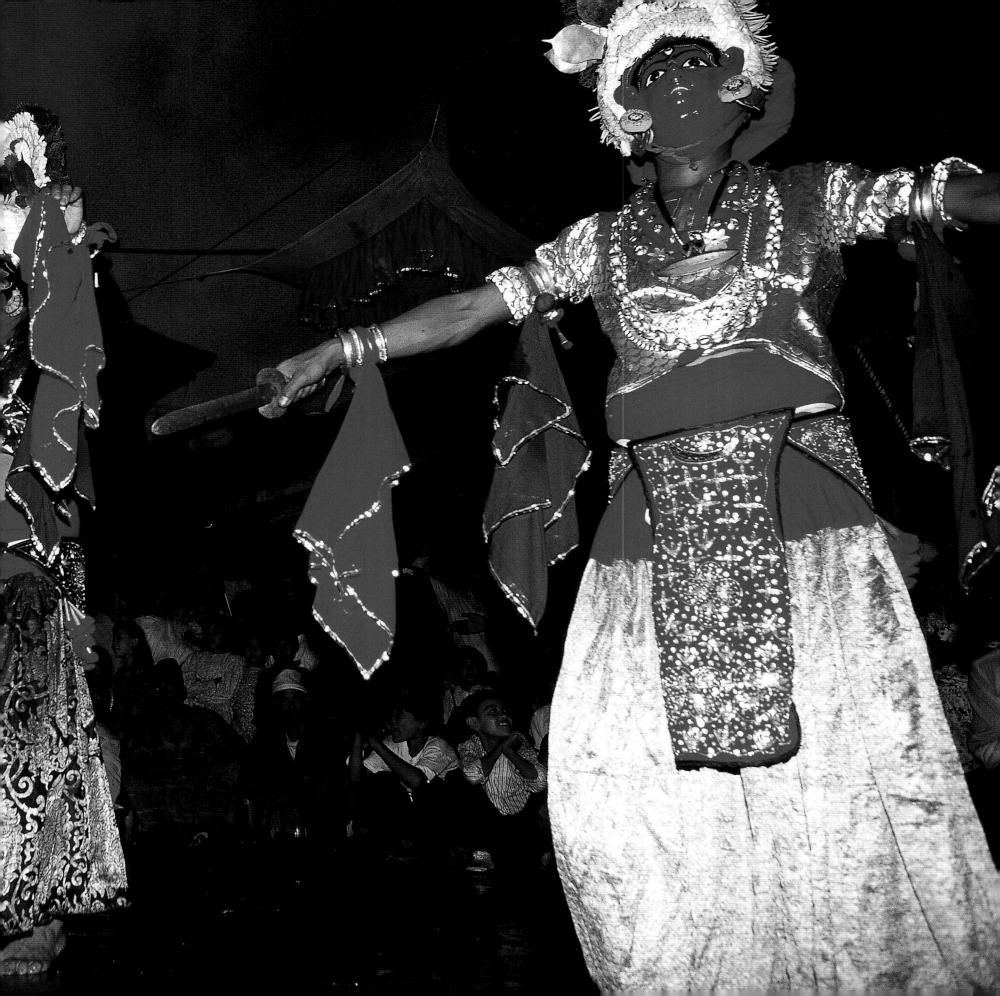

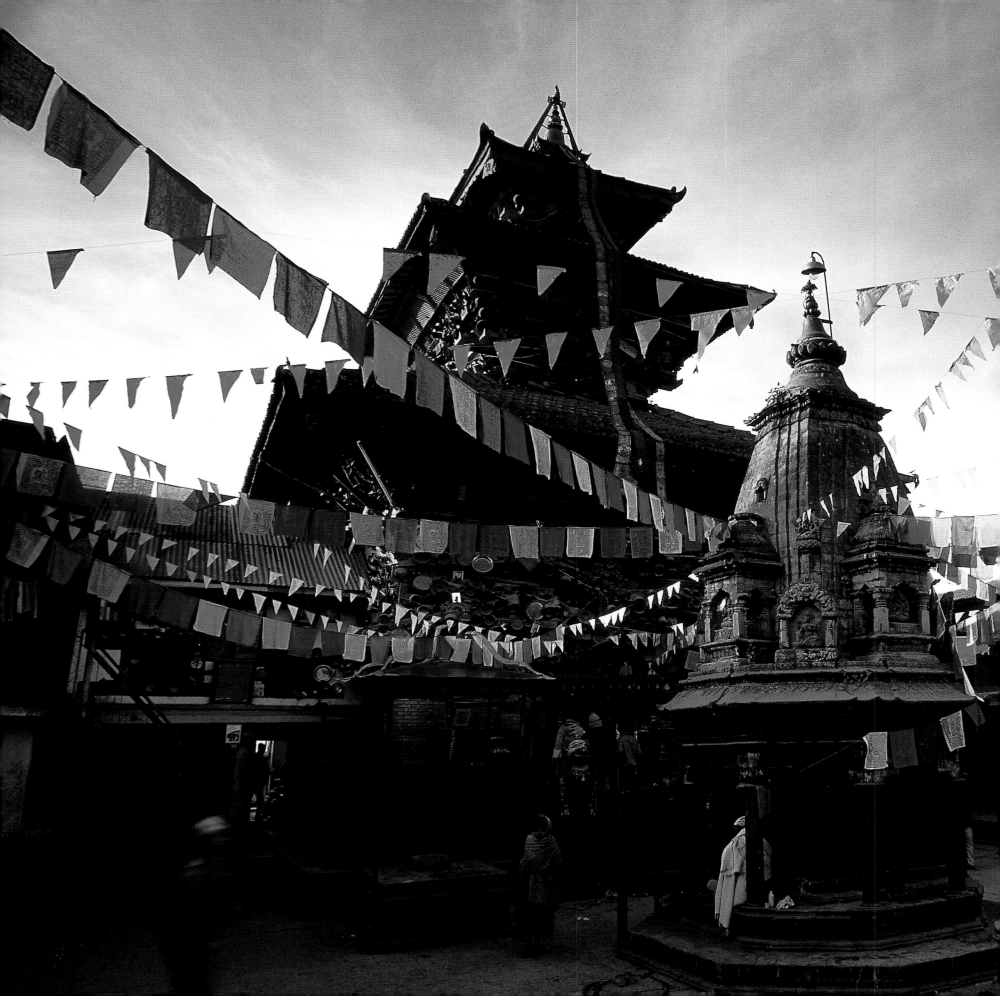

(Above)
Prayer flags flutter over this elderly Tibetan man, who with prayer wheel and mala, the 108-bead rosary used to count the recitation of mantra, embodies the deep Buddhist devotion of so many Tibetans.

(Left)
The 17th-century temple of Adinath Lokeswar in the little Newari hilltop village of Chobhar enshrines an image of Adinath Avalokitesvara, a Buddhist deity of compassion who is equally worshipped by Hindus as Surya, the Sun God. The pots and pans nailed up under the eaves of the main temple are donated for various reasons: by devotees grateful for a granted wish, by newlyweds seeking a happy married life, or by children supplicating for a prosperous afterlife for deceased parents.

41

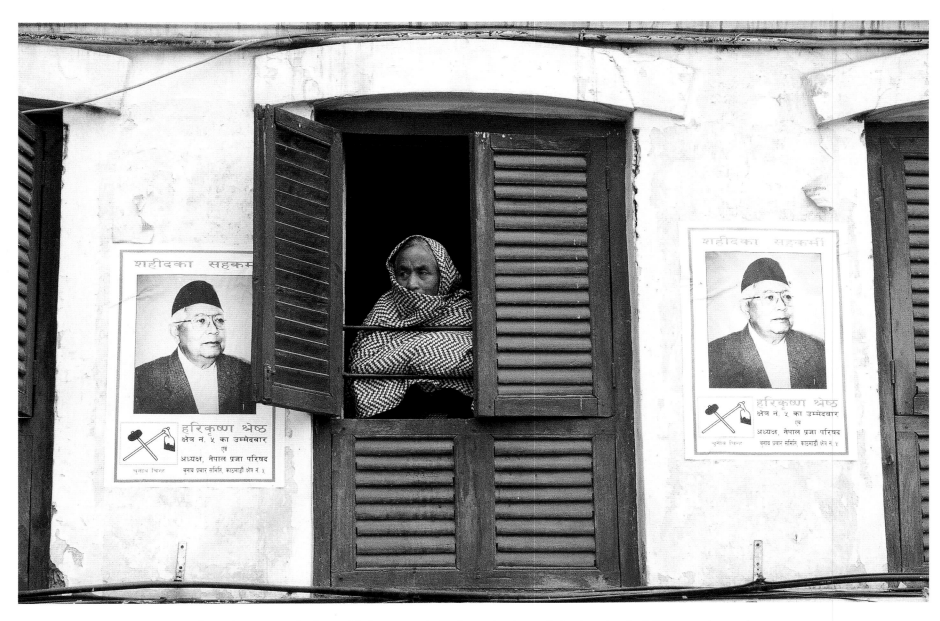

Campaign posters flank an elderly woman in Kathmandu. Around election time buildings are plastered
with posters and slogans exhorting the populace to vote for a particular political party. Because of
Nepal's high illiteracy rate, parties are represented on the ballot
by an easily recognised symbol – in this case, farming tools.

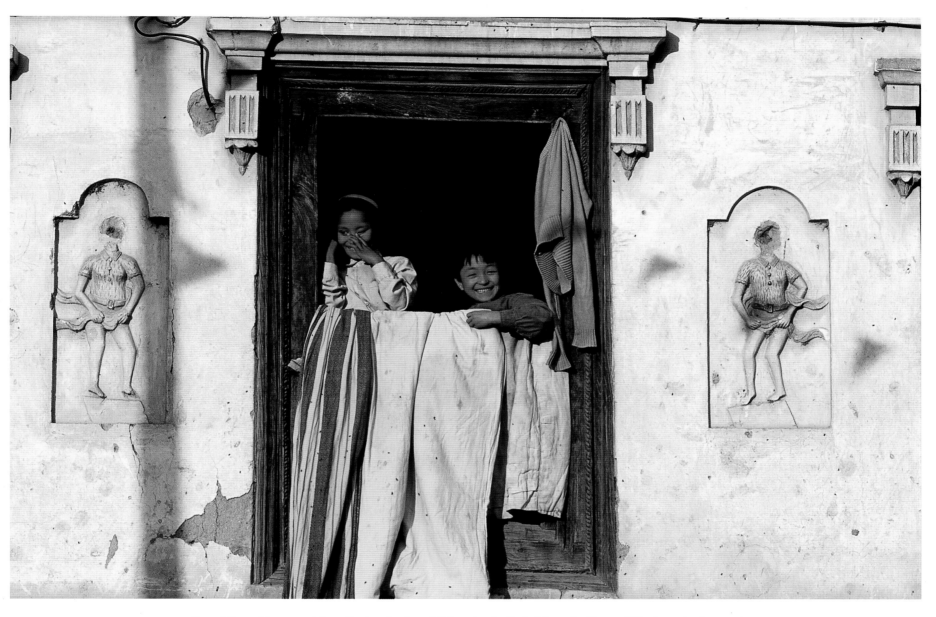

Crumbling old stucco inlays flank grinning children in the little Newari village of Khokana in the south Valley. Old buildings often feature humorous architectural details with unexpected elements – the figure here appears to wear a Western-style belt, and why is he clutching at his loincloth?

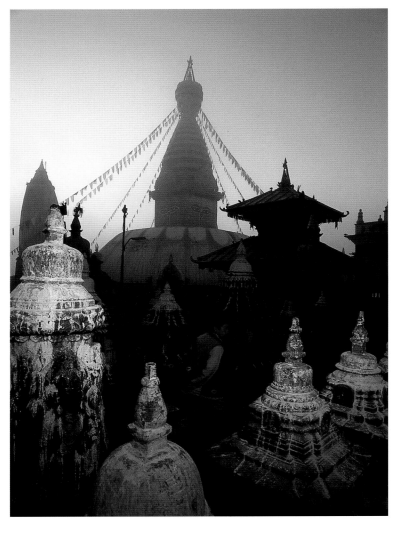

(Above)
A forest of small votive chaitya rises on the east side of
Swayambhunath. These elegantly carved stone monuments mimic the
shape of larger stupas: they may be constructed as a sign of devotion,
or as a memorial for a deceased family member. Some of the Valley's
chaitya date as far back as the fifth century.

(Right)
A Tibetan woman clad in chuba and blouse touches her forehead to
the base of Swayambhunath's great gilt vajra in reverence. The stone
base of the monument is ringed by carvings of the 12 animals that
make up the Tibetan cycle of years.

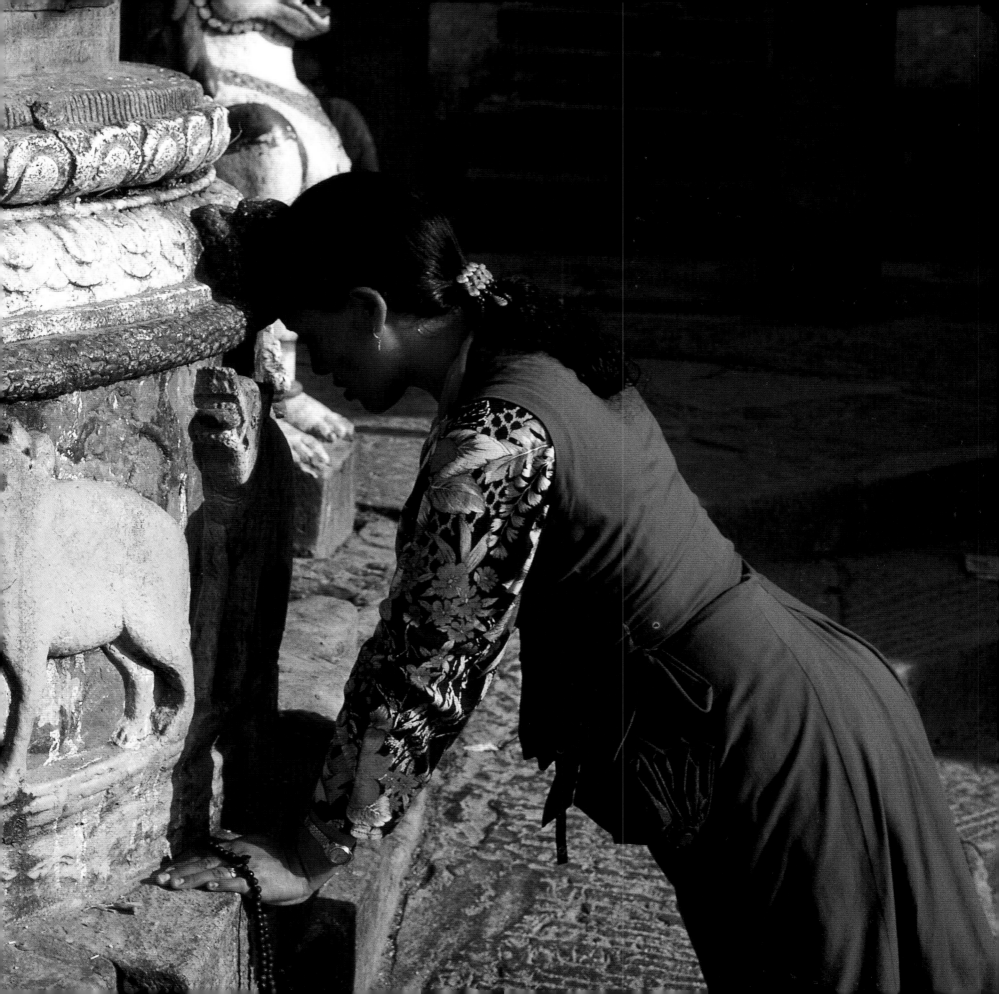

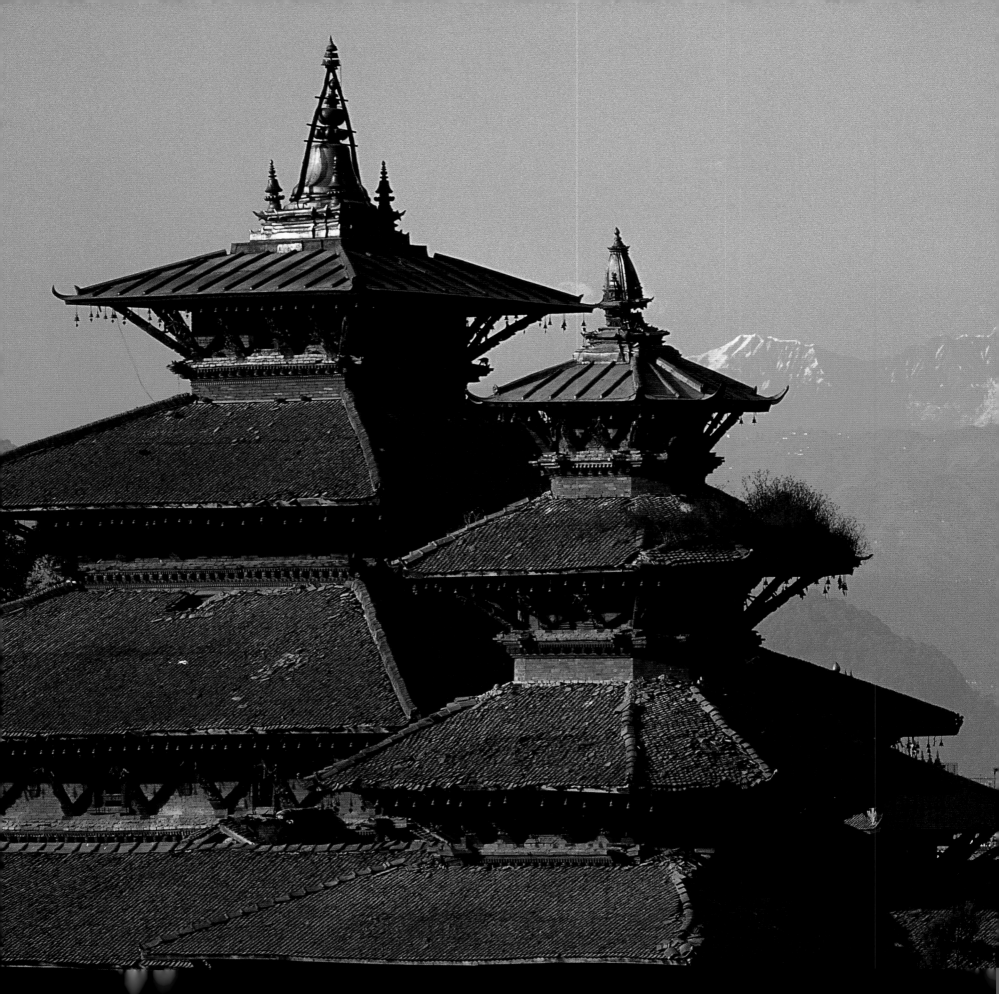

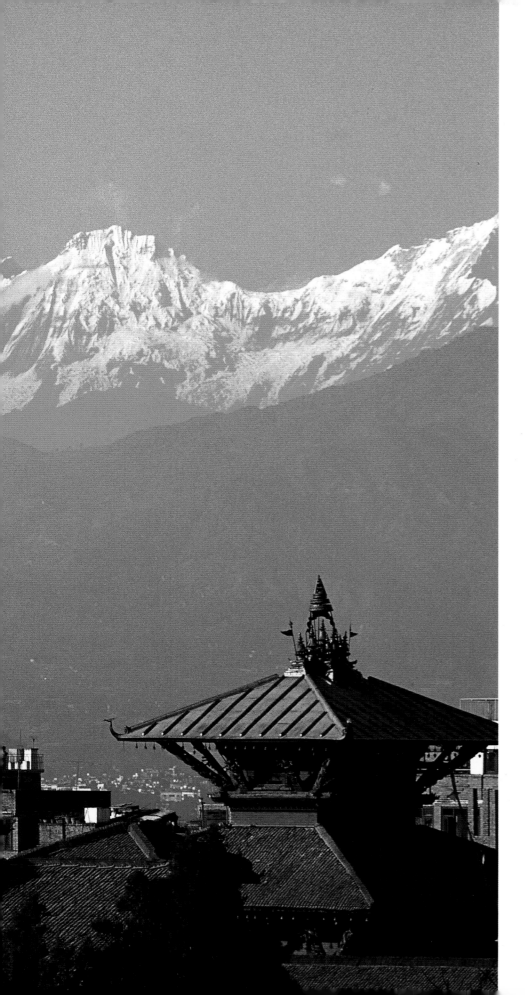

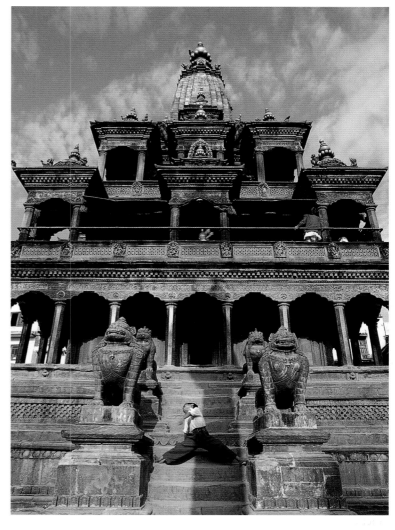

(Above)
The exquisitely carved temple of Krishna Mandir in Patan's Durbar Square is widely considered the finest example of stonework in all Nepal. The multifaceted shikara-style dome is blended with airy Moghul-influenced colonnades in an inspired combination of architectural styles. The carved friezes rimming the first storey depict scenes from the Hindu epic Ramayana.

(Left)
Some scholars maintain the stacked roofs characteristic of Newari temples were inspired by the great mountains to the north. The sheer snow-covered peak looming behind the tiled roofs of Patan's Durbar Square provides graphic support for this argument.

47

(Right)
An elderly Newari woman raises folded hands to forehead in prayer. Religion is not a Sunday affair in the Valley: it permeates daily life, from the pre-dawn clanging of temple bells to the late-night singing of devotional hymns or bhajan.

(Facing page)
An elderly man holds a puppy, an unusual sight as dogs in the Valley are generally considered more of a barking nuisance than fondly regarded pets. Once a year, during the festival of Tihar, dogs are worshipped with flower garlands and vermilion tika daubed between their eyes.

(Page 50)
Bundled up against the winter cold, a man puffs on a hookah, a water-based tobacco pipe often shared among old friends on quiet afternoons.

(Page 51)
A craftsman in a Patan atelier puts the final touches on a brass water jug. Patan is famed for the quality of its metal work, and the narrow streets of the quarter of Jom Bahal are lined with small shops producing and selling brass and bronze items, from embossed puja baskets to temple ornaments.

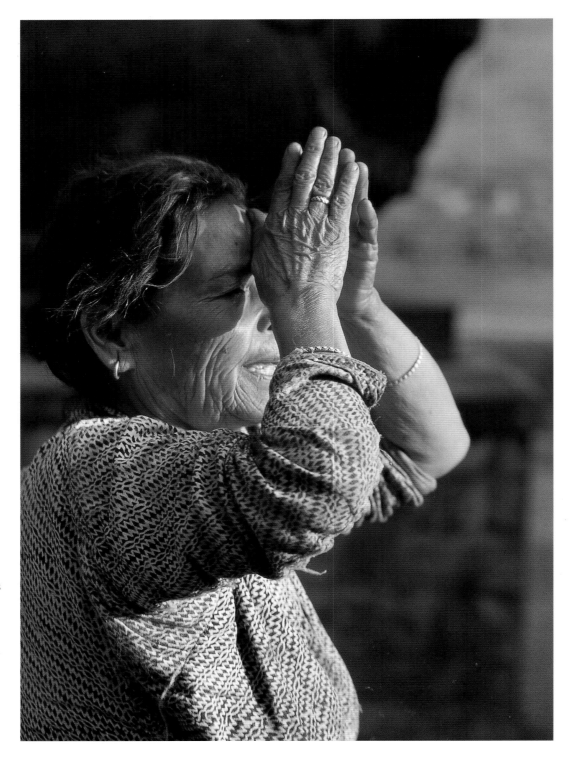

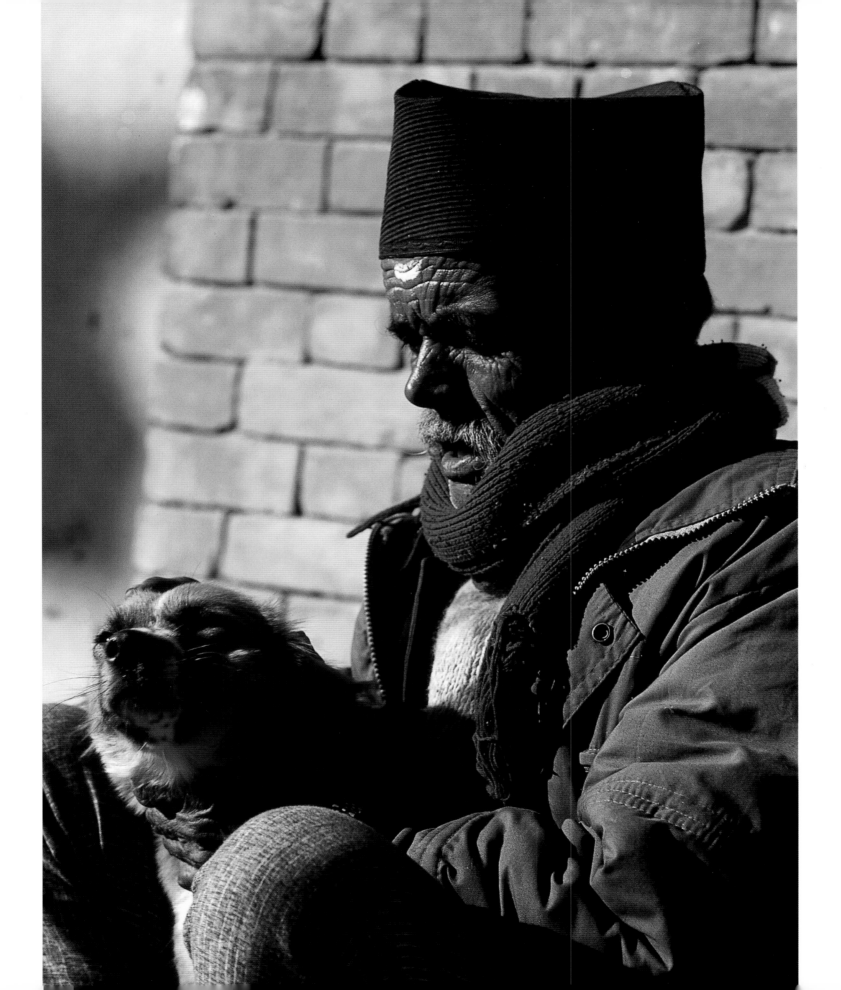

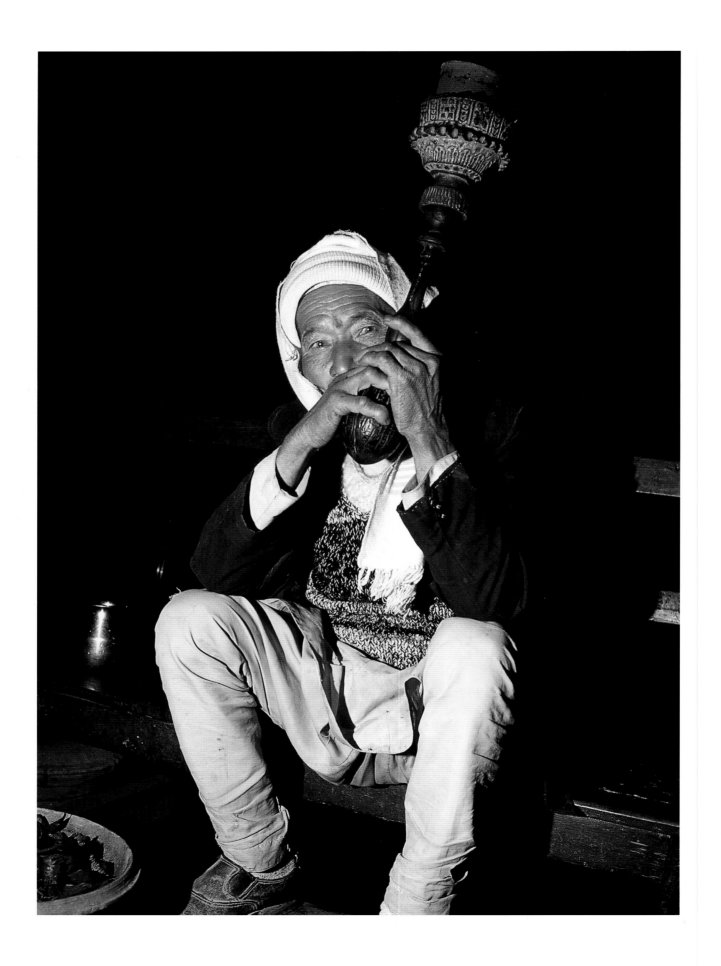

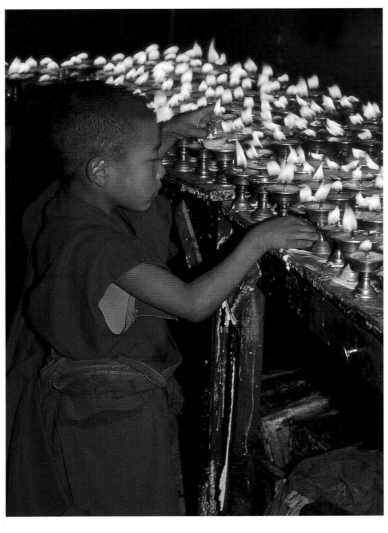

(Above)
A small Buddhist monk in training arranges oil lamps lit in offering. In Tibet such lamps are fuelled with yak butter, but Nepalis have adopted the simpler practice of filling them with refined cooking oil.

(Right)
Tibetan parents, as well as Tamangs, Sherpas, and other Nepali Buddhists, often send one of their sons to live in a monastery in order to study religious texts and learn rituals. When he comes of age he may decide to take on full vows as a monk, or he may return to worldly life, his reputation enhanced by the prestige of his childhood career.

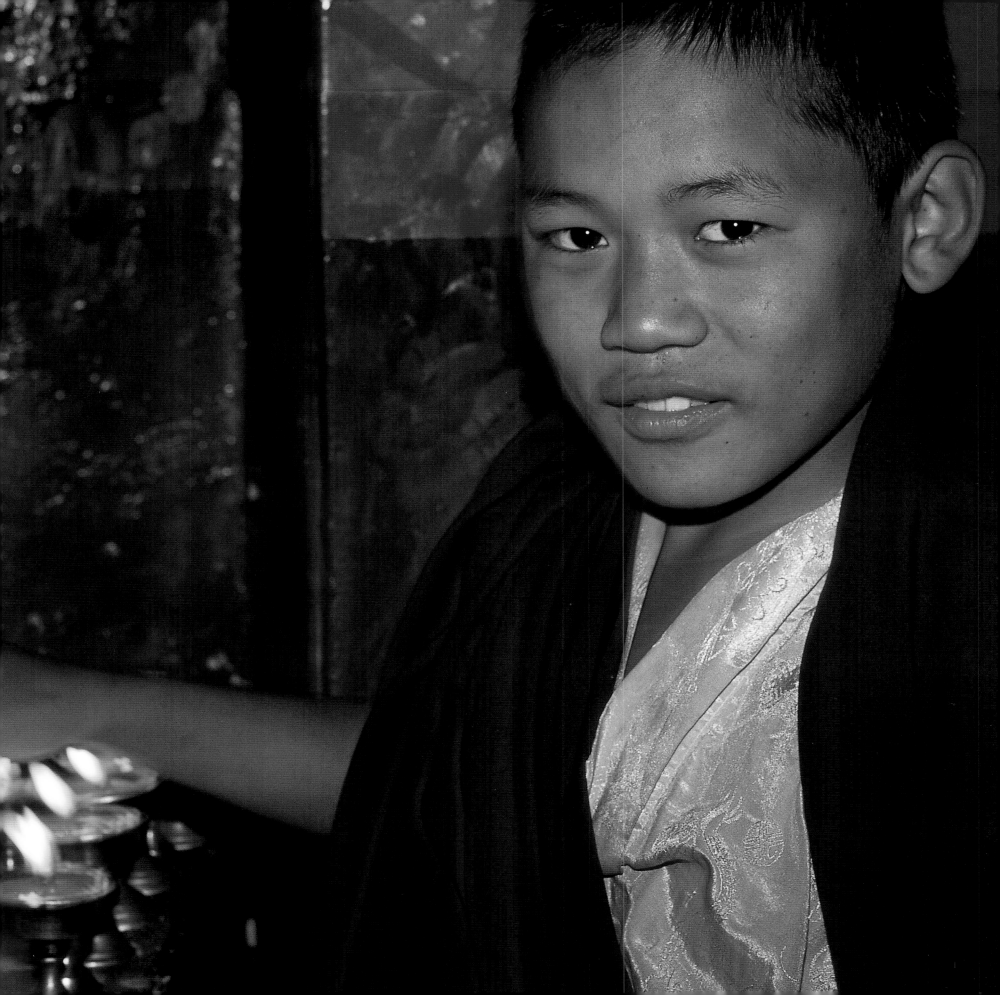

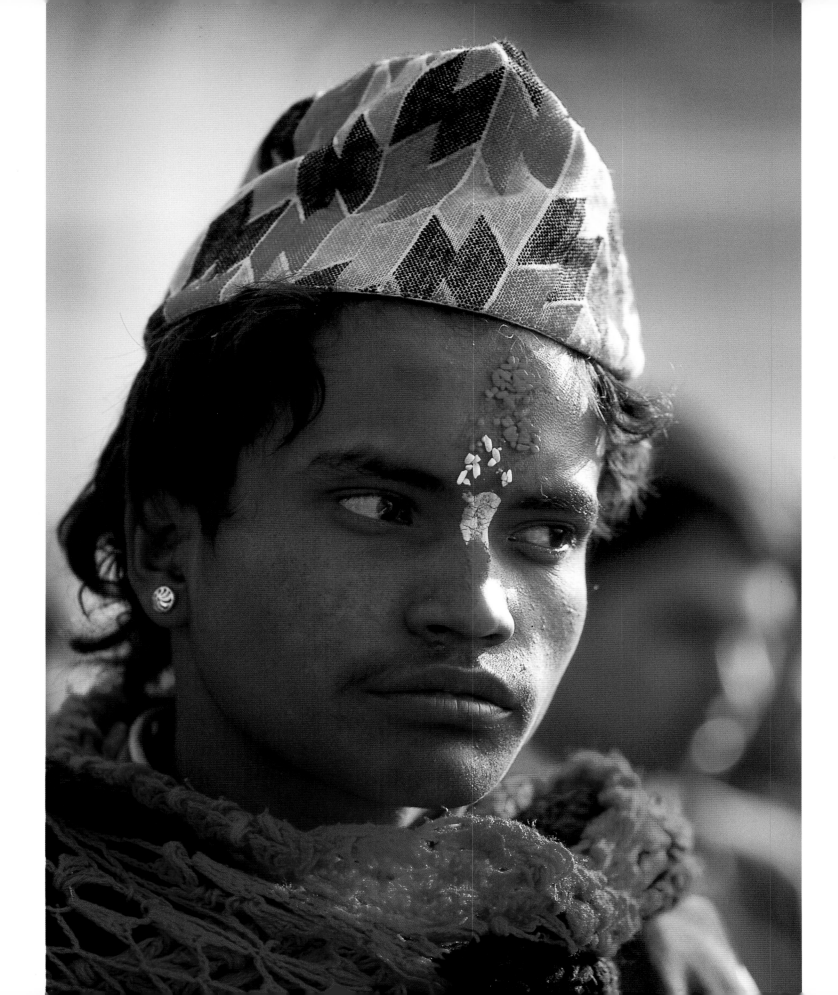

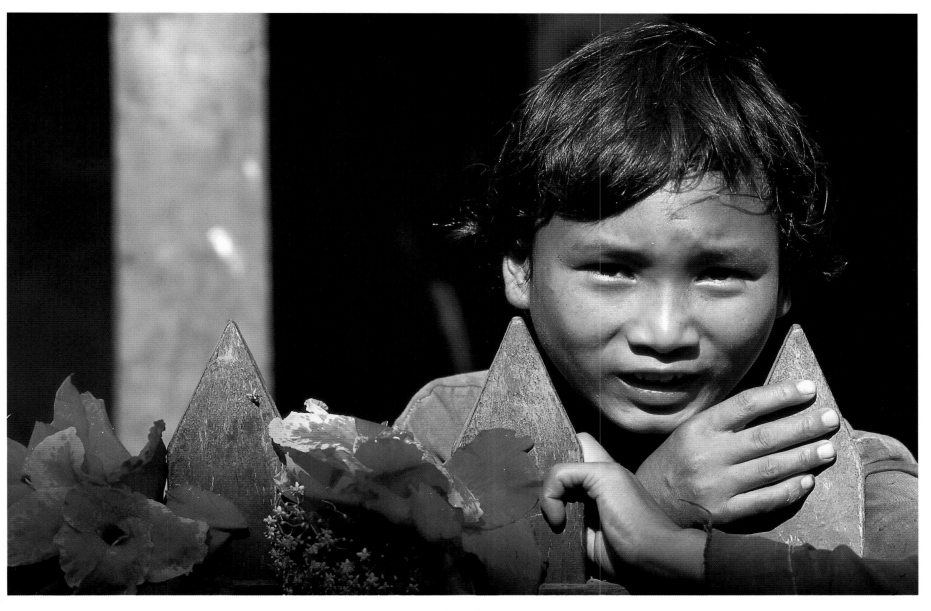

(Above)
A young boy peers inquisitively from behind the picket fence fronting Kathmandu's Kasthamandap Temple, flanked by
scarlet canna lilies typical of the Valley's extravagant flowers. The broad-roofed shrine located at the start of the old
Tibetan trade route off Durbar Square is said to have been magically fashioned from a single piece of wood.
One of the oldest buildings in the city, it is believed to be the source of Kathmandu's name.

(Facing page)
A Nepali Hindu youth wears a topi fashioned of brightly patterned hand-loomed dhaka cloth, and a magnificent tika,
a mark of blessing placed on the forehead in the location of the mystic third eye. Simpler tika are part of everyday
worship (women may use prefabricated stick-on bindi), but festivals and rituals are marked by elaborate varieties
such as this one, fashioned of rice grains, yoghurt and red sindhur powder.

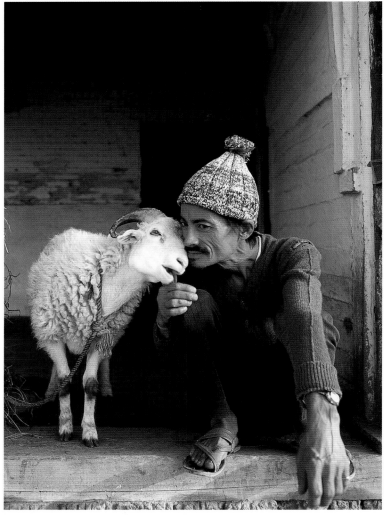

(Above)
A sheep enjoys a nuzzle with a friend. Goats and sheep manage to thrive on the scanty pasture of Nepal's hills. Each fall, enormous flocks are driven down into the Valley for sale during the Dasain festival, an occasion for animal sacrifices and meat feasting. "Mutton", the generic term for both sheep and goat meat, is a luxury in Nepal, where the staple diet is rice, lentils and vegetables, or for poorer families a mush of cooked meal.

(Right)
"I told him five rupees, no more…. "Two friends enjoy a lively conversation punctuated by animated hand gestures. The leisurely pace of Valley life allows plenty of time for conversation.

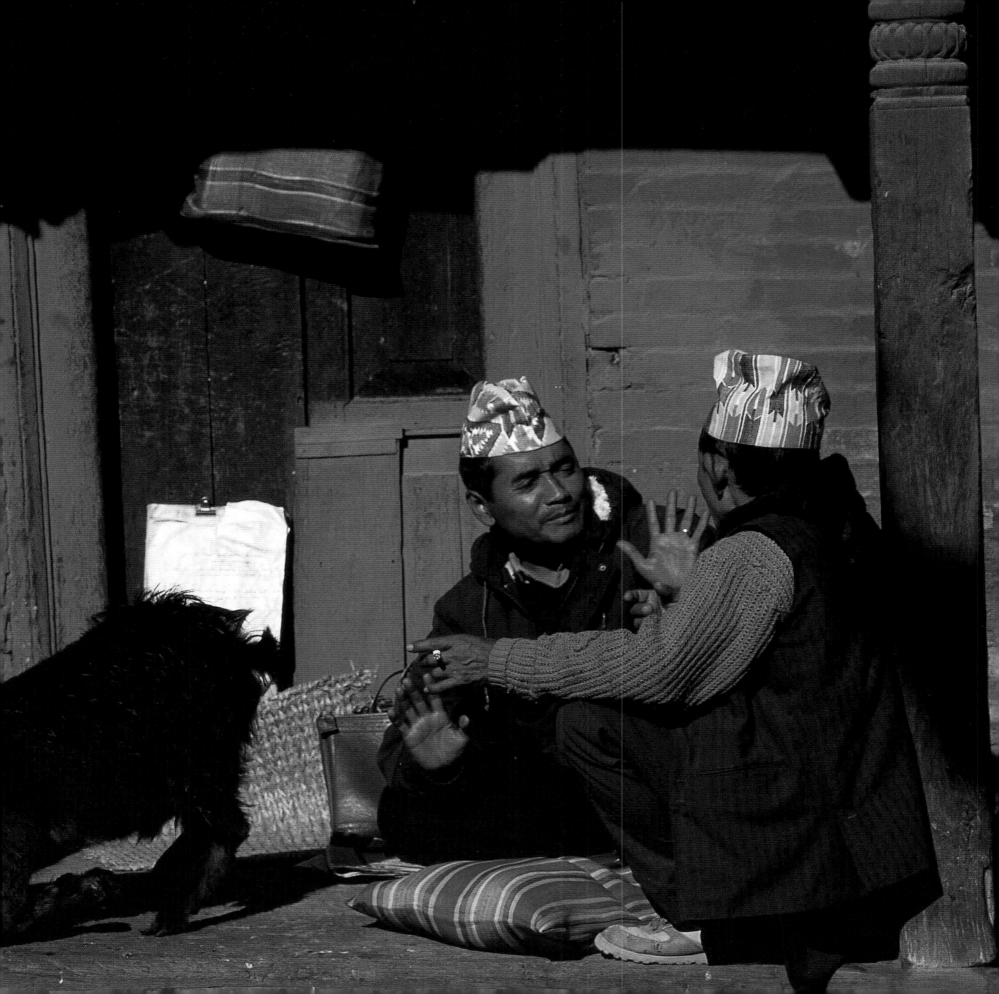

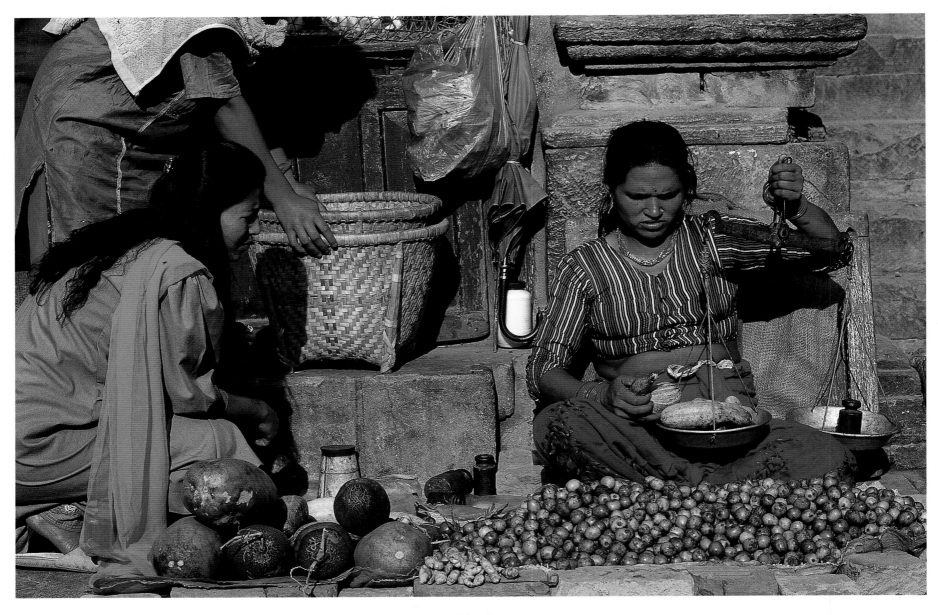

(Above)
A seller weighs out cooling cucumbers on a hand-held scale at the Patan vegetable market. The lack of refrigeration and an insistence on freshly cooked food sends women to the open-air bazaars for daily shopping. Early morning is the best time to pick through fresh produce.

(Facing page)
A boy fresh from a frolic in the sacred pond of Patan's Kumbeshwar Mahadev temple sits by a carved architectural embellishment representing a naga. These snake-like supernatural beings are said to rule over underground wealth and may cause disease if their subterranean homes are unwittingly disturbed. Nagas are only one of the invisible legions of supernatural beings who inhabit the Valley.

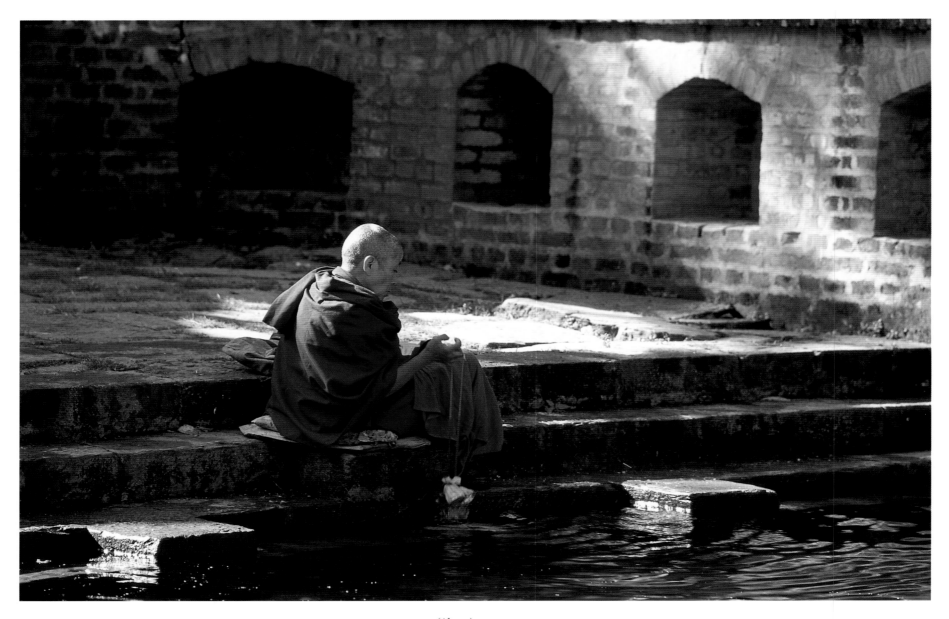

(Above)
A shaven-headed Tibetan Buddhist nun performs a ritual on the steps of a pond filled by Pharping's
sacred spring. A doubly holy site, Pharping draws both Hindu and Buddhist pilgrims; the former
to worship at the Vishnu temple of Shikhar Narayan, the latter to revere the meditation cave
of Guru Rinpoche and visit the Buddhist monasteries scattered around the hill.

(Facing page)
Staring plaster eyes, a protective device to avert evil spirits, guard the entrance to Patan's Raato
Machhendranath temple. This "Red" Machhendra, close kin to Kathmandu's "White" Machhendra,
is Patan's most beloved deity, an ancient godling with a reputation as a rainmaker. He is paraded around
town in a riotous chariot procession in the dry, dusty months preceding the yearly monsoon.

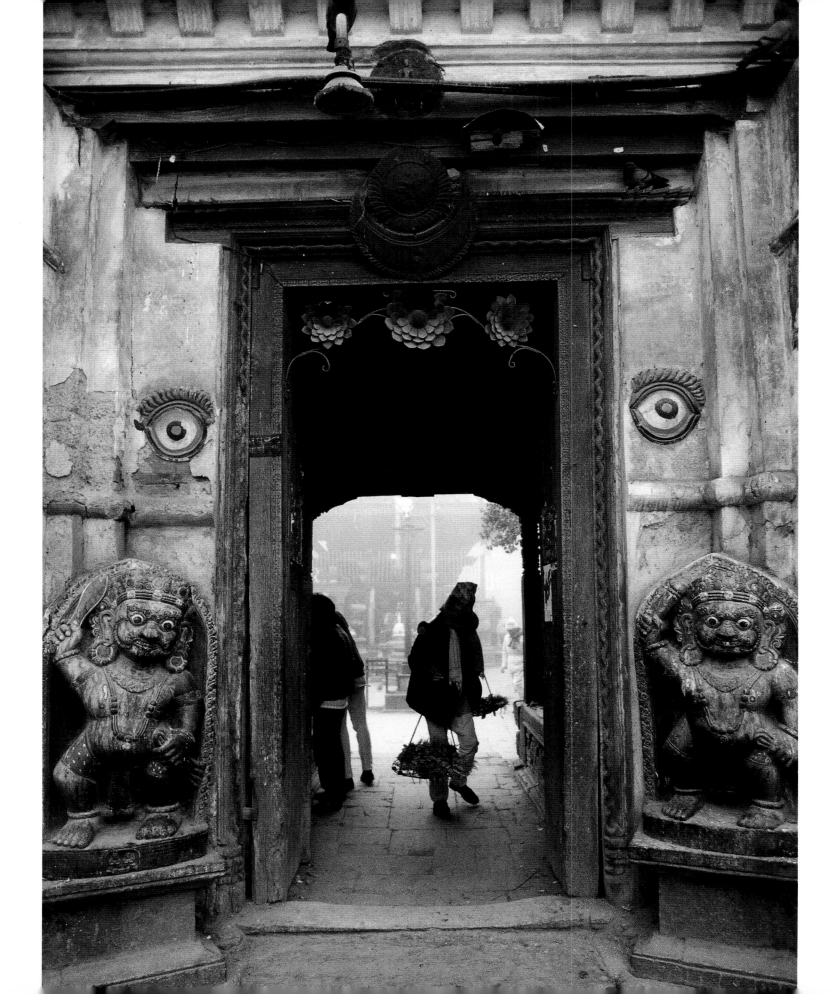

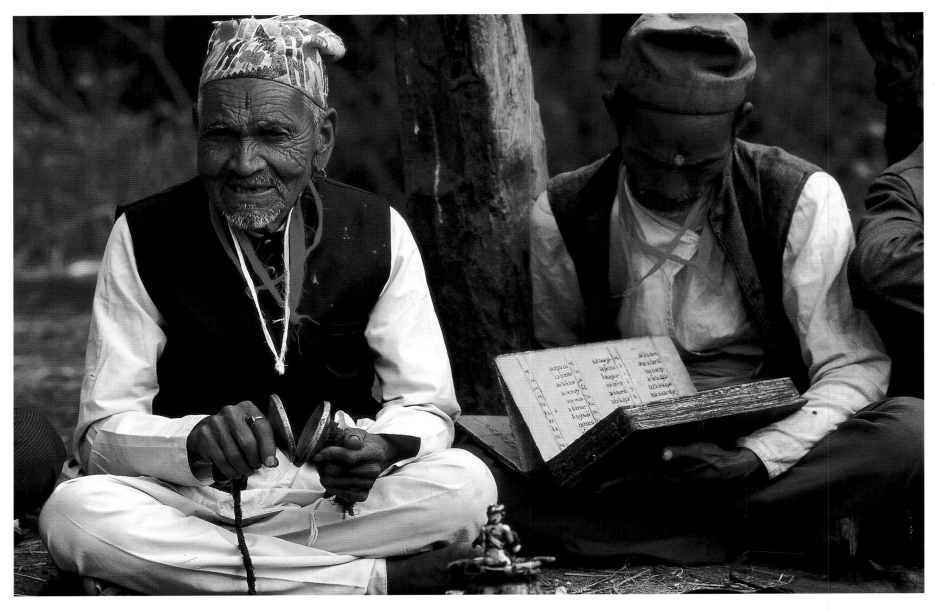

(Above)
Every brother in Nepal, from babies on their mother's backs to elderly grandfathers, is worshipped by his sisters on the festival day of Bhai Tika. These Newari men from Bhaktapur wear red tika imprinted by their sisters, as well as red blessing cords around their necks. They are singing old religious songs or bhajan.

(Facing page)
A gilded figure of the Nepali queen who constructed it kneels atop a stone pillar facing the temple of Tripureshwar Mahadev in Kathmandu. Built in 1818, the shrine is dedicated to the memory of the queen's ill-fated husband, King Rana Bahadur Shah, assassinated in 1806. Nineteenth-century Nepali politics was characterised by brutal plotting and intrigue: for 75 years, not a single prime minister met a natural death.

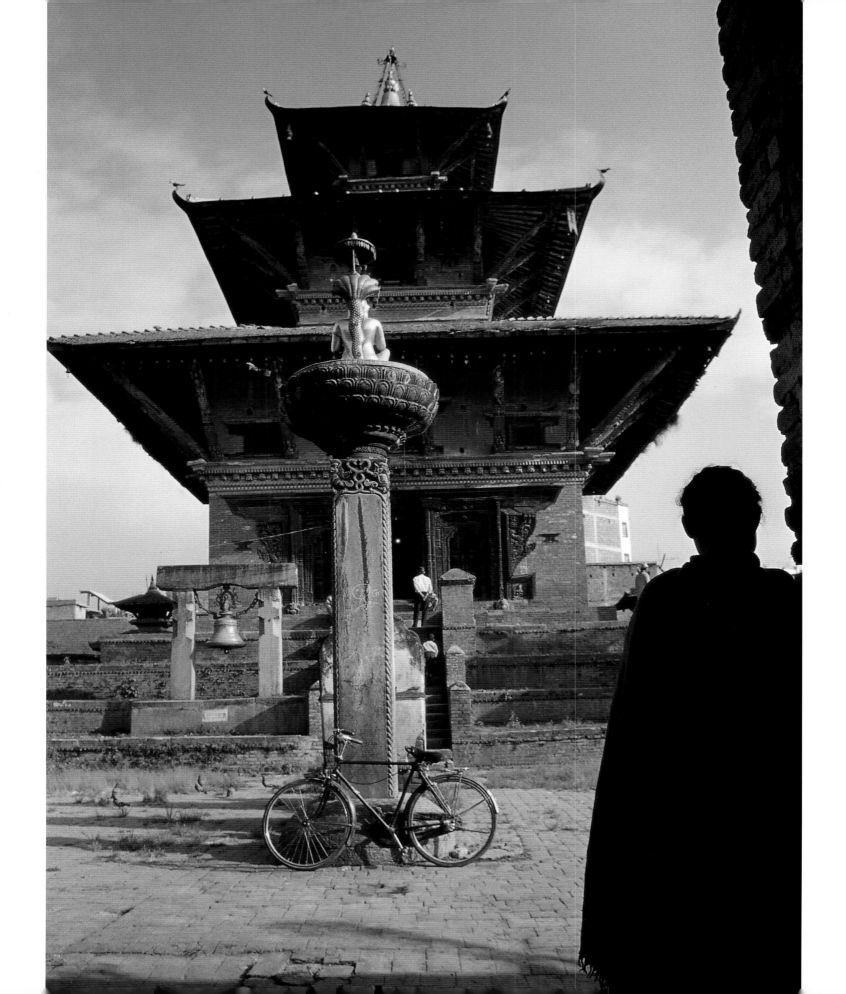

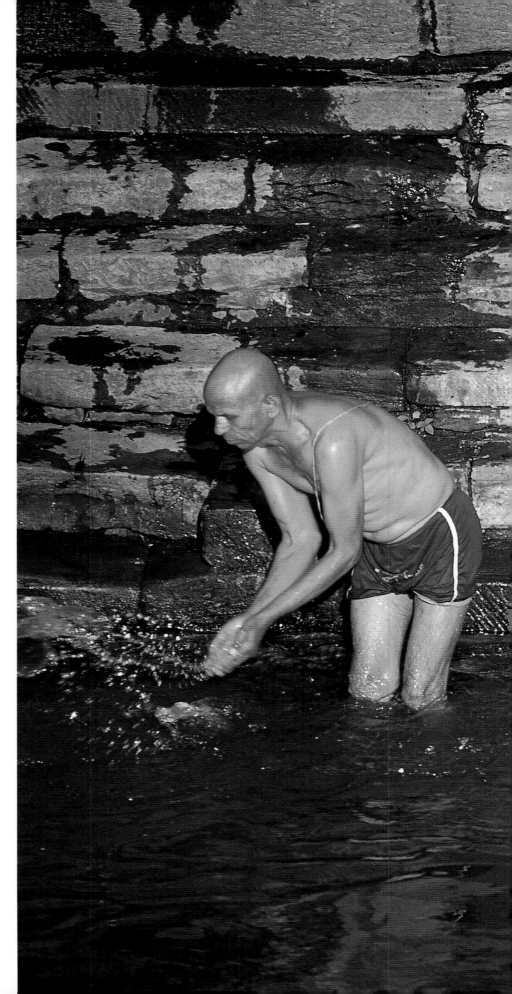

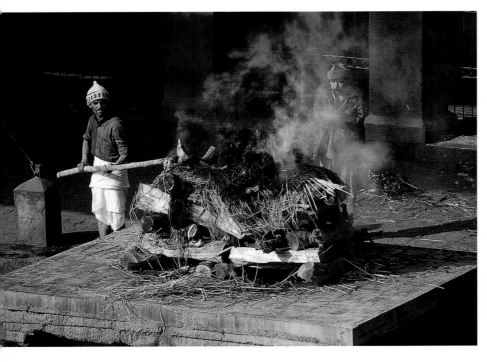

(Above)
A corpse is burned on a funeral pyre at the cremation ghats of Pashupatinath on the banks of the Bagmati River. The holiest of all Hindu temples in Nepal, Pashupatinath is considered one of the subcontinent's four great Shiva shrines. To die or be cremated here is said to bring the highest good fortune.

(Right)
Three sons, heads freshly shaven, bathe in the sacred Bagmati River during funeral rites for a parent held at Pashupatinath. Sons are dearly desired by every Nepali family, for only a son can perform the all-important funeral rites that lead the soul to the ancestral heavens. Following the funeral, the eldest son will wear white for a year as a symbol of mourning.

(Following pages)
Sadhus or Hindu holy men wander the Indian subcontinent on a perpetual barefoot pilgrimage to holy places. Though they deliberately reject the conventions of the Hindu caste system, their own subculture involves an intricate network of sects and traditions. A sadhu's affiliation can be interpreted by his garments, by the implements he carries, and by the coloured designs painted on his forehead. The yellow-clad man on the left worships Vishnu, as indicated by the horizontal lines; the trident symbol on the forehead of the man on the right shows he is a Shivaite.

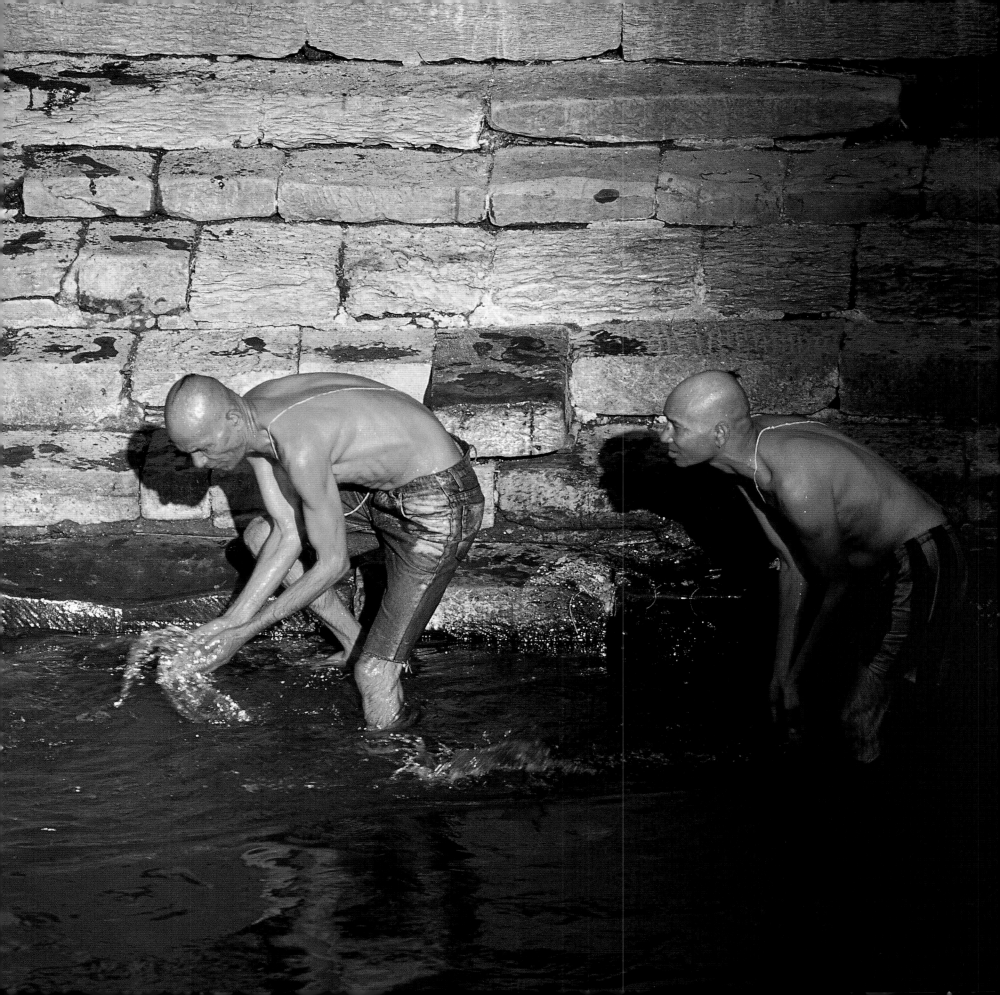

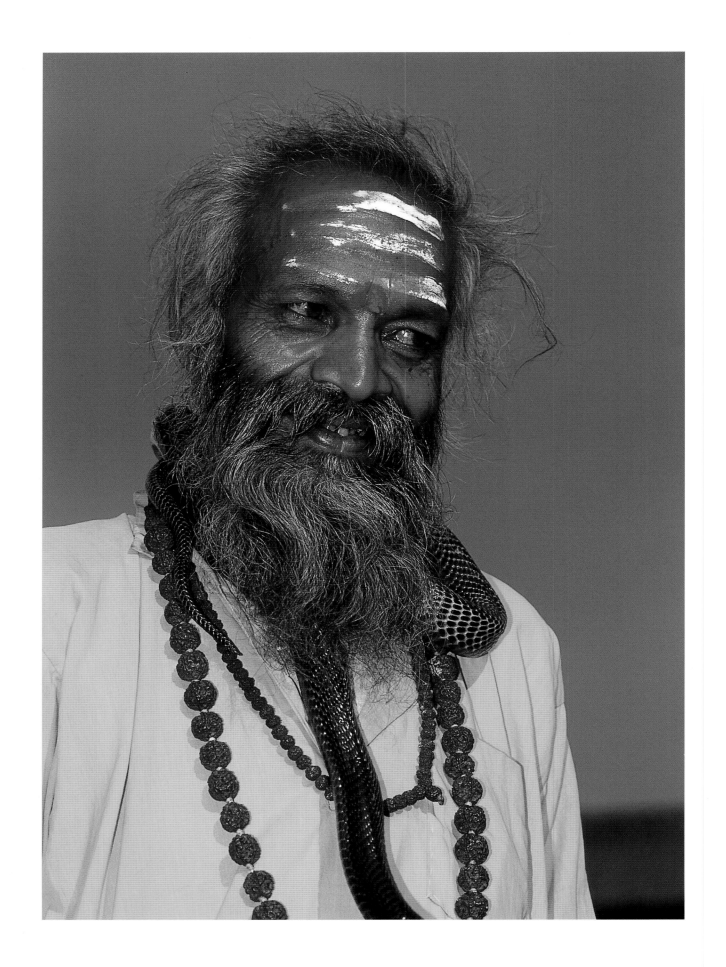

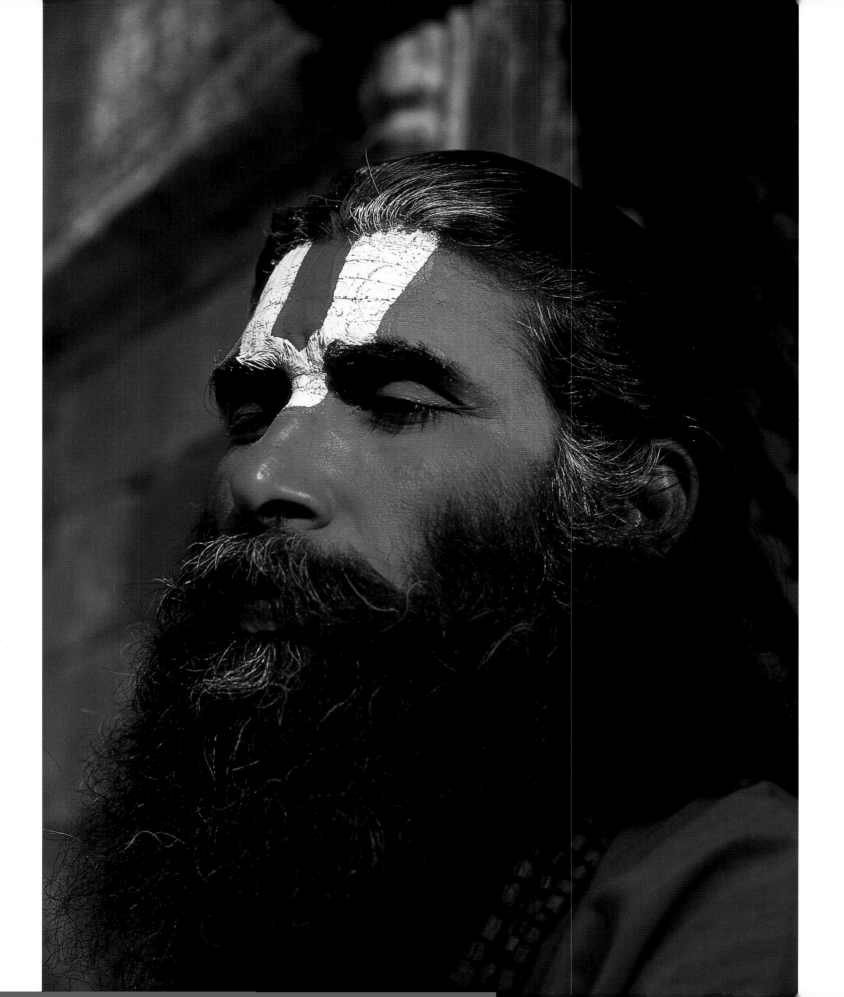

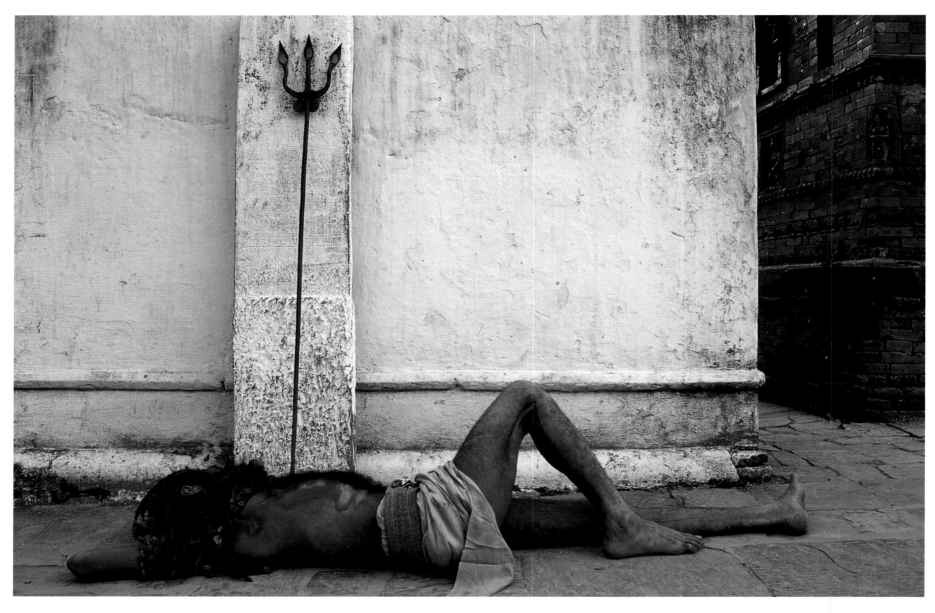

Sadhus can be saints, sinners, or rogues, or sometimes all three in the same body. Having vowed to neither trade nor work, they beg for a living, sometimes casting spells, making charms, or telling fortunes as a sideline. This one sleeps beneath his trident, an ancient symbol of Shiva. Other essential possessions of a sadhu include a begging bowl, a bag of red cloth, and fire tongs.

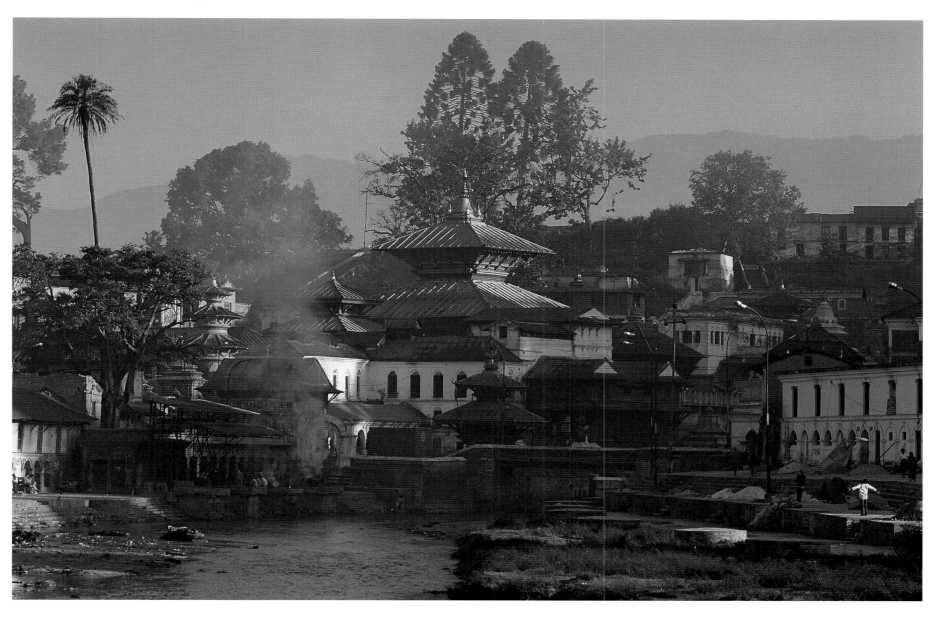

Smoke from a cremation pyre rises in front of the gilt-roofed temple of Pashupatinath. Non-Hindus are not allowed inside the main building, which enshrines a black stone linga, a cylindrical form carved with four faces of Shiva. The holiest of holies for Nepali Hindus, it is tended by a retinue of Brahman priests with elaborate daily rituals of bathing, adorning, and offerings.

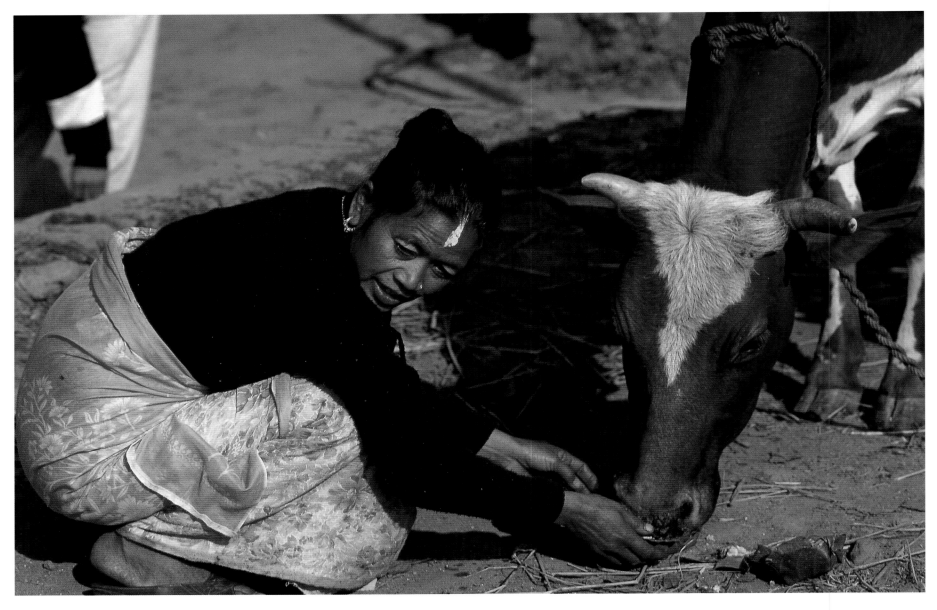

(Above)
A sacred cow munches from a leaf plate proffered by a woman at Pashupatinath. The cow embodies fertility and
prosperity, and is revered for its five gifts of milk, yoghurt, ghee, dung and urine – the latter used as
a medicinal remedy. A century ago, cow slaughter was a crime punishable by death in Nepal;
today the penalty is a jail term and a stiff fine.

(Facing page)
"Bom Shiva Shankar"... a red-eyed sadhu takes a hit of charas or hashish from a clay chillum in front of
Gorakhnath Mandir, part of the Pashupatinath temple complex. Although sadhus have renounced sensual
pleasures and intoxicants, hashish is considered one of the 16 substances sacred to Shiva,
said to increase spiritual insight and transform consciousness.

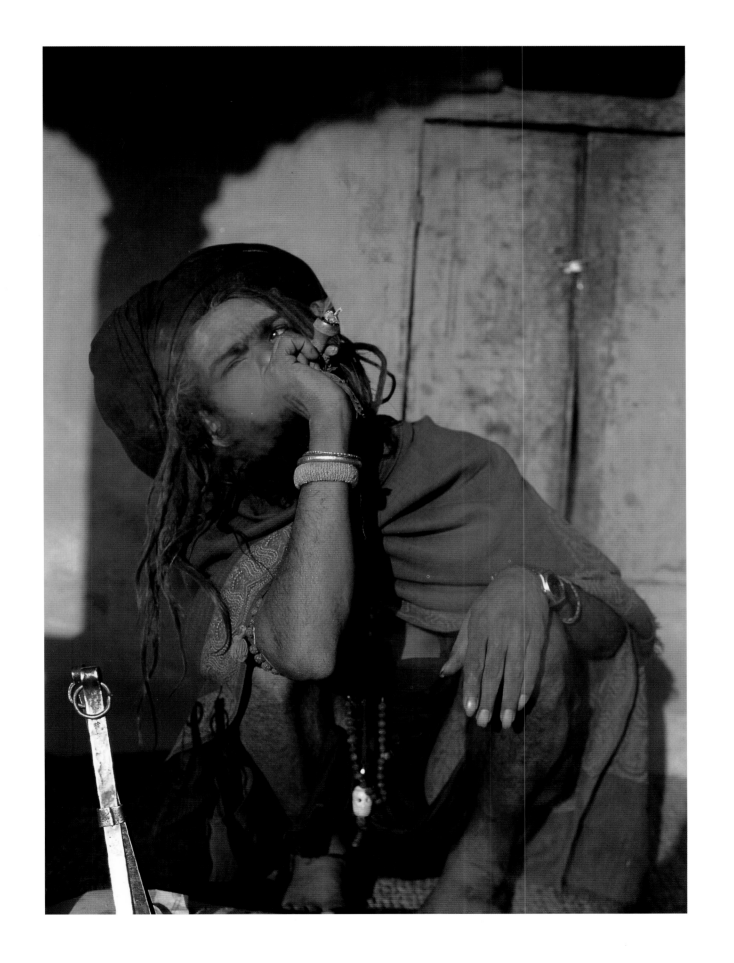

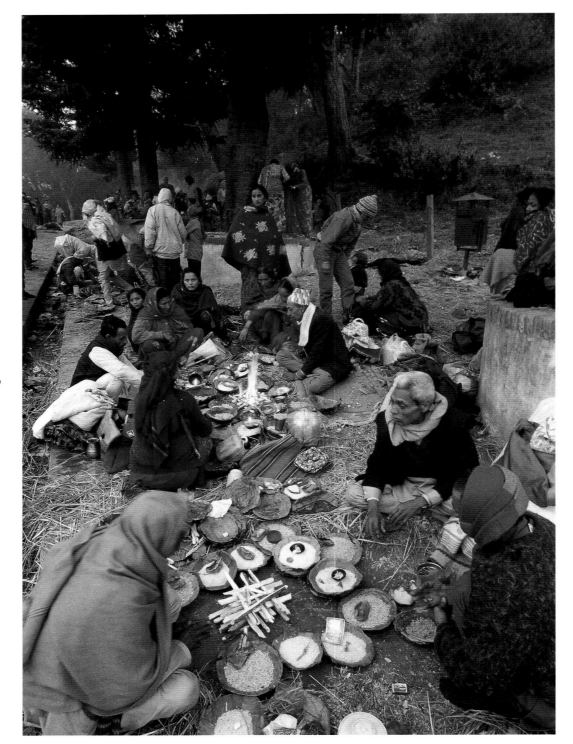

(Right)
Tamang families from the Valley
and its surrounding hills gather to
pray for deceased relatives during
the winter festival of Bala
Chautardasi at Pashupatinath.
Following an all-night vigil
warmed by bonfires and songs,
they make offerings of seven
kinds of grain to earn merit for
departed kin.

(Facing page)
A shy bride touches her new hus-
band's feet in a gesture of respect
at a marriage ceremony held at
Budhanilkantha. Hindu wed-
dings, involving several days of
feasting and rituals, are held on
astrologically auspicious dates in
the winter months. Brides wear
red, a colour reserved for married
women, as a symbol of conjugal
happiness.

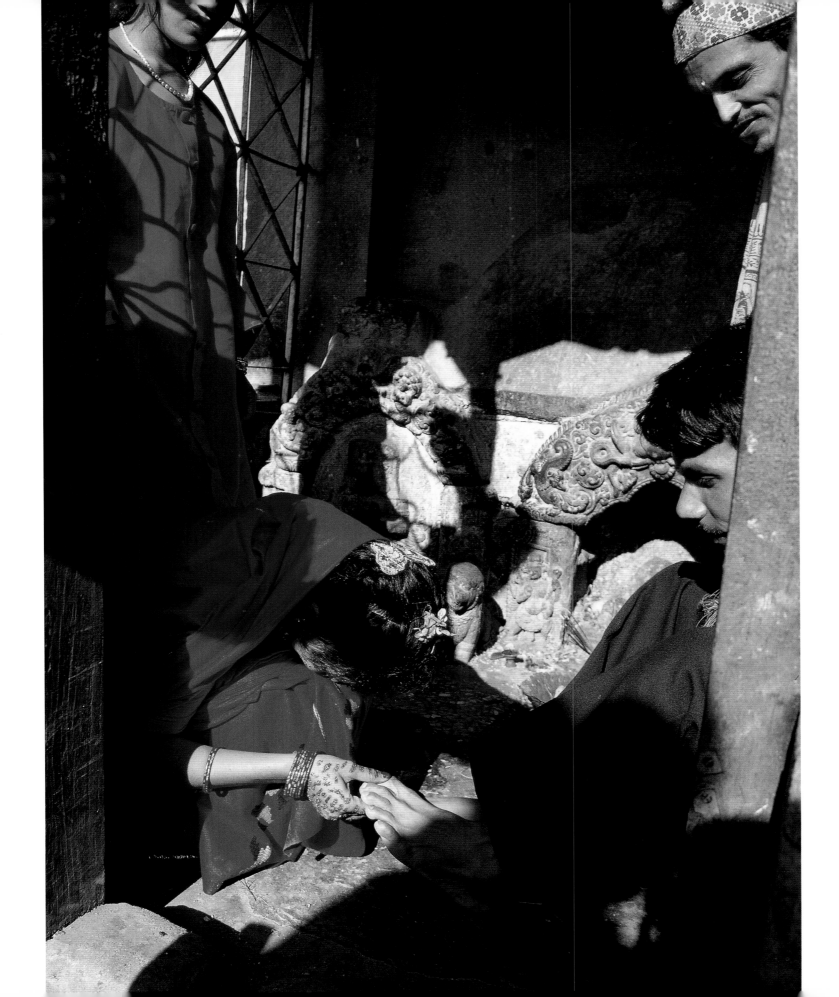

(Right)
Brahmans perform puja by the river at Pashupatinath. For Nepalis, the Bagmati assumes the spiritually redemptive role of India's sacred Ganges.

(Facing page)
Two friends balancing on a narrow railing in Patan watch the leisurely flow of life. The modern development focused on Kathmandu has largely bypassed neighbouring Patan, which retains a peaceful air remarkably in touch with its historic past.

(Following spread)
Boudhanath Stupa backed by afternoon thunderclouds: the eastern Valley is regularly swept by dramatic rainstorms. The form of the stupa is based on ancient Indian burial tumuli and embodies hidden symbolism. The different parts represent the various elements: the base earth, the dome water, the spire fire, and the tip air.

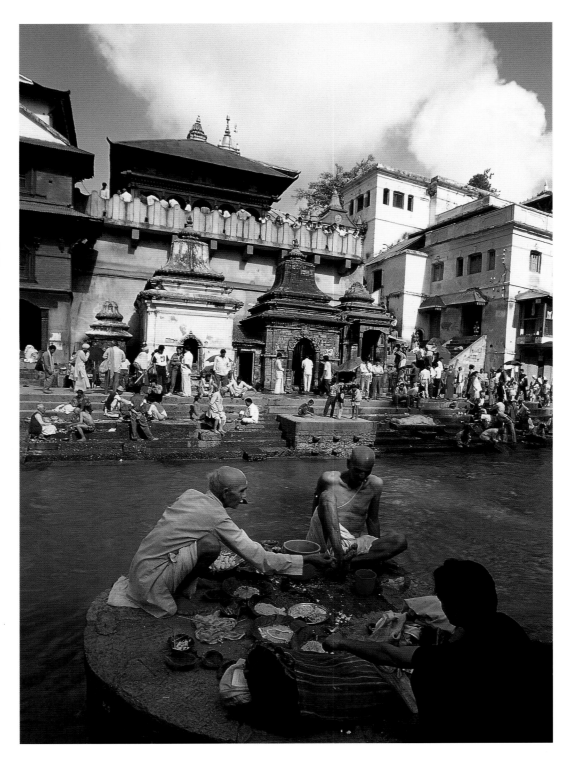

74

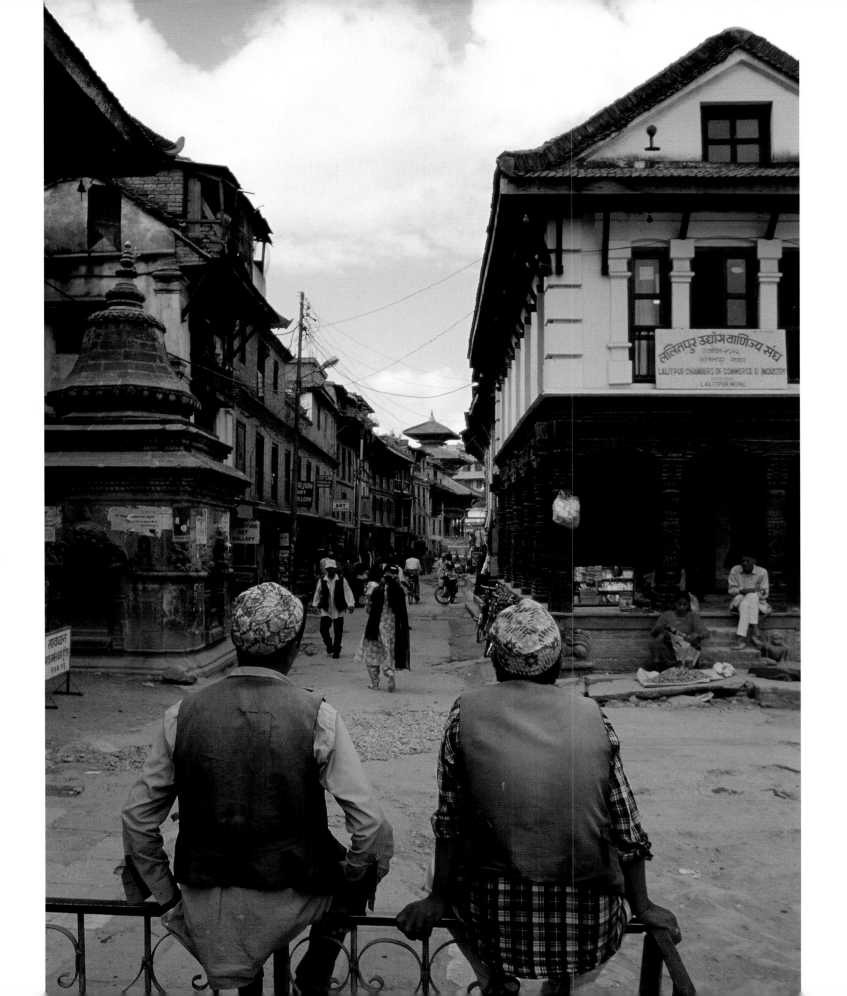

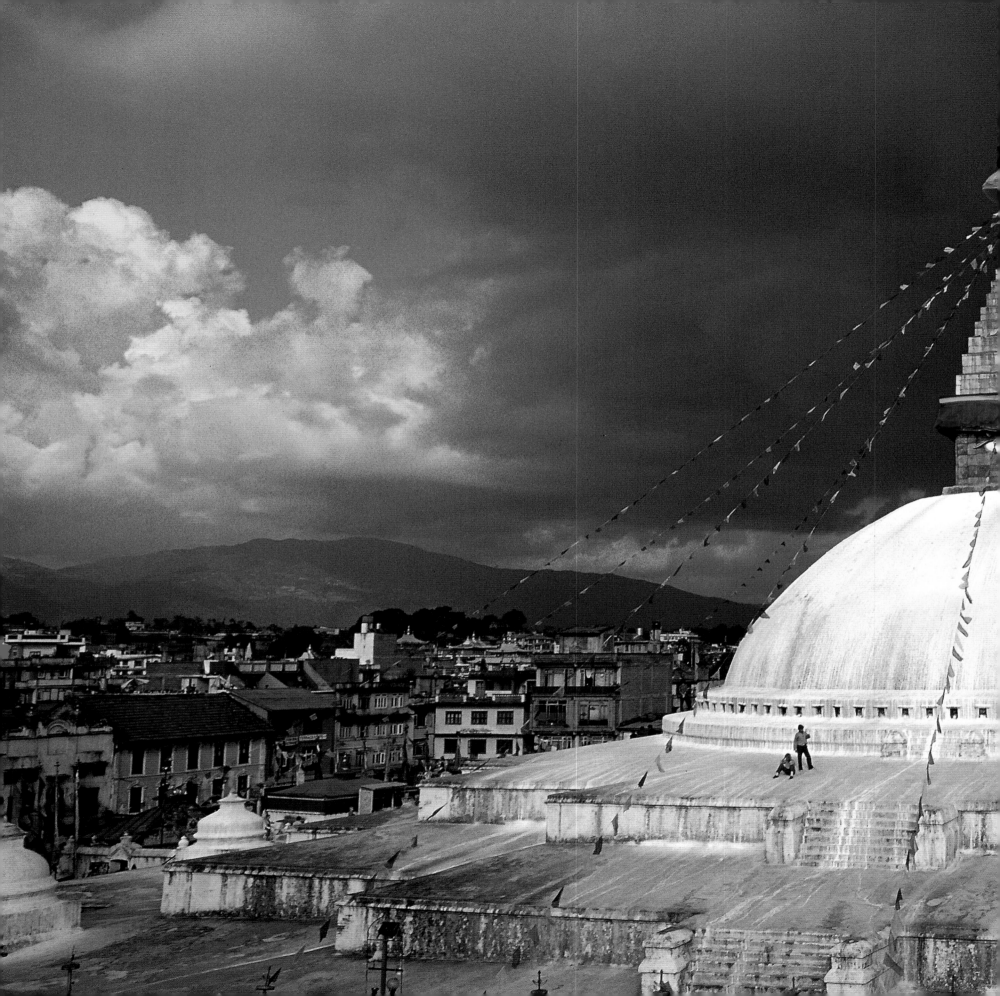

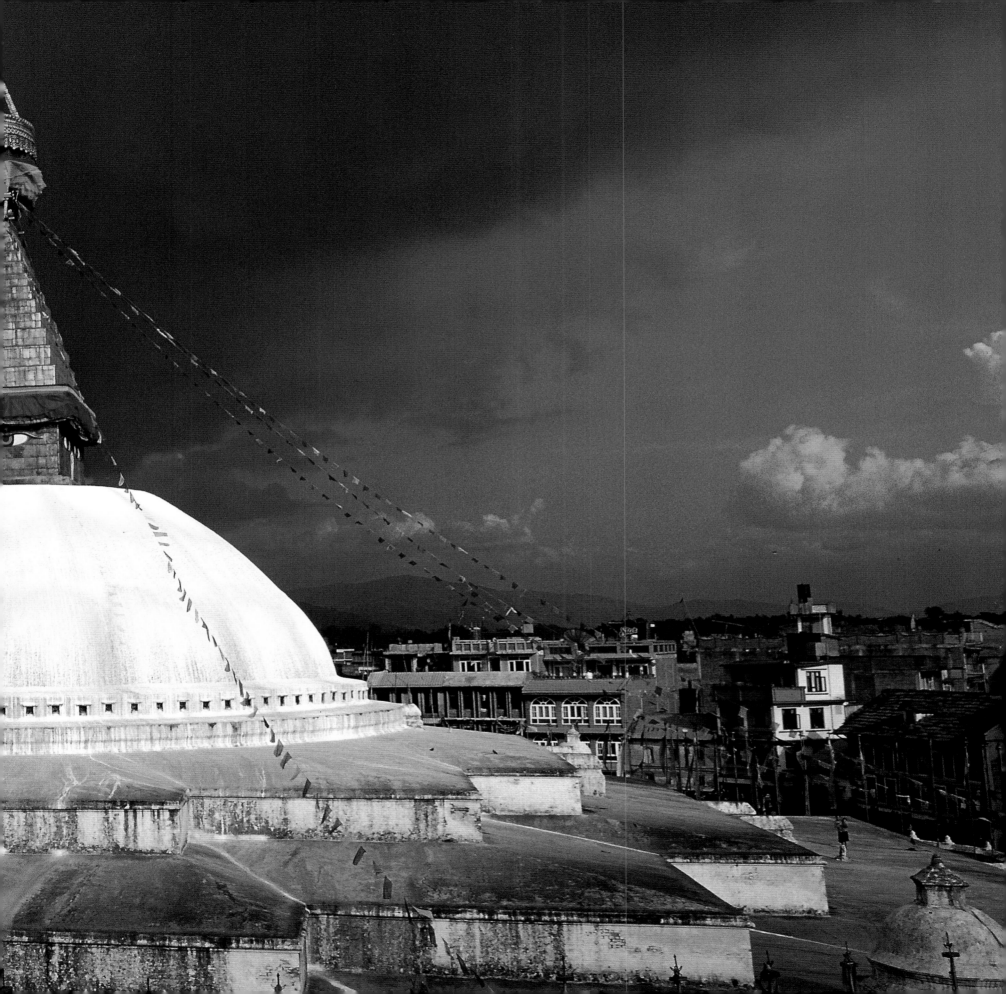

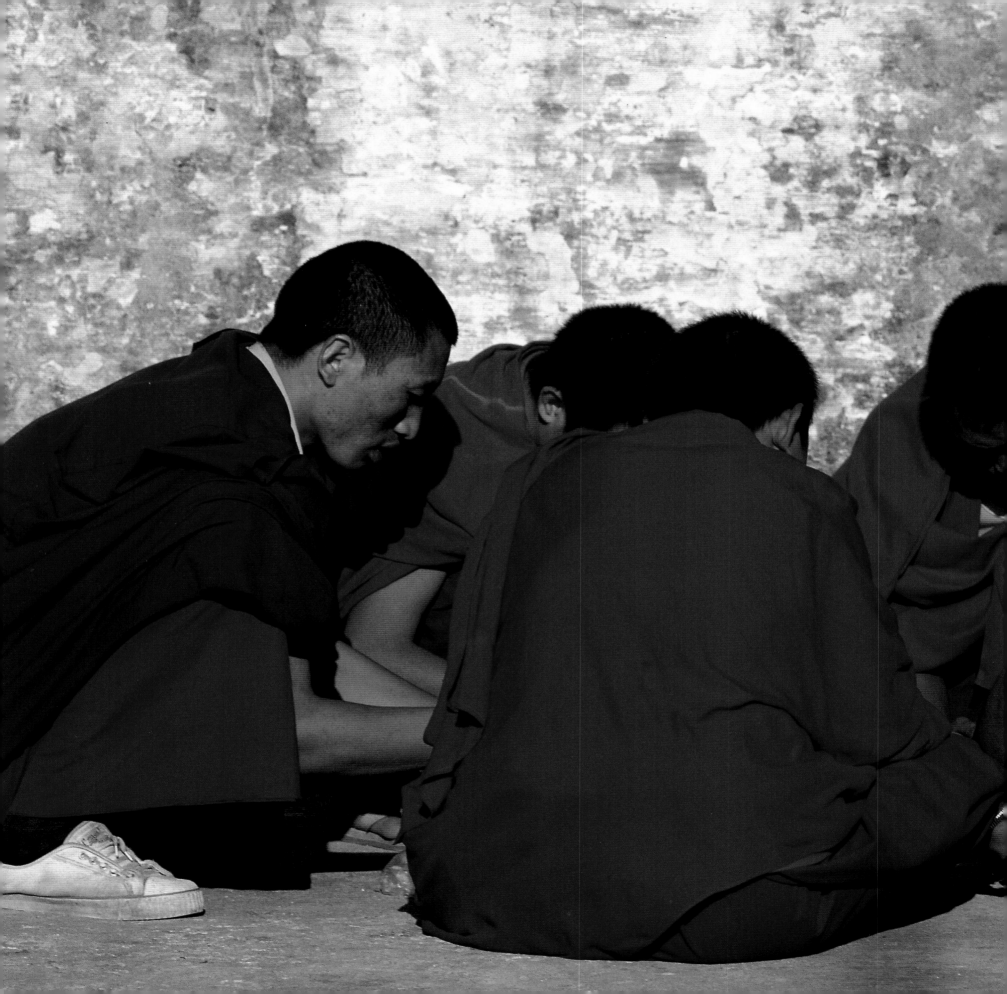

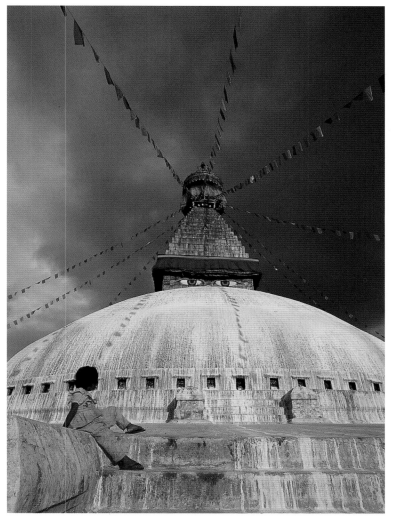

(Above)
A girl loiters beneath the whitewashed stupa dome, which after painting is splashed with saffron-infused water to create a pattern of golden rings. Buddhist families earn religious merit by sponsoring frequent maintenance of the stupa.

(Left)
Monks gather around a worldly pursuit – perhaps an illicit game of cards – atop the stupa's platform. Their maroon robes are typically Tibetan, but some two-thirds of Boudha's monks are actually Nepali – Tamang, Sherpa, or members of Nepal's many northern ethnic groups. China's invasion of Tibet in the 1950s and the resulting diaspora has spawned a cultural renaissance of Tibetan Buddhism in Nepal.

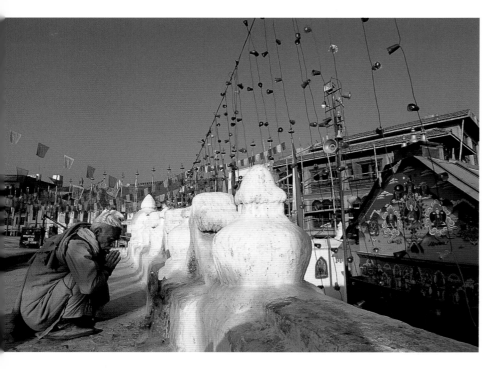

(Above)
A Nepali man crouches in prayer before a painted mural of Guru Rinpoche at Boudhanath. Also known as Padmasambhava, the "Lotus-Born", he is a major figure for followers of the Nyingma or Old School of Tibetan Buddhism.

(Right)
A young Tamang man sits near a large copper prayer wheel embossed with sacred mantra. The insides of these devices are filled with rolls of paper written with prayers which are believed to be released by each clockwise spin. Boudhanath is an excellent place to view the many ingenious prayer technologies developed by Tibetans.

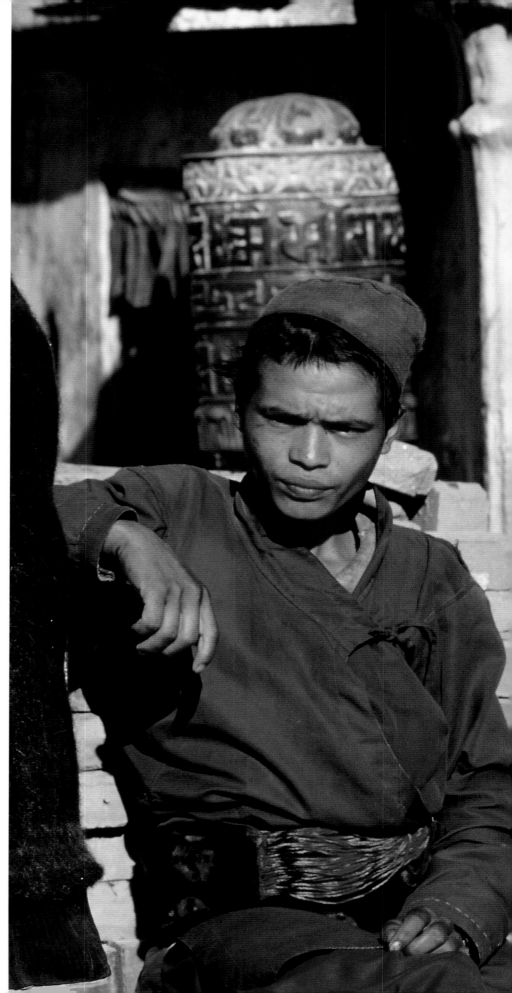

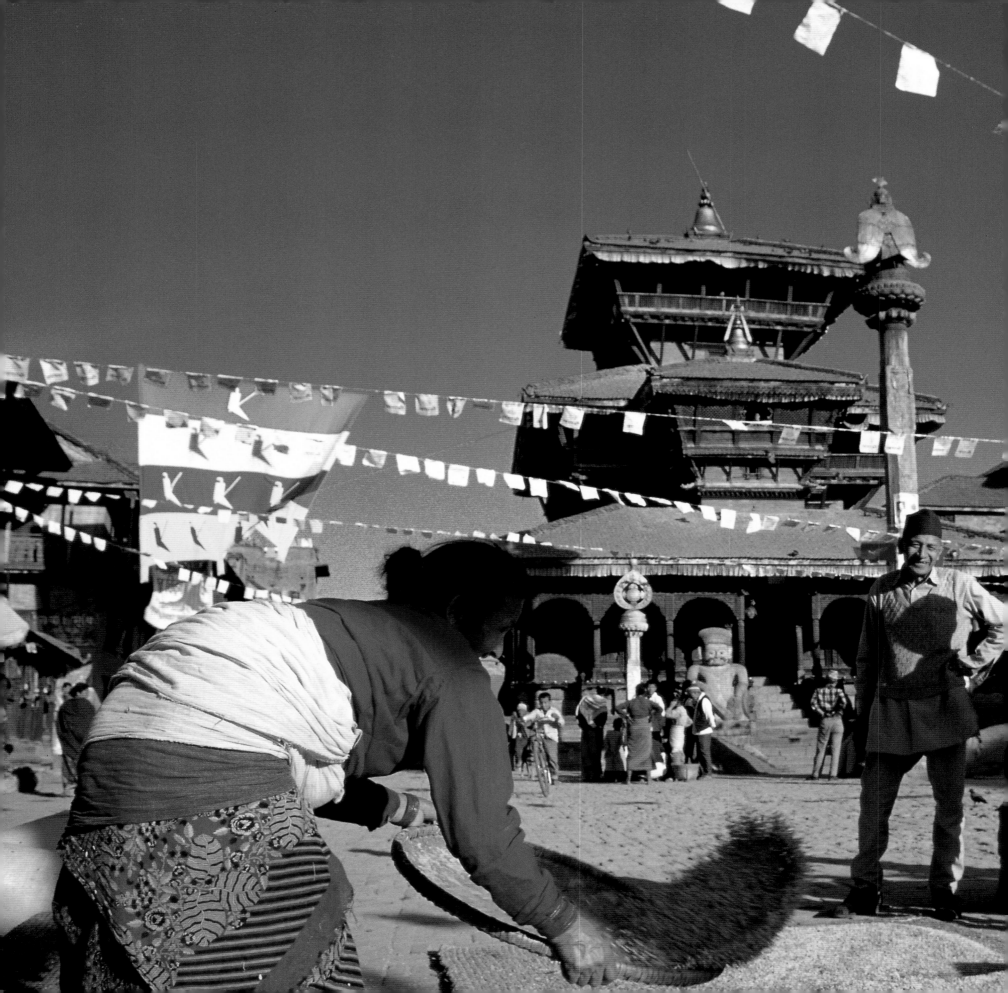

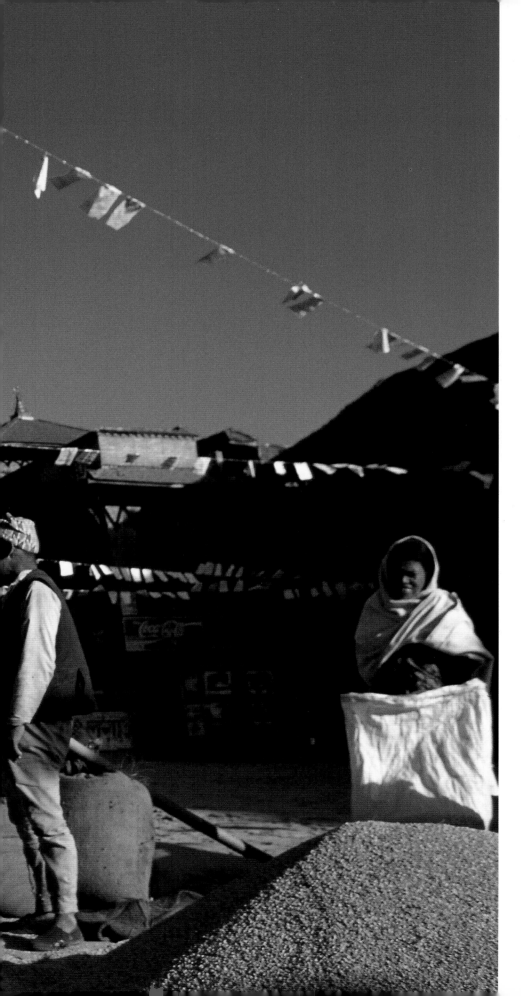

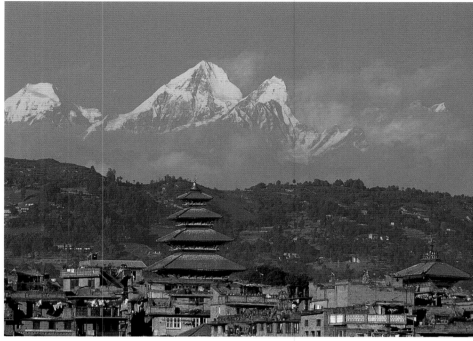

(Above)
Roadside stops on the Arniko Rajmarg leading to Tibet provide an unrivalled view of Bhaktapur's tiled roofs backed by soaring snow mountains. The unforgettable Himalayan vistas appear most frequently in the clear autumn months which constitute Nepal's major tourist season.

(Left)
Harvest bounty invades Bhaktapur's streets at Tachapal Tol, as Jyapu woman winnow grain in the main square. The stately Dattatreya temple in the background is dedicated to a unique three-headed combination of the Hindu trinity of Brahma, Vishnu and Shiva.

(Page 84 top)
Men of the Prajapati caste work their massive wooden wheels at Bolachha Tol or "Potters' Square" in central Bhaktapur.

(Page 84 bottom)
Another man shovels smoking straw from the remains of the temporary kilns used to fire pots.

(Page 85)
A woman lays pots out to dry in the sun, arranging them in neatly symmetrical patterns. Dipped in slip, the black clay turns a terracotta hue after firing. The woman's red-banded skirt and blue-tattooed calves reveal her membership in the Jyapu or farmer subcaste which forms the backbone of Bhaktapur's population.

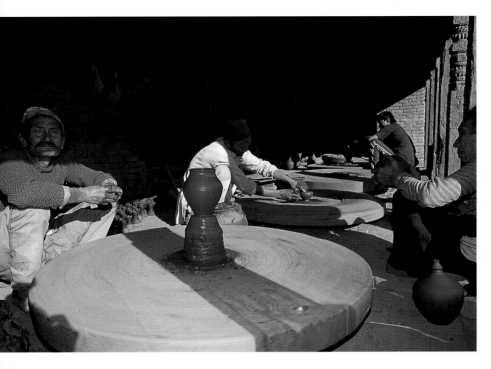

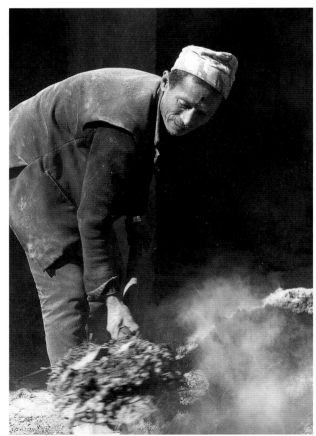

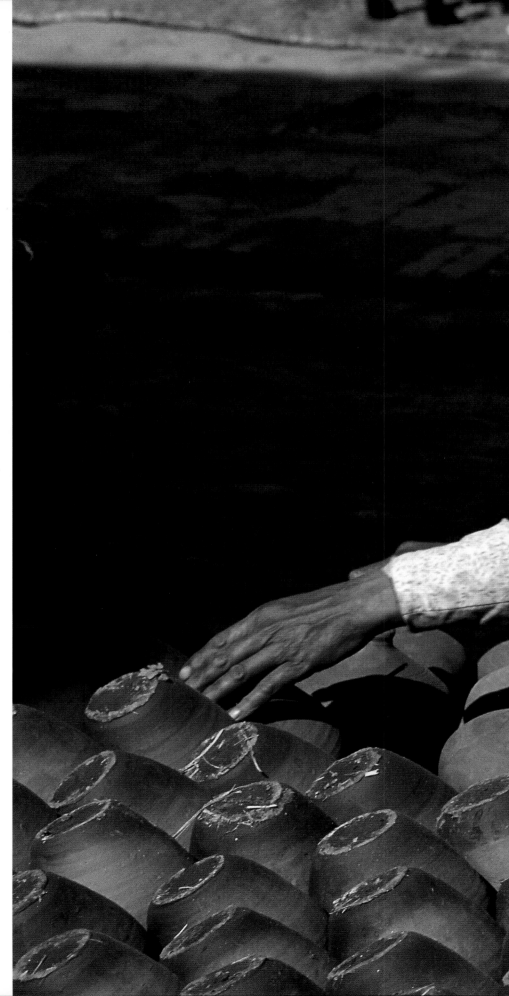

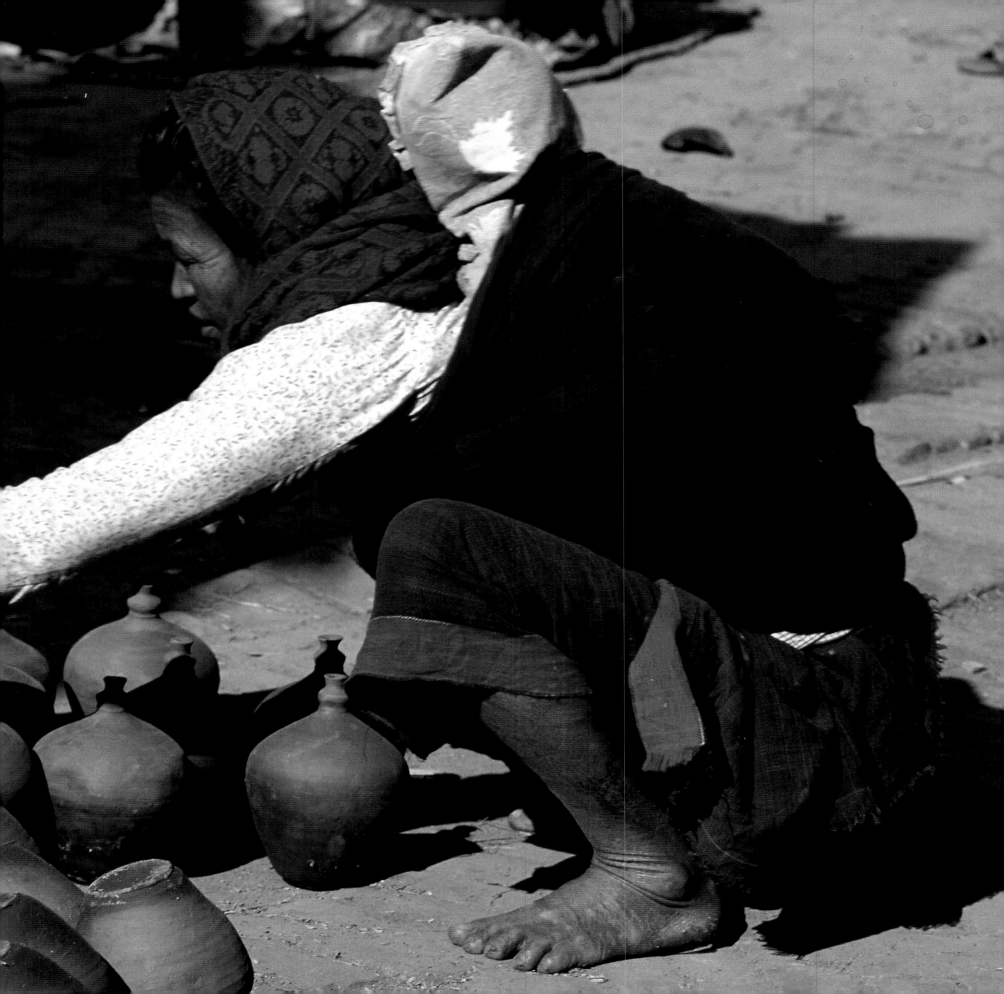

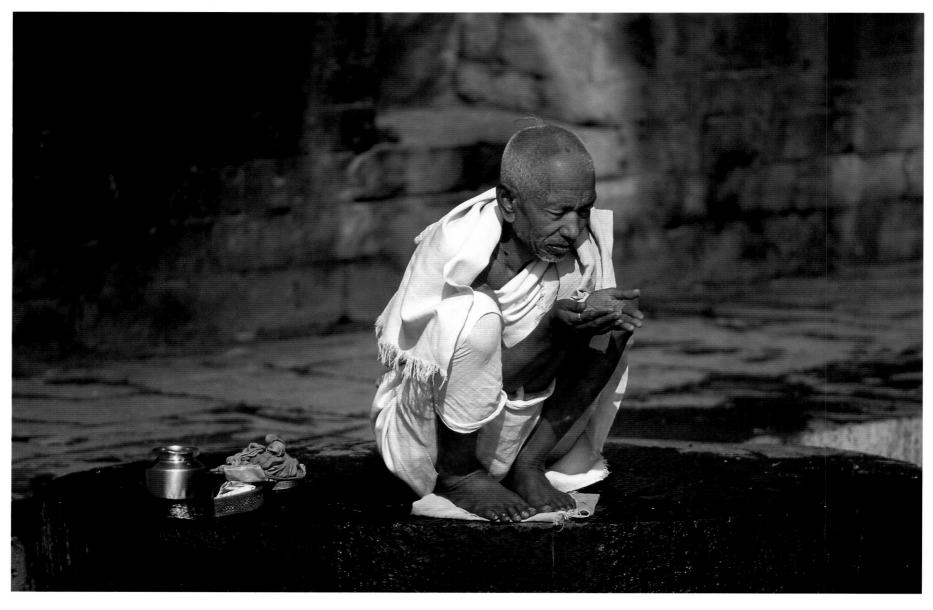

(Above)
An elderly Bhaktapur Brahman prays at the riverside shrine of Hanuman Ghat in Bhaktapur. Bhaktapur's
Rajopadhaya Brahmans, originally of Indian origin, were traditionally associated with the Malla court.
Today they serve as the highest link on the Newari caste ladder.

(Facing page)
A Newari man enjoys a puff on his hookah in Bhaktapur. The Indian practice of smoking a "hubble-bubble"
of tobacco mixed with herbs and molasses (gur) is one of the quiet pleasures of life for elderly men.

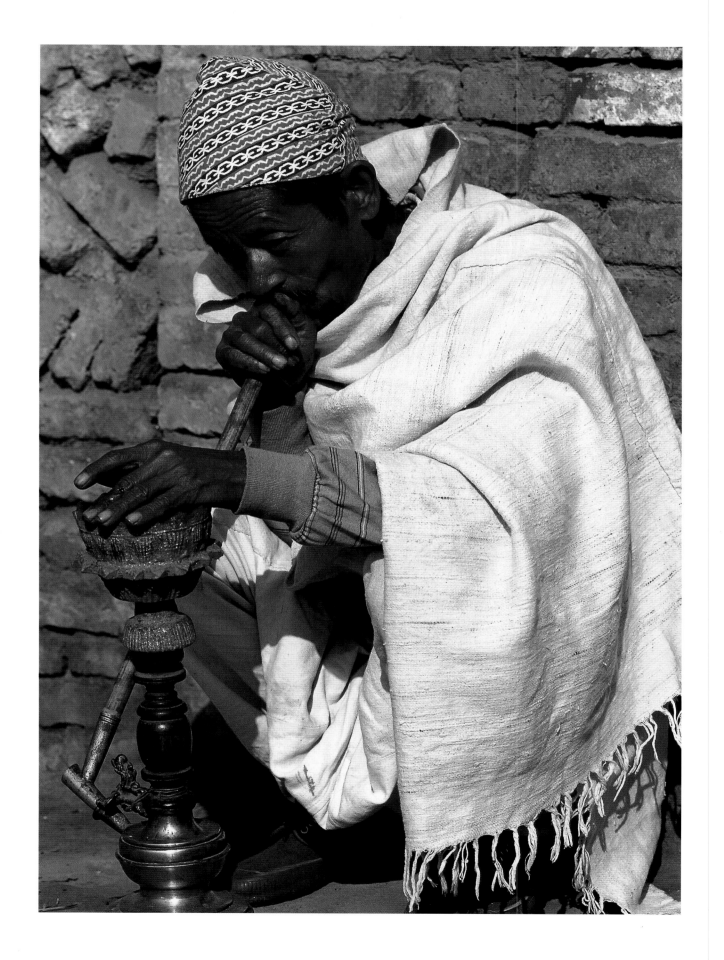

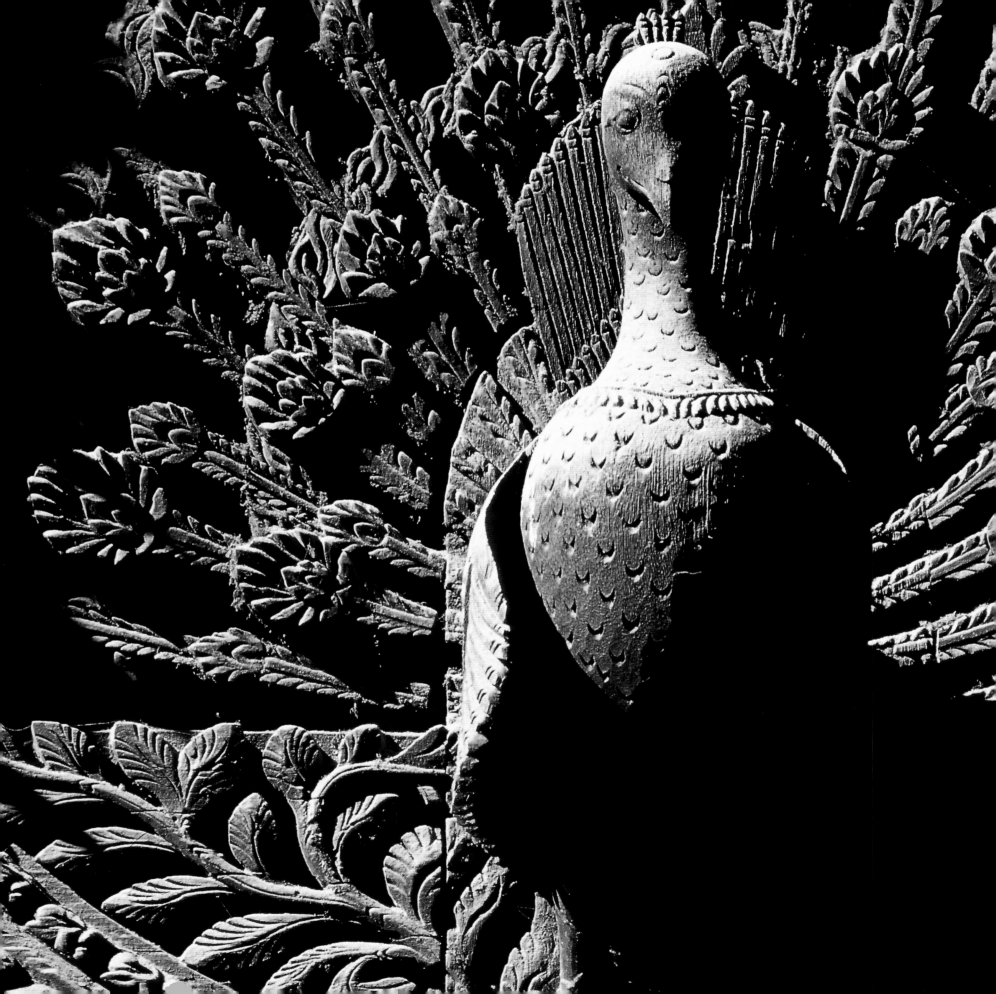

(Above)
A small girl rides a stone temple guardian in Bhaktapur. Children lounging on images of mythical beasts are a common sight, representative of the interweaving of the mundane and sacred that characterises the Valley.

(Left)
A splendid peacock spreads his intricately carved wooden tail in the famous "Peacock Window" of Bhaktapur's Pujari Math. The elaborately carved building houses the National Art Gallery's Woodworking Museum, a fine display of objects re-presenting one of the many skills of Newari craftsmen.

89

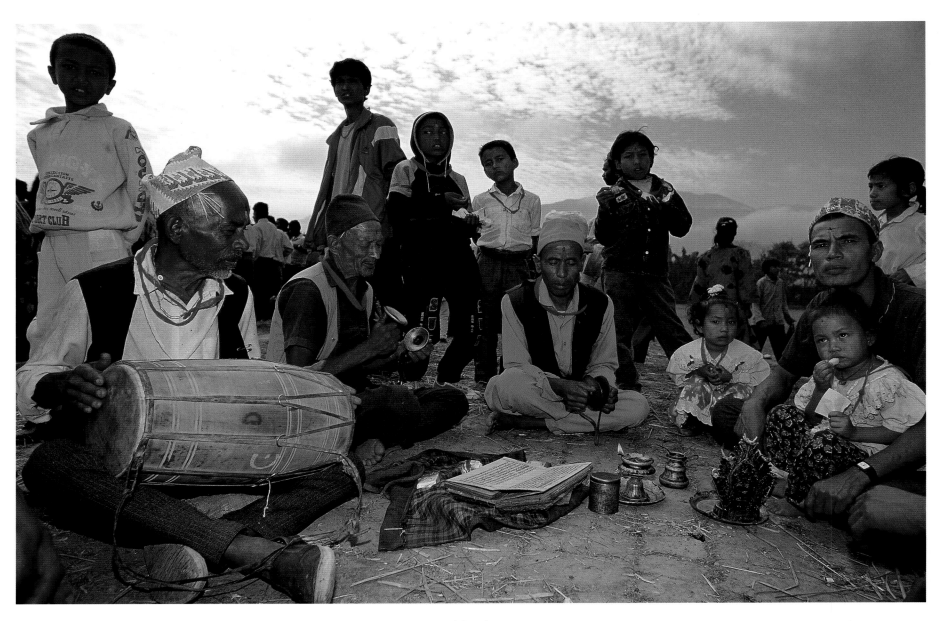

(Above)
Children munching on holiday treats gather to listen to Newari musicians in Bhaktapur during the great
autumn festival of Dasain. The yellow sprouts tucked under the musicians' caps, as well as the red strips
of cloth around their necks, are auspicious marks of blessing distributed
on the 10th day and last day of the festival.

(Facing page)
Newari boys participating in an initiation ceremony sit carefully balancing clay oil lamps at Bhaktapur's
Brahmayani Temple on Bhai Tika day. The Hindu Tihar festival coincides with the celebration
of Newari Lunar New Year. Nepal is unique in having four New Years annually: the Western January 1st,
Tibetan Losar in February, Nepali New Year on April 15th, and the Newar Swanti celebration in November.

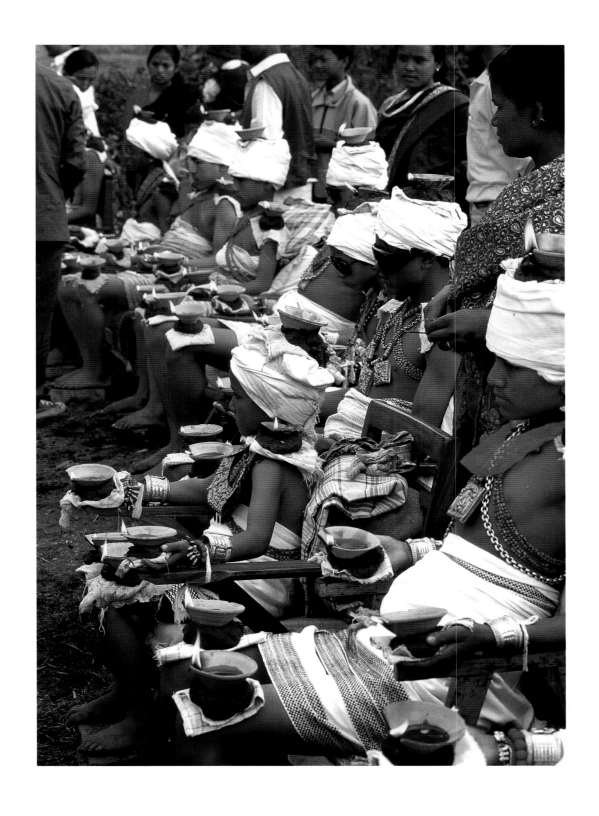

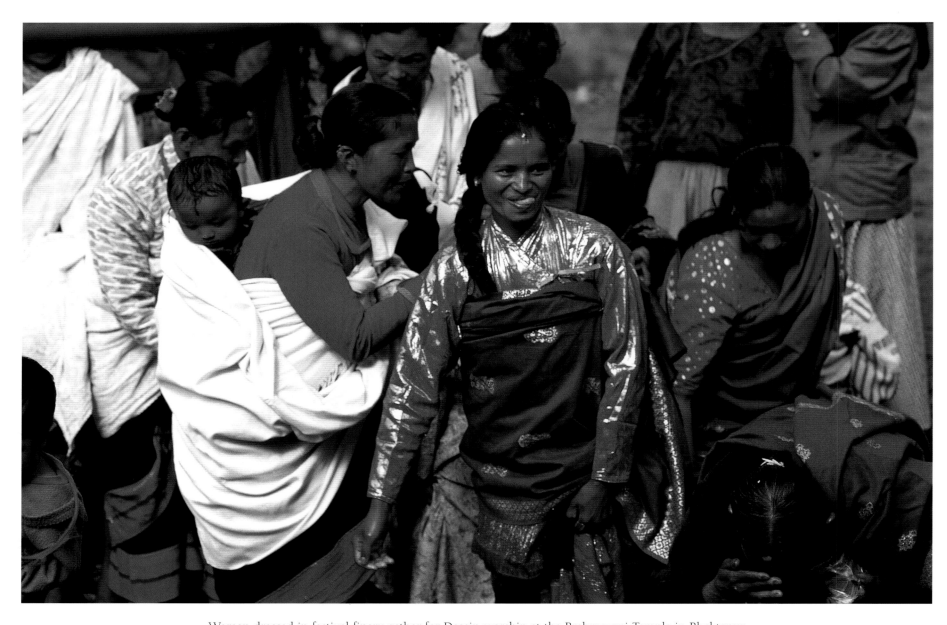

Women dressed in festival finery gather for Dasain worship at the Brahmayani Temple in Bhaktapur.
The colour red symbolises happiness and is worn exclusively by married women, in a theme repeated
in red tika marks and the red sindhur powder dusted in the central part of the hair. The women to the rear
wear the red-banded black hakuwa patasi favoured by Jyapu women.

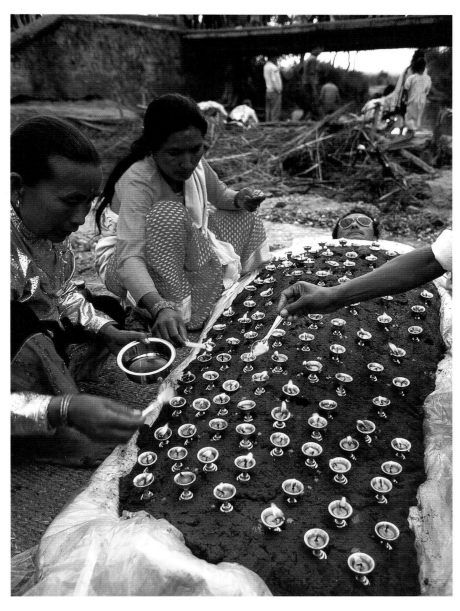

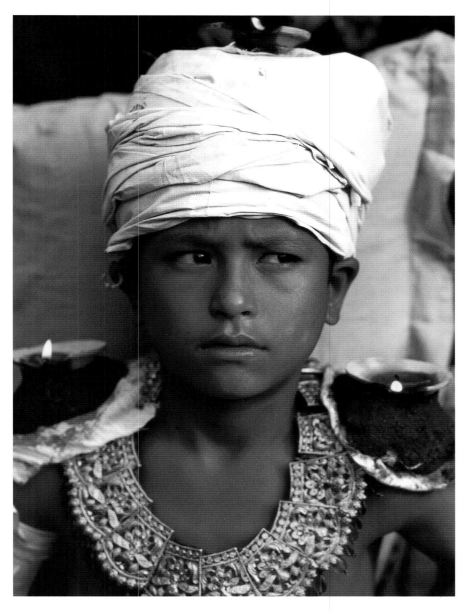

Women spoon oil into small clay lamps set over
the earth encasing a ritual-performing man
at the Brahmayani Temple in Bhaktapur.
Sunglasses add a modern touch.

A young boy balances oil lamps on his head
and shoulders during the same festival.
His intricate gold collar is typical of
the fine quality of Newari metalwork.

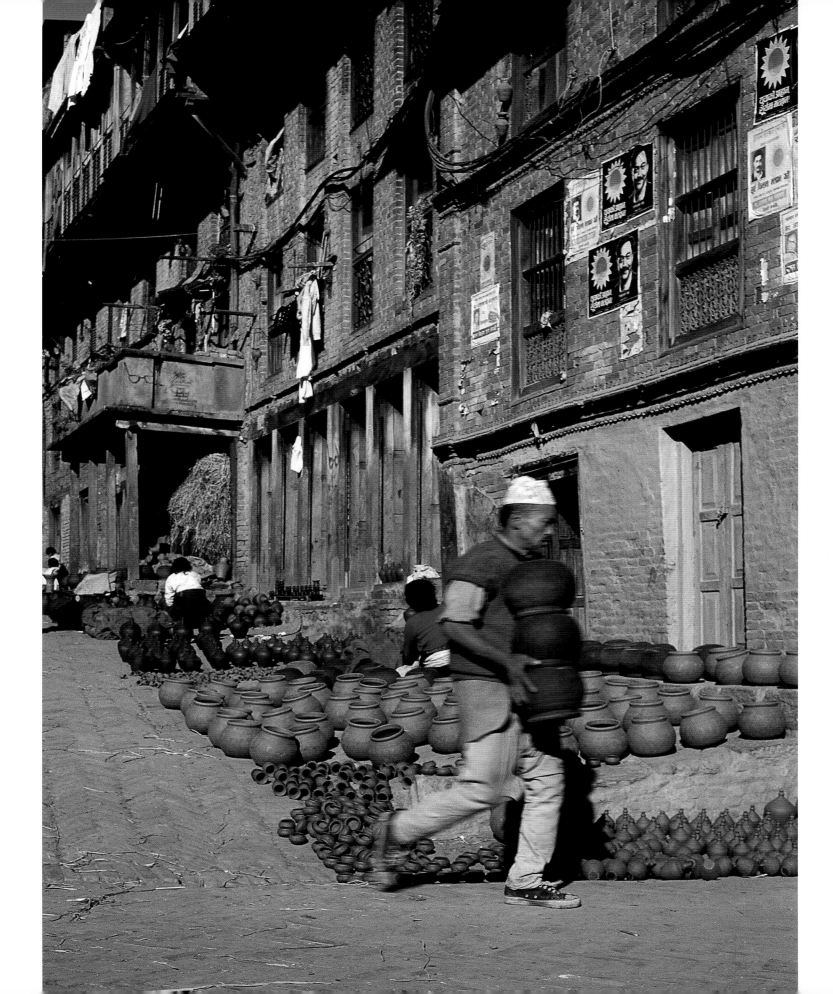

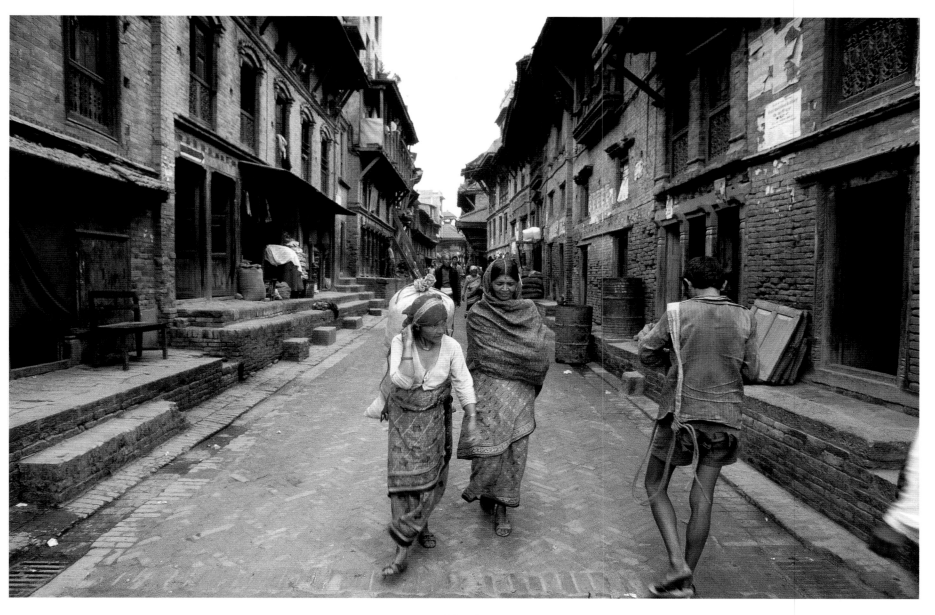

(Above)
A woman carrying a load with a namlo or woven headband passes an off-duty porter on a Bhaktapur street.
The tump line evenly distributes the weight of a load along the spine, allowing the legs to work most efficiently.
Goods are carried by porter in most areas of Nepal, as the country's rugged
mountainous terrain makes road construction difficult.

(Facing page)
A potter moves stacks of unfired vessels laid out to dry in the sun in Bhaktapur. This town, along with the
neighbouring village of Thimi, is the centre of the pottery-making trade for the entire Valley.

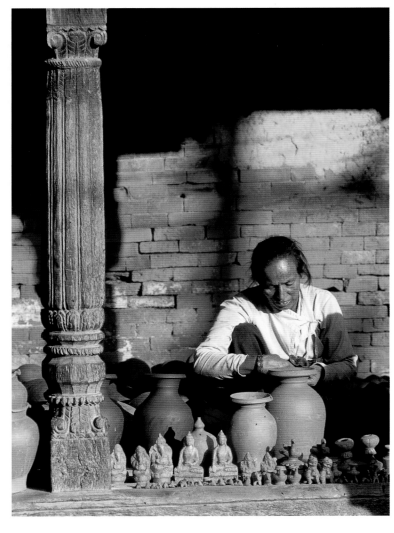

(Above)
Late afternoon light spills its glow on a woman smoothing the edge of a newly-made pot. Clay vessels come in all sizes, from giant urns used to store water and grain to whimsical figurines smaller than a fingernail.

(Right)
Agricultural rhythms infuse the urban landscape of Bhaktapur, the most rural of the Valley's three cities. Chickens and tethered goats may be kept outside the home, and grain and other crops are regularly laid out in public spaces to dry. A woman cleans grain on a bamboo nanglo or winnowing tray. The doorway of her home is decorated with ritual patterns in ochre and white.

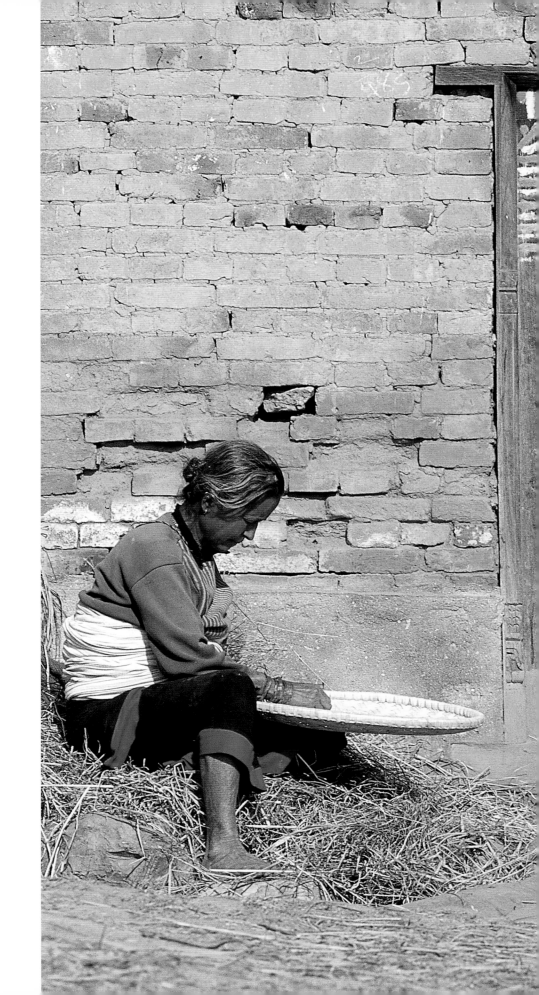

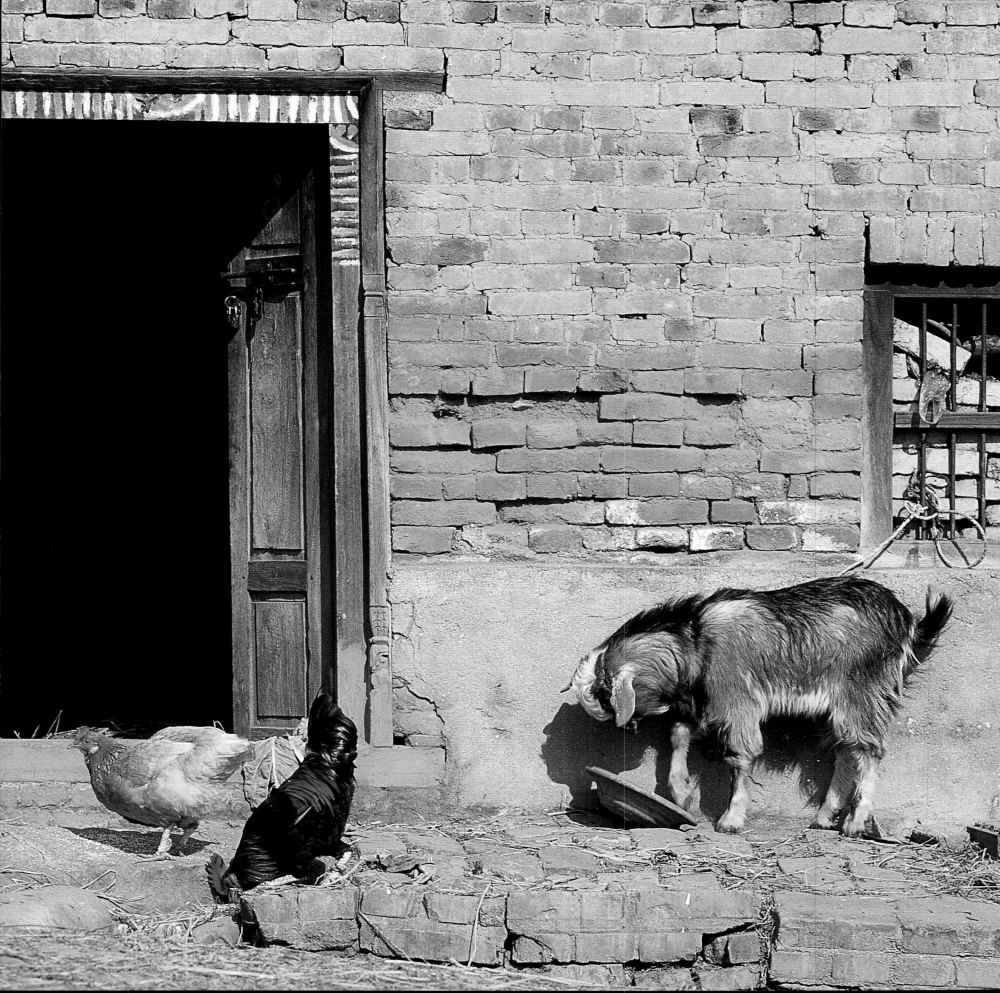

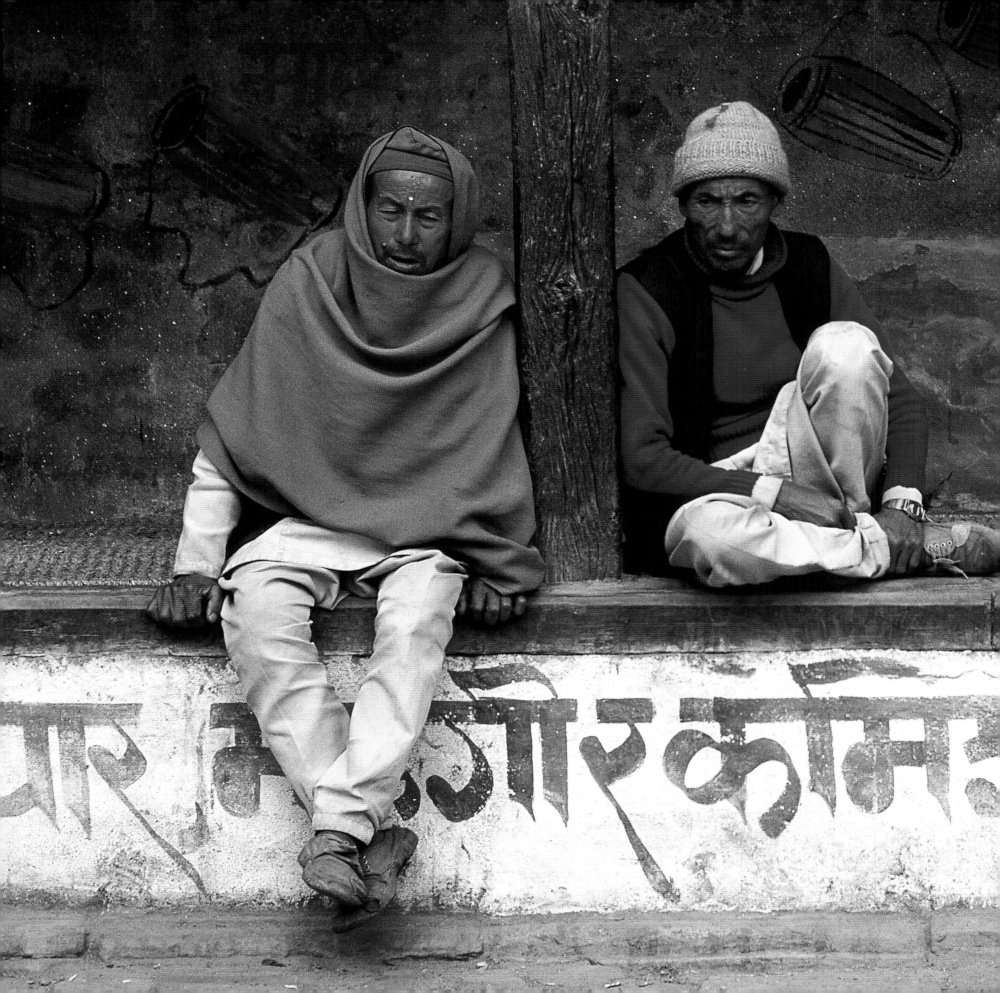

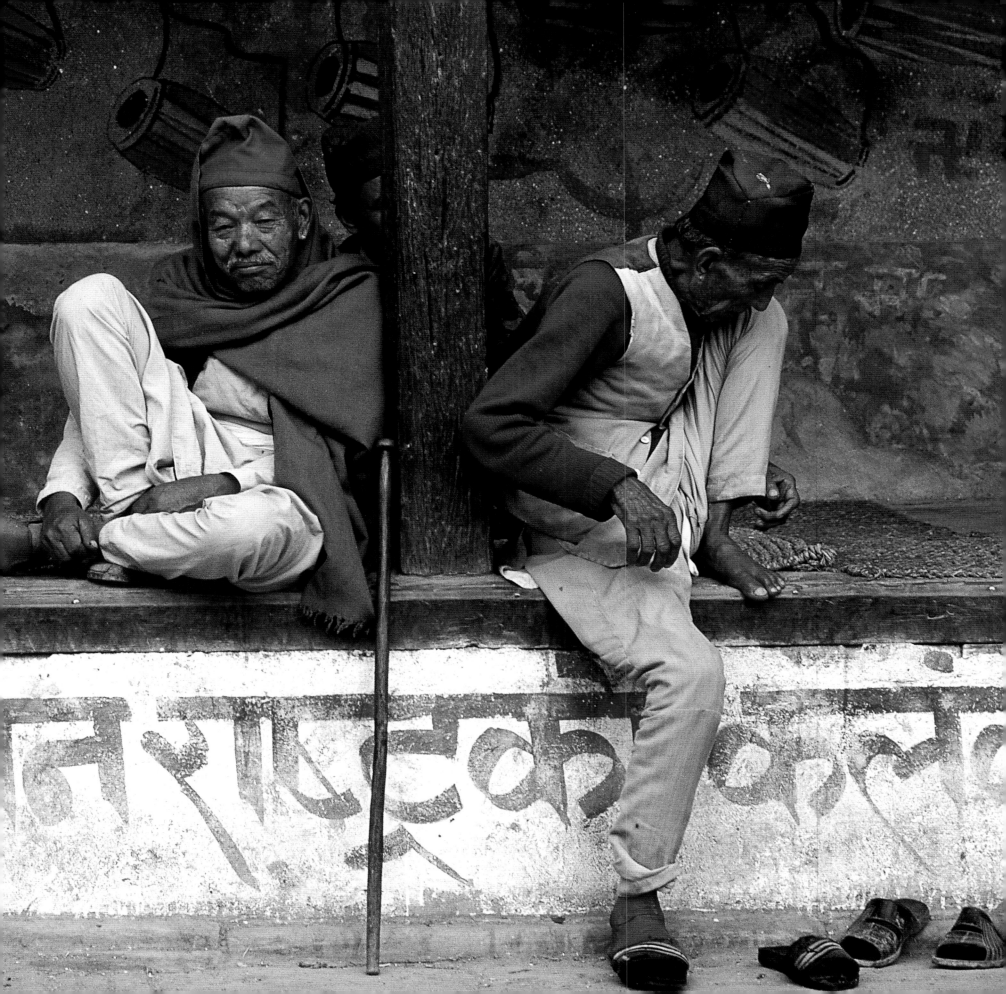

(Previous spread)
Elderly Newari men relax in a
public resthouse and watch the
world go by. Adult men form the
mainstays of guthi, communal
associations which have tradition-
ally regulated Newari social tradi-
tions and date back to Licchavi
times. Modernisations – television,
video parlours and a general
increase in materialistic diversions
– have undermined the guthis'
power, as did the government
land reforms of the early '60s,
which nationalised the organisa-
tions' endowments of land, reduc-
ing their revenues and thus their
prestige.

(Right)
The hilltop fortress town of
Kirtipur was attacked by Gorkha
forces in their 18th-century drive
to conquer the Valley, but its
Newari defenders mounted a stiff
resistance. It took three separate
sieges for the town to fall. The
Gorkha king then ordered a grisly
punishment – that the noses be
cut off of every Kirtipur male over
the age of 12. The remaining city-
states soon succumbed to the
conquering Gorkhali troops, and
by 1768 the entire Valley was
united under Gorkha rule.

(Facing Page)
A woman relaxes for a moment
watching her sheep graze a bare
field near Kirtipur in the south
Valley.

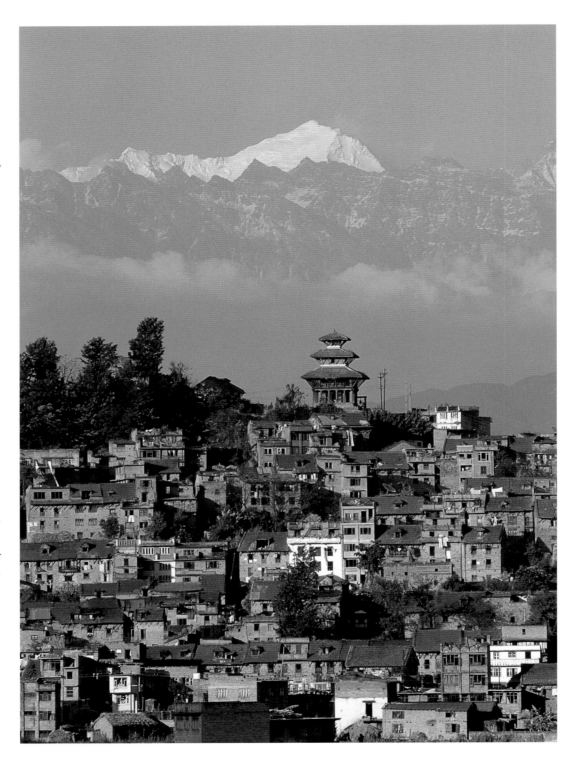

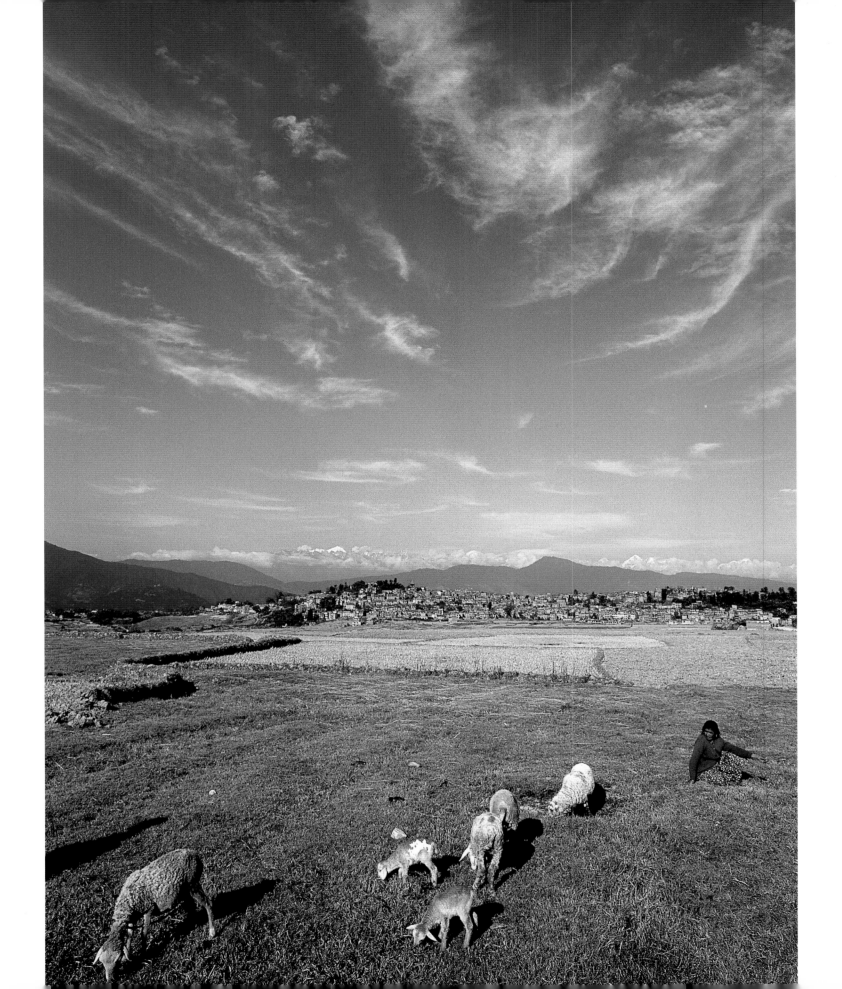

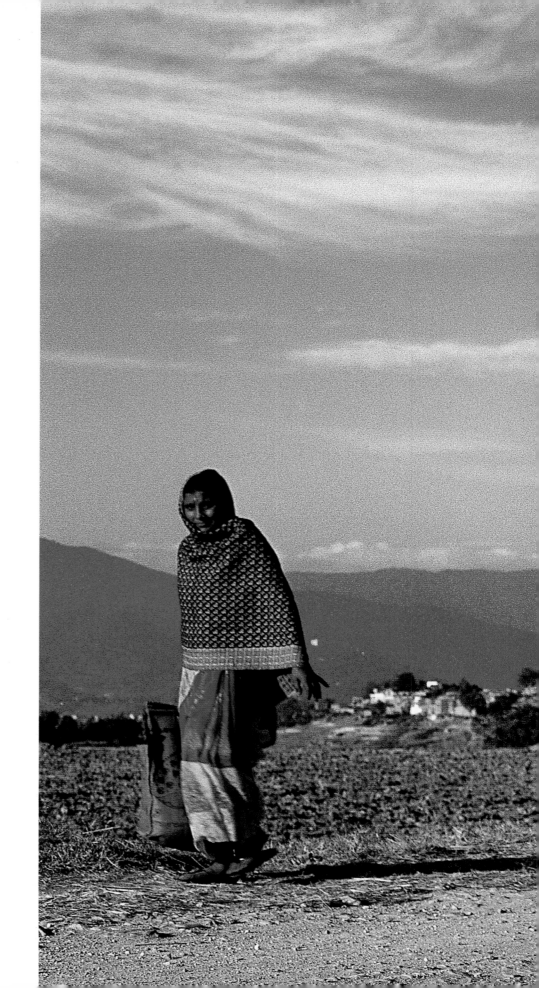

(Above)
A woman in a Kirtipur courtyard winnows rice with a nanglo, a tray fashioned of woven bamboo strips.

(Right)
Women are the workers of Nepal, responsible for collecting water, fodder and firewood and performing many farming tasks. These women are carrying loads of fodder to feed their family's livestock – most likely goats, or perhaps water buffaloes or cows.

(Previous spread)
Different members of a joint family fill the elegantly carved wooden windows of an old Kirtipur home. The latticed design provides privacy while letting in light and air. The old towns of the Valley are characterised by traditional red-brick houses adorned with carved wood. Newer buildings tend to be of the cement-box variety.

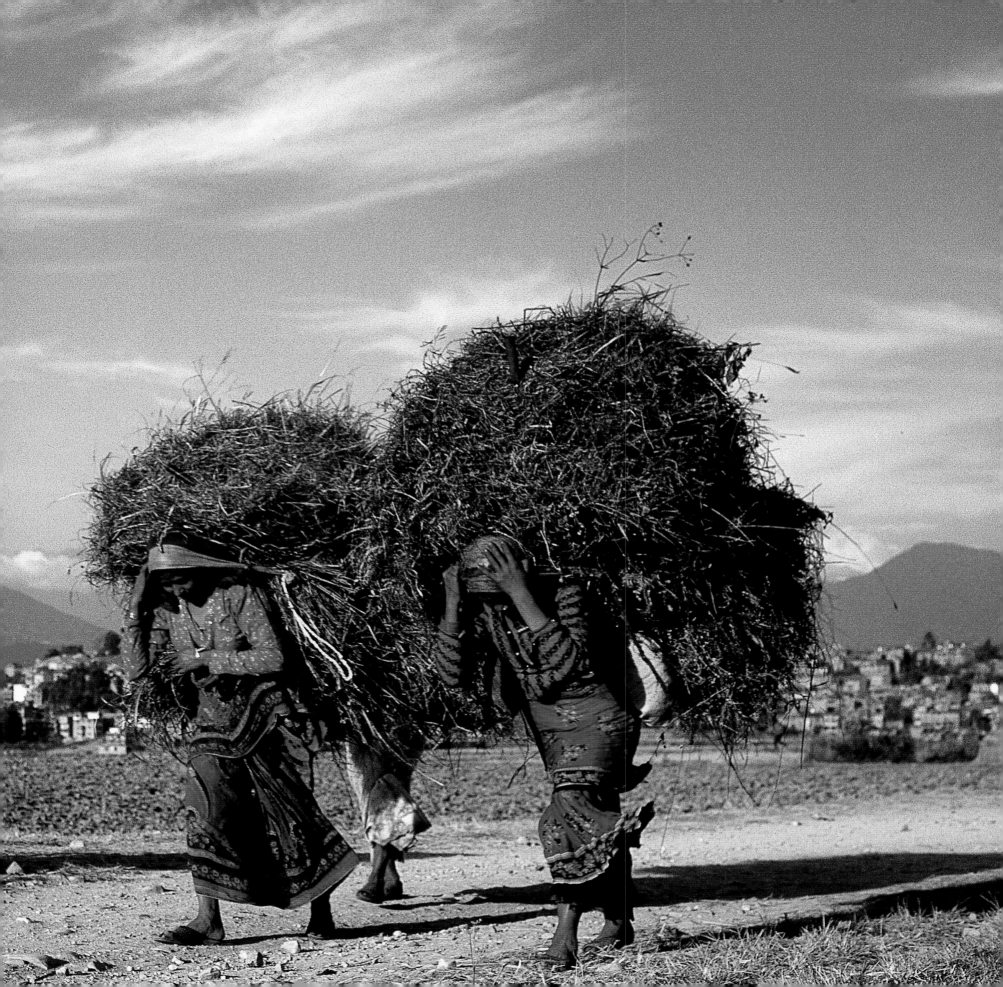

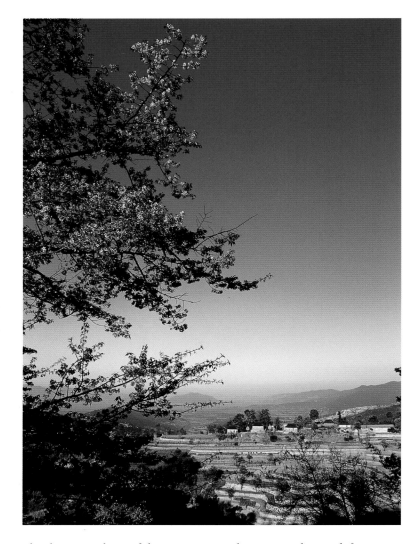

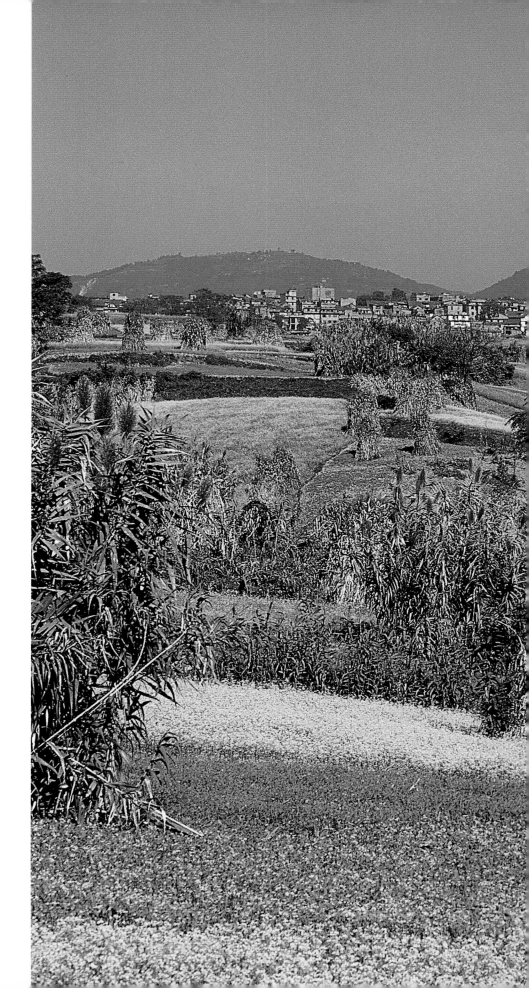

The changing colours of the season carpet the countryside in a shifting patchwork of different hues: (Above) The Valley's winter is brief and mild, characterised by cold nights and clear, sunny days. By early February the fruit trees are blossoming and the winter wheat is ripening, as in these fields near Nagarkot. *(Right)* Fields of mustard flowers and clumps of dried cornstalks form repetitive patterns on a hilly landscape near Kirtipur.

(Page 108)
Intense colours and textures provide simple decoration for a tea shop near Changu Narayan, a hilltop temple in the east Valley. Sweet, strong dudh chiyaa or milk tea is a Nepali staple, made from low-grade "dust" tea boiled with milk and sugar.

(Page 109)
Necklaces of drying corn garland a house at Changu Narayan.

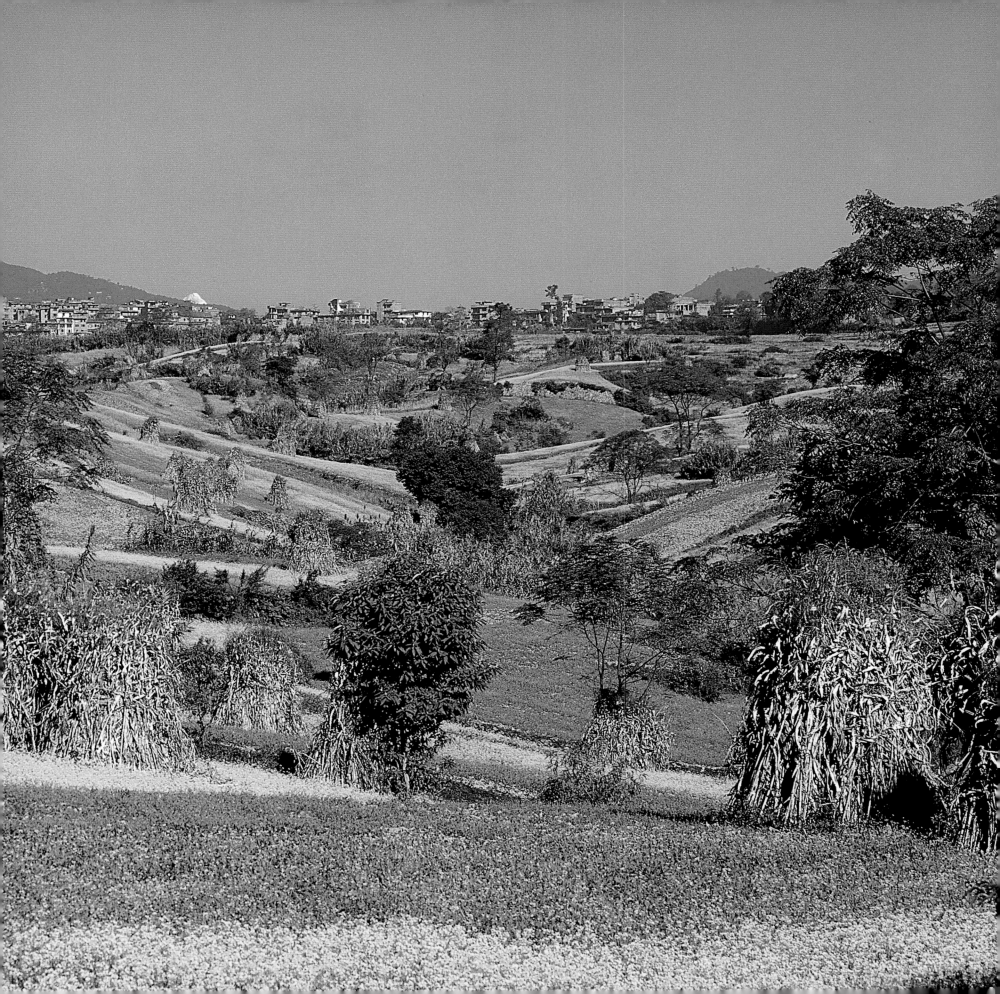

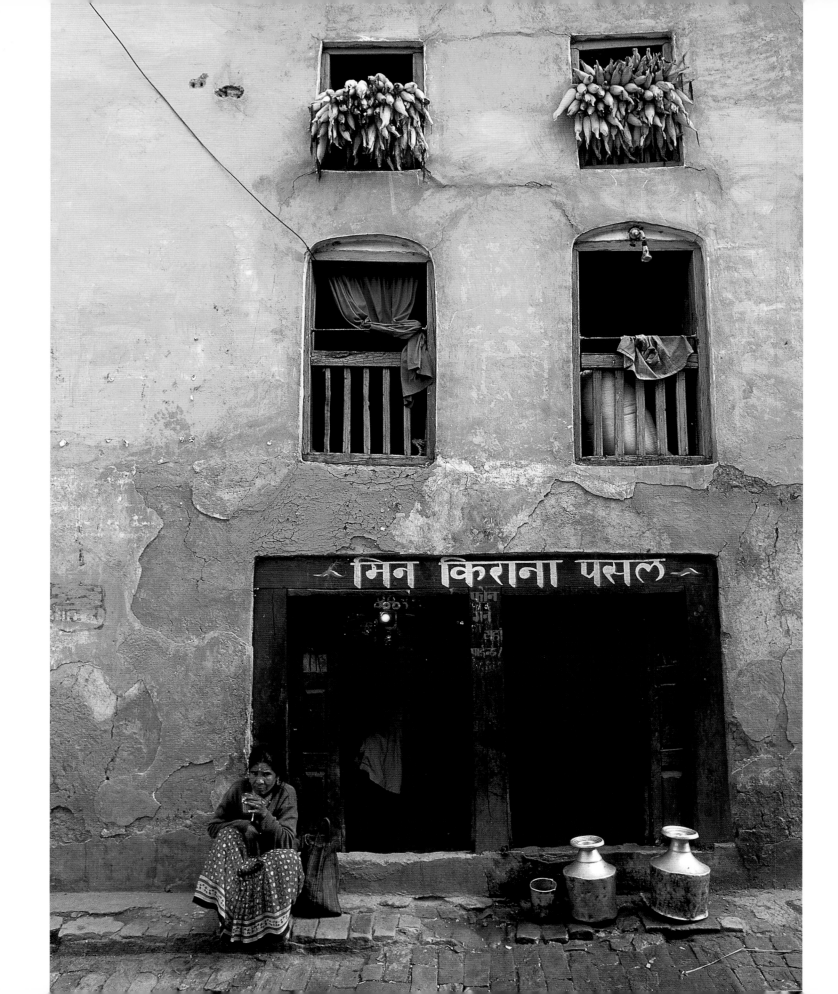

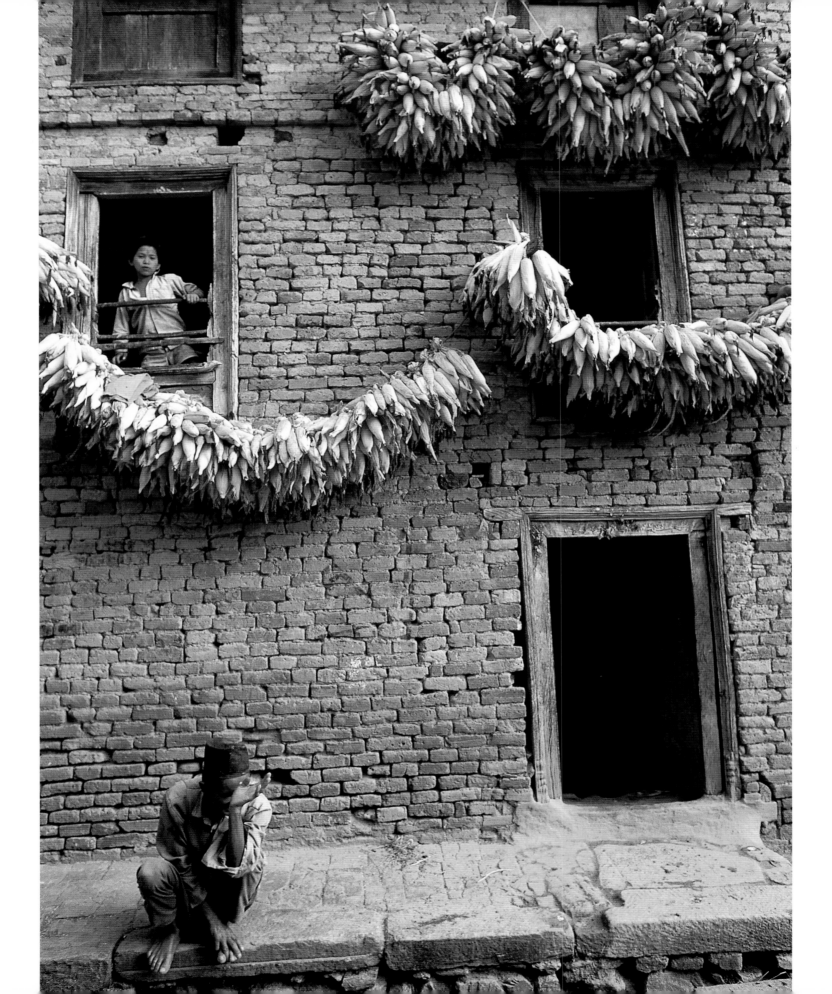

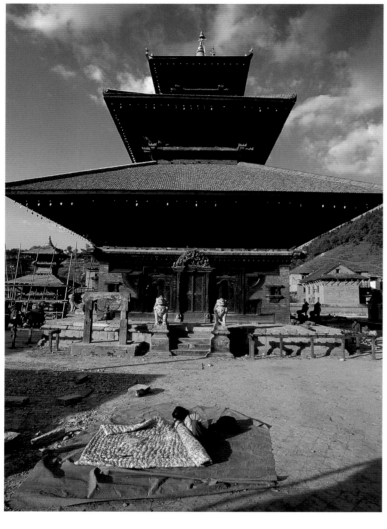

(Above)

The temple of Indreswar Mahadev in Panauti, an ancient settlement just over the Valley rim, displays the stately proportions typical of a Newari temple. Originally constructed in 1294, the temple has undergone periodic reconstruction, most recently repairs from the damage wrought by the 1988 earthquake. In front of the temple, a woman suns a quilt of cotton batting.

(Right)

Women bathe at the sacred confluence of three rivers in front of Gokharna Mahadev Temple in the eastern Valley. This sacred Shiva temple built in the 14th century is the site of Hindu and Buddhist festivals honouring the dead. The temple complex was restored with assistance from UNESCO in the early 1980s, and remains a beautiful example of fine woodcarving and classic architecture.

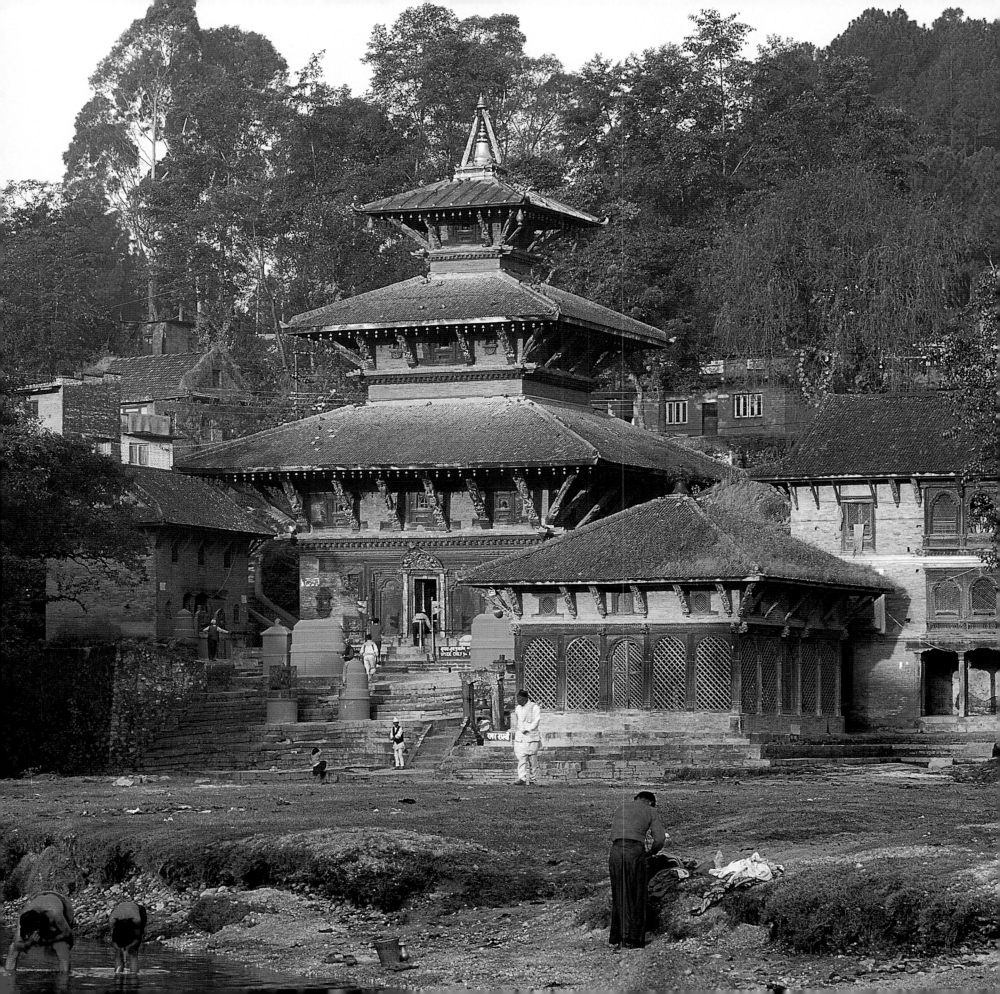

The Sleeping Vishnu (Jalasyana Narayana) of Budhanilkantha is one of the marvels of the Valley. Consecrated in 648 A.D., the image was carved from a single block of stone hauled from a distant quarry.

(Above)
The figure depicts a slumbering Lord Vishnu resting on the sinuous coils of the serpent Ananta – a poetic image of the dormant creative force.

(Right)
The massive figure is worshipped daily with ritual puja by a Brahman priest.

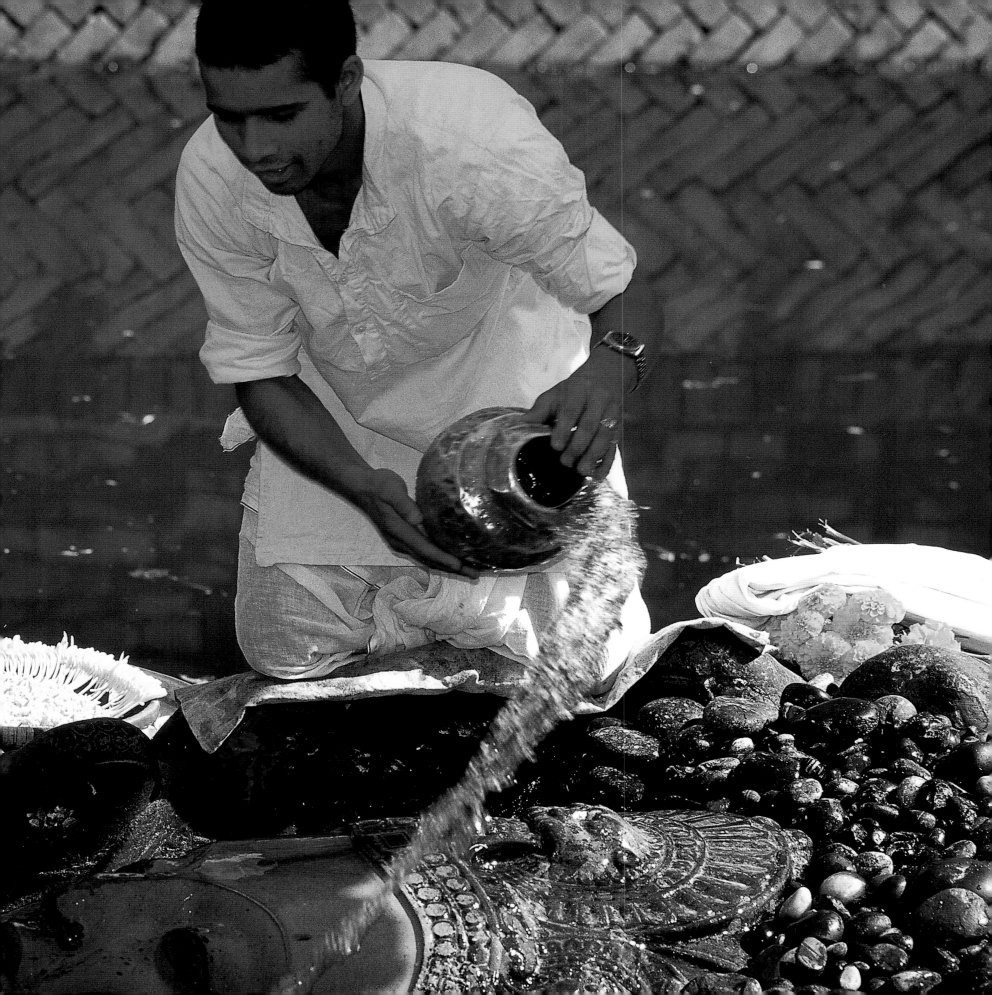

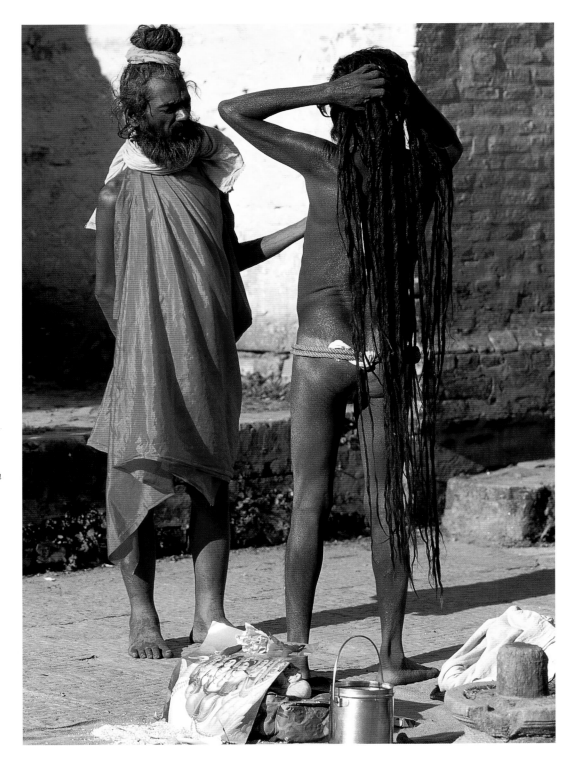

Budhanilkantha is also a habitat for sadhus who wander up from India in the cold season to make the tour of the Valley's sacred sites.

(Right)
The knee-length locks of this sadhu, and his leathery skin, represent one of many kinds of austerities performed by *babas*. Others may raise one arm in the air for years on end, or take a vow to never sit down.

(Facing page)
Fiercely flying dreadlocks imitate Shiva's matted hair, said to tumble down like the waters of the sacred Ganges.

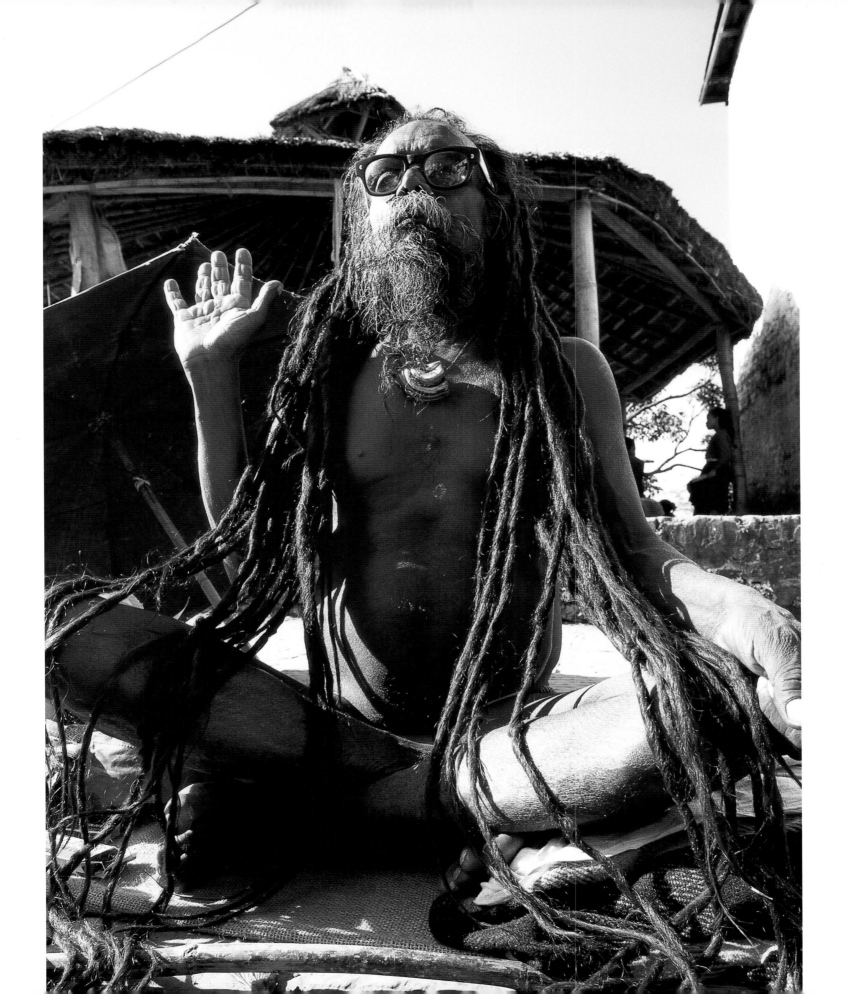

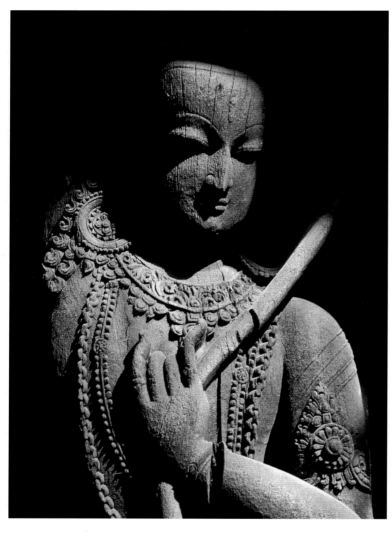

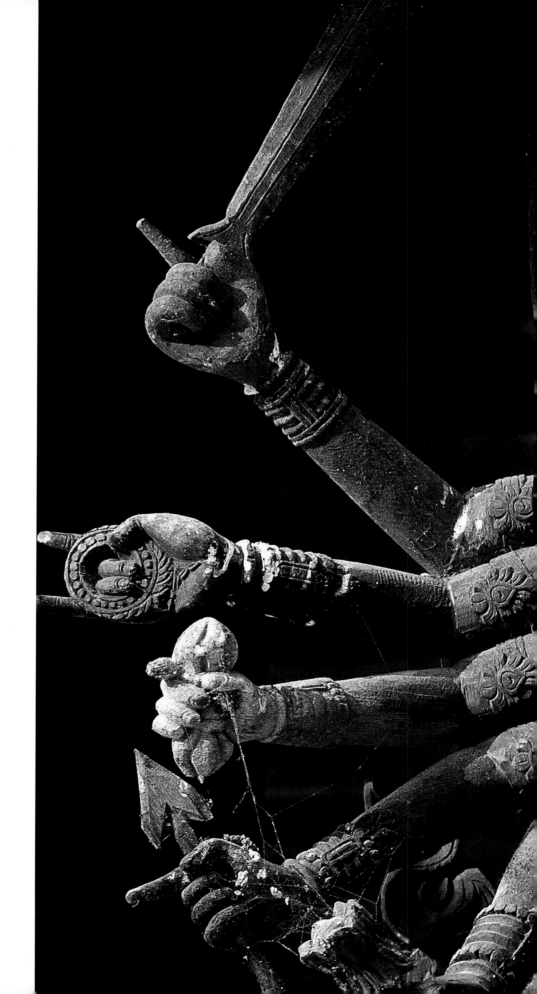

(Above)
The timeless beauty of a sculpted face at Panauti's Indreswar Mahadev temple speaks across the ages. The carved wooden roof struts of this shrine are some of the finest in Nepal.

(Right)
Multi-armed deities dance, threaten and beckon, their poses serving as advertisements for their manifold capacities. This carving on the Chandesvari temple in Banepa depicts the goddess holding an array of implements, each representing a different aspect of her power.

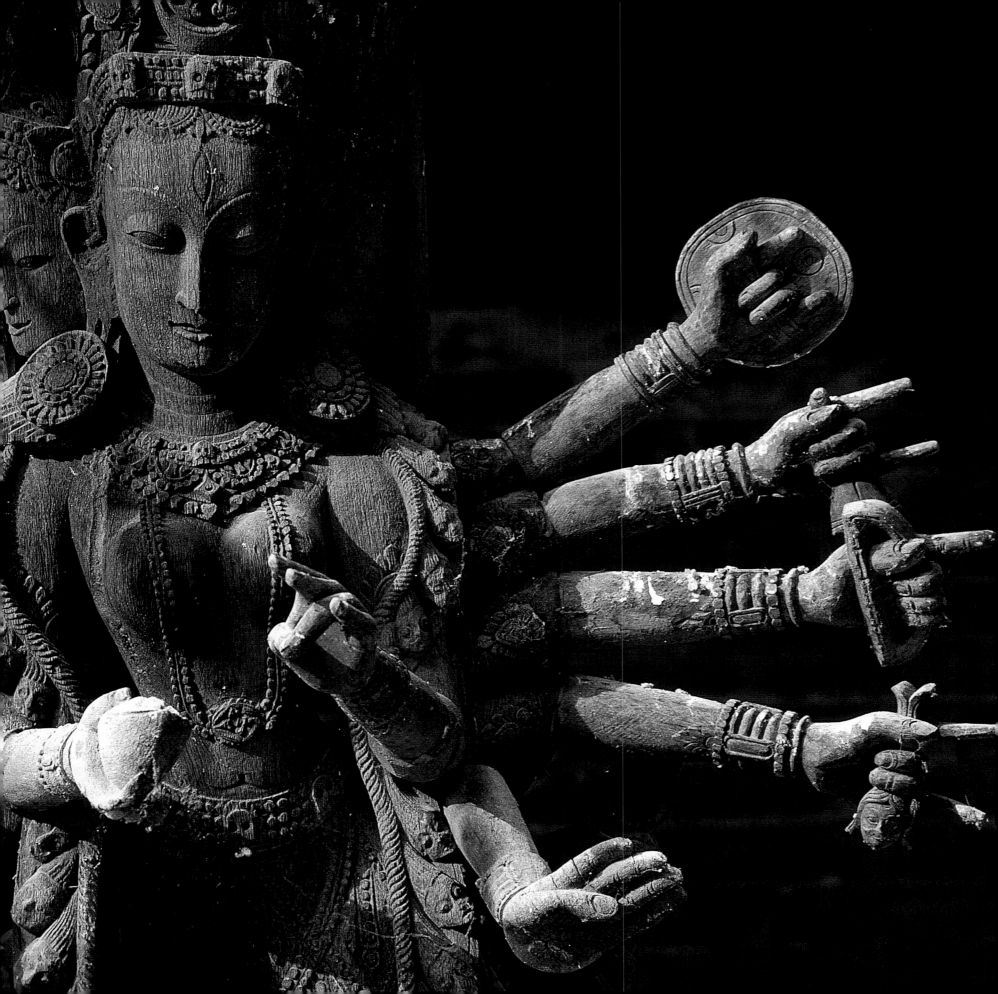

The gilt-roofed temple of Vajra Yogini, located on a hillside above the Newari village of Sankhu, was originally a power place sacred to a nature goddess. Over the centuries it was transformed into a shrine dedicated to the Buddhist goddess Vajra Yogini. The Sankhu temple is considered the most powerful and important of the four Valley sites dedicated to this deity. She is worshipped by both Newari Buddhists and Tibetan Buddhists (like the red-robed monk to the left); Hindus revere her as a form of Durga.

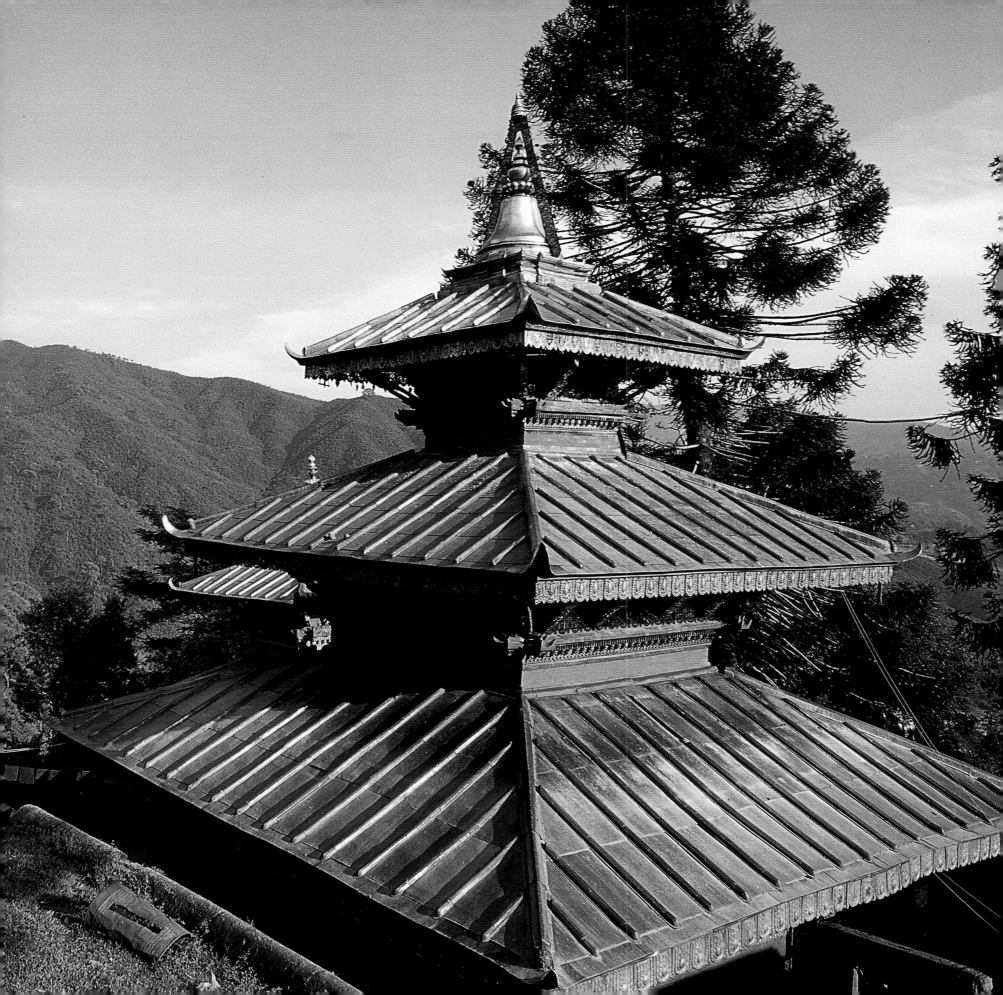

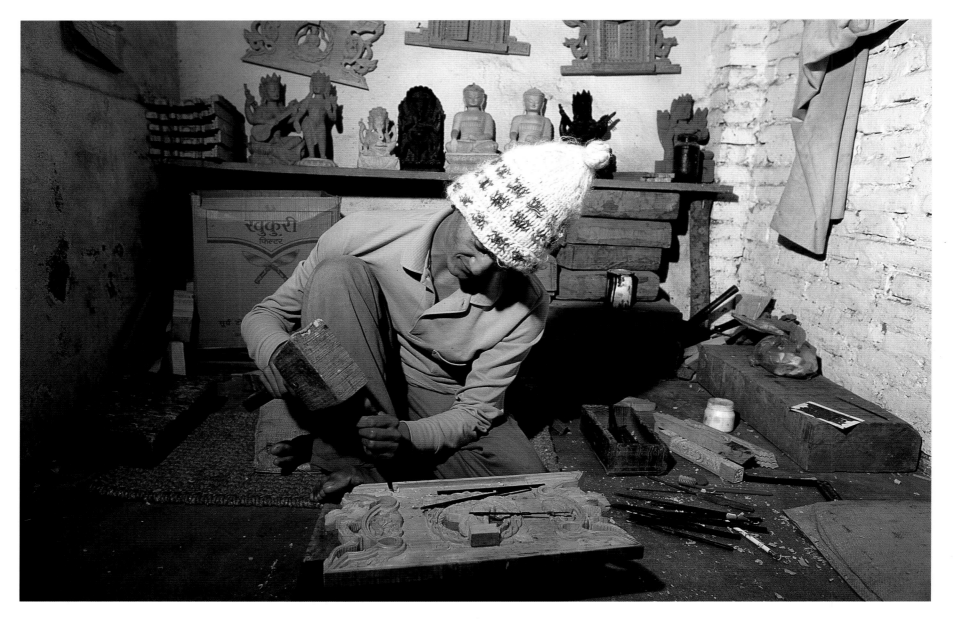

(Above)
A Newari woodcarver in Bungamati works on a miniature window for the tourist trade. Tourism is
a growing sector in the Nepali economy, providing a new market for traditional arts and crafts.

(Facing page)
A torrent of holy water cascades over a bather at Balaju Water Gardens. Balaju's 22 water spouts (Baais Dhara)
are carved in the form of giant makara, mythical crocodile-serpents associated with water and wealth.
The sacred taps are used for daily bathing and laundry as well as for ritual bathing.

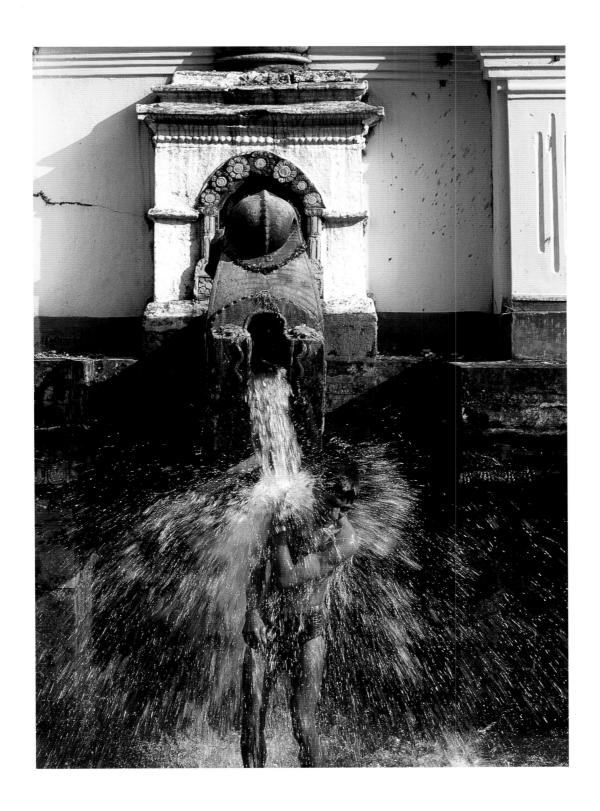

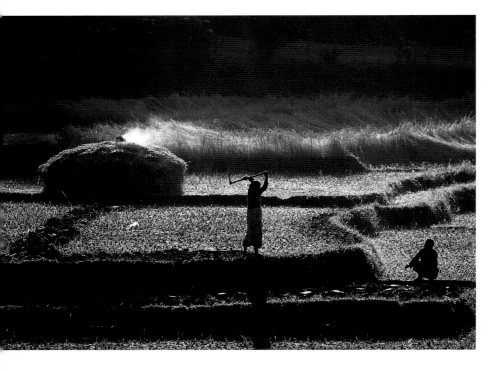

(Above)
A woman wields a hoe on a fallow field in the sheltered little valley of Ichangu Narayan. Farmers follow the timeless rhythms of planting and harvest in a peaceful rural setting only a few kilometres from urban Kathmandu.

(Right)
Terraced ricefields glow golden in late afternoon light. The Valley's steep hillsides are carved with layered terraces patiently hewn out over the centuries through backbreaking labour. Arable land constitutes only 18 percent of Nepal's total area, making every scrap valuable.

(Page 124)
A woman sits on the porch of her ochre-daubed farmhouse in Lele, just over the Valley rim. Mud-walled farmhouses such as this one are typical of Brahman and Chhetri caste groups. Each morning the women of the house smooth the floors with a fresh coating of mud mixed with ritually pure cow dung.

(Page 125)
Farmwork, like threshing, is still done by hand in much of the Valley, though increasingly the hum of a motorised thresher can be heard. Similarly, chemical fertilisers are replacing the traditional practice of enriching the soil with ancient sedimentary deposits of "black clay" left over from the Ice Age lake.

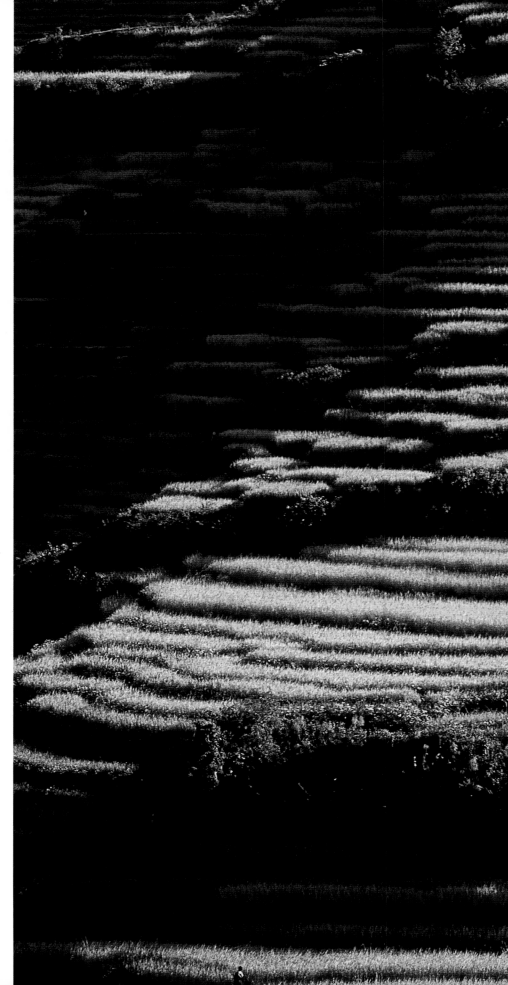

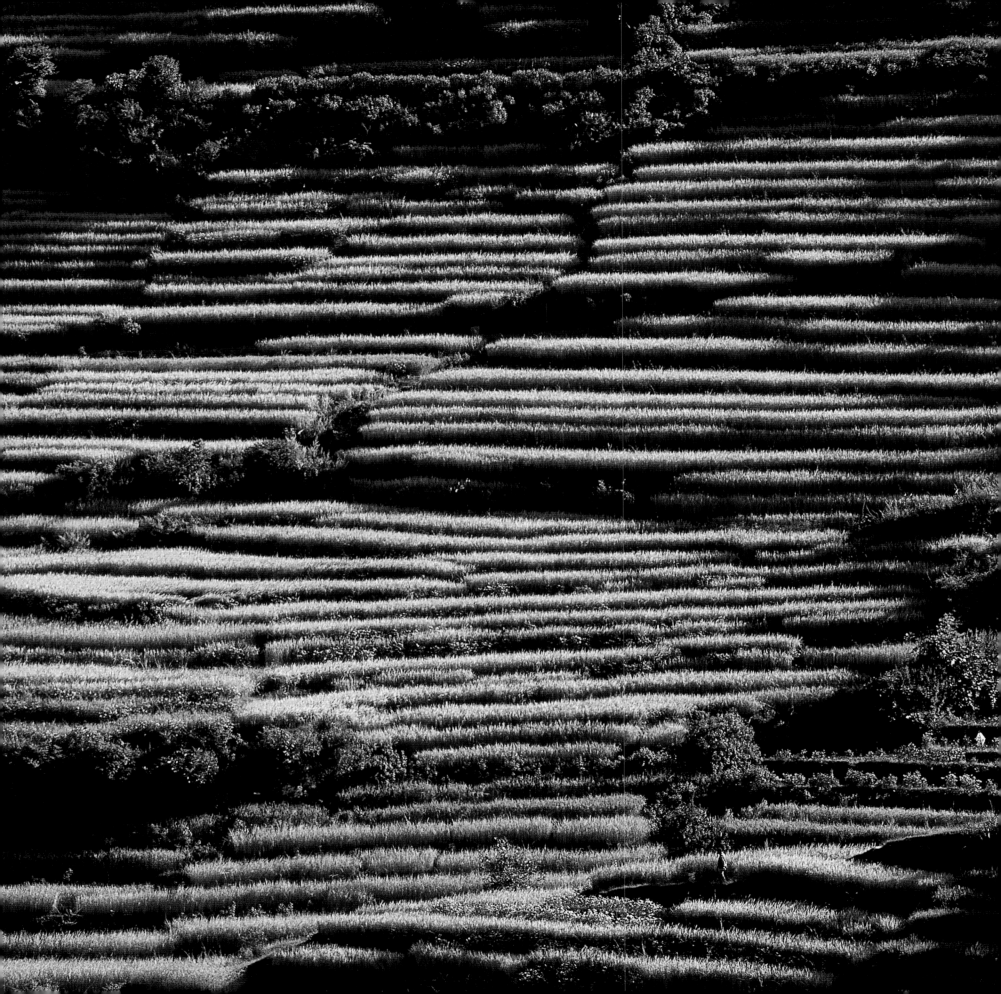

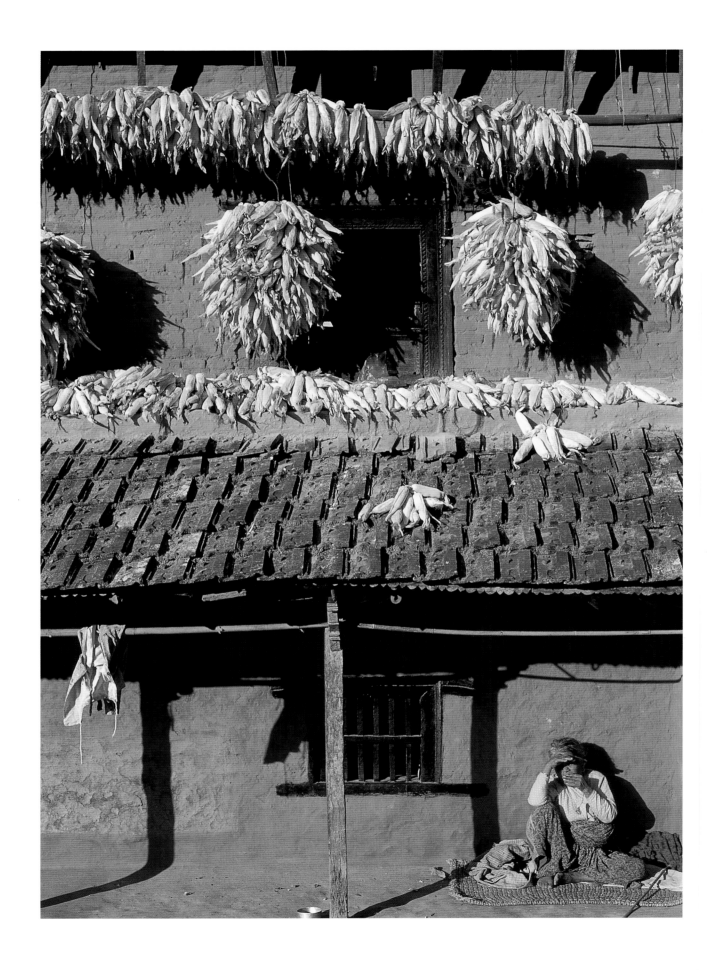

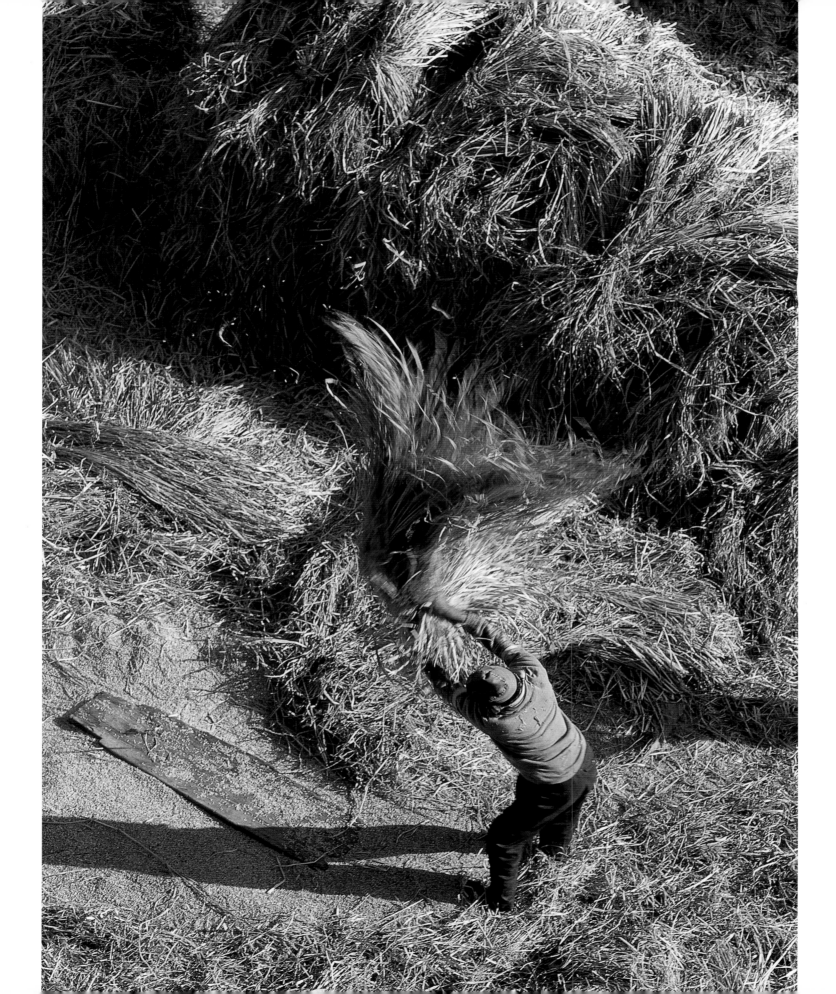

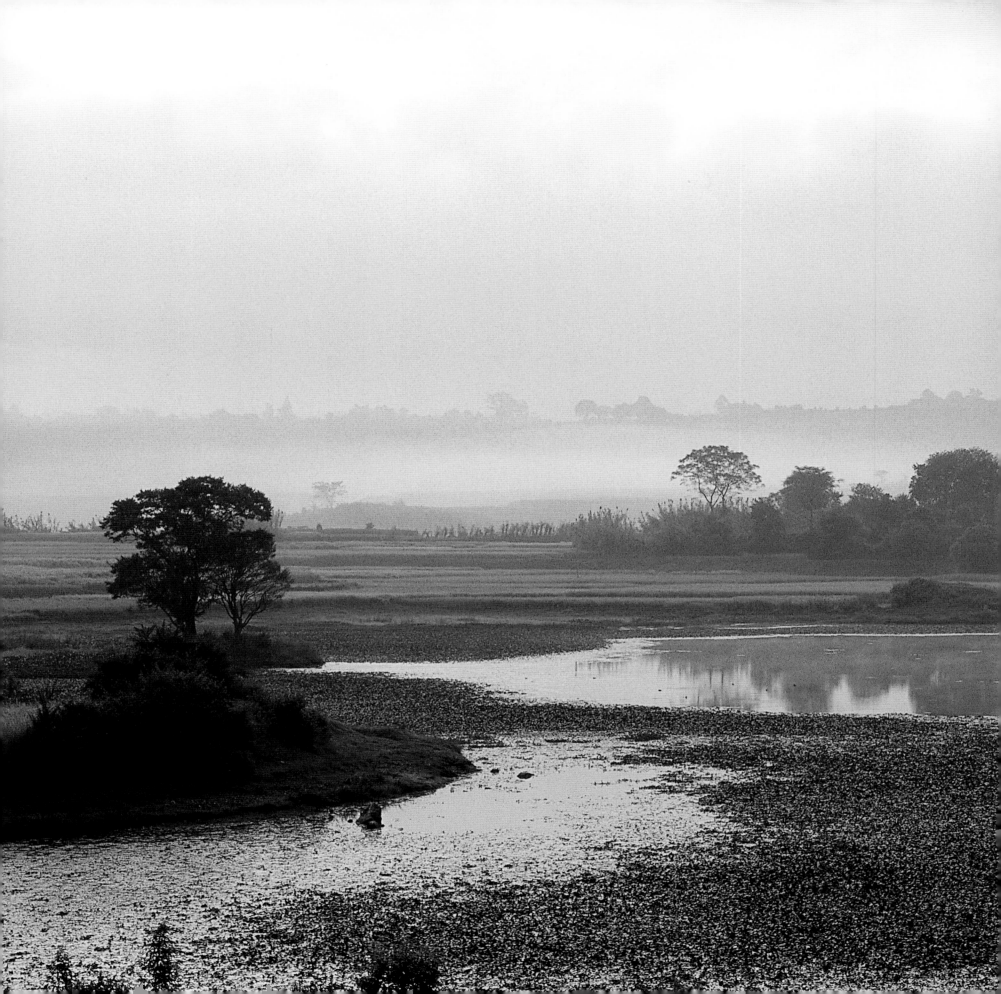

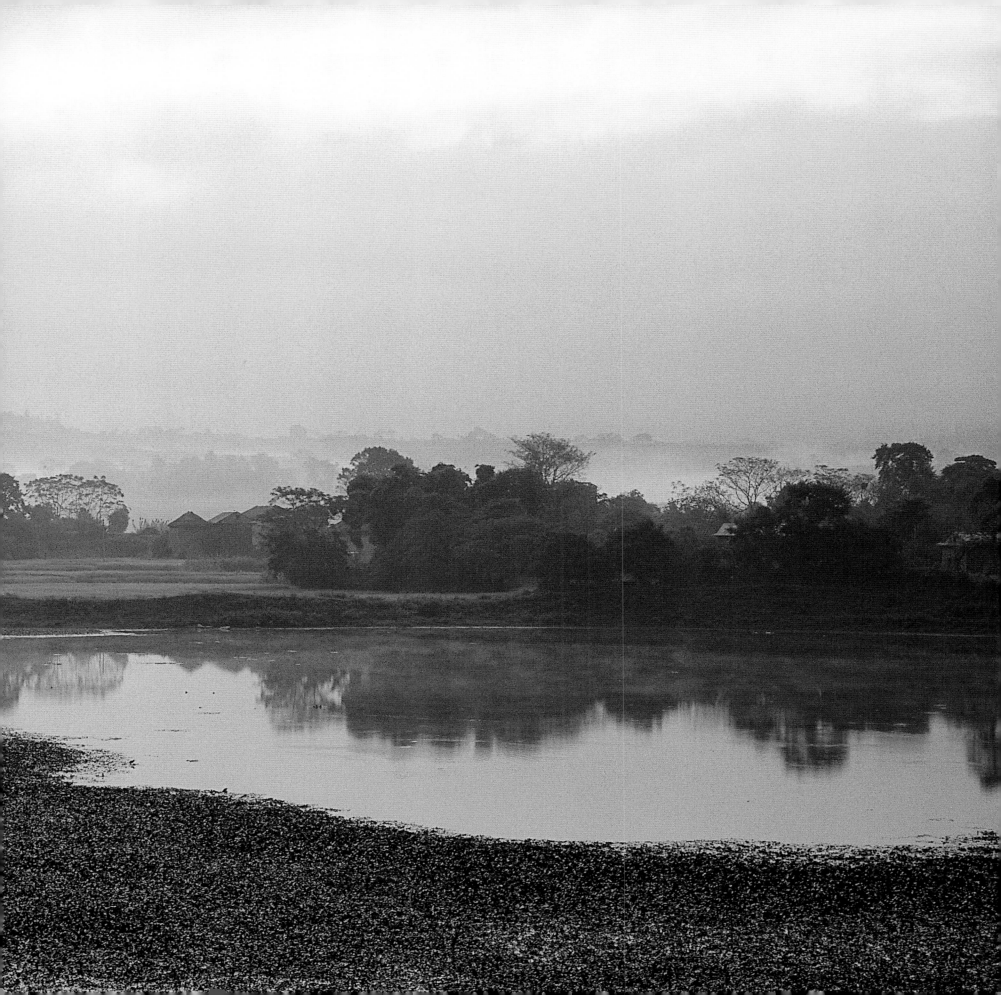

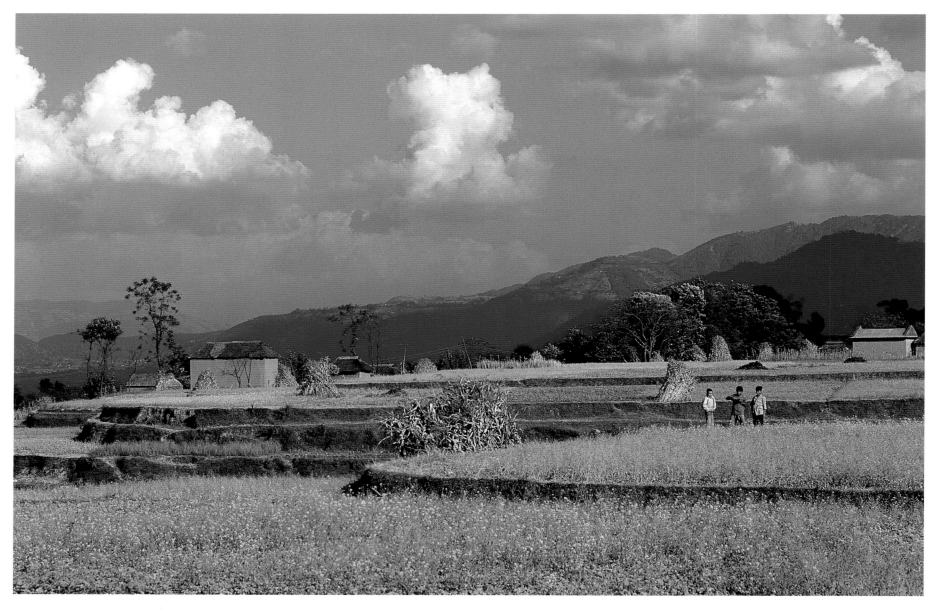

(Above)
Pastoral landscapes like this one still characterise much of the Valley. The tiny seeds of the flowering yellow mustard plant are pressed in community-owned mills to extract a clear oil used for cooking, as well as for therapeutic massages administered in the warm winter sunlight.

(Facing page)
Women harvesting rice near Sankhu. Small independent farmers form the backbone of Nepal's largely rural economy, using traditional systems and techniques expanded to the limits of the possible.

(Previous spread)
The placid waters of Taudaha, a small lake in the southern Valley, are said to shelter the enchanted palace of the King of the Nagas. Snakelike beings believed to protect the Valley's wealth, the naga are said to dispel the underwater gloom with the light of magical jewels set in their foreheads. Nepal's Rana rulers had the lake dragged in the last century in an unsuccessful search for its mythical treasures.

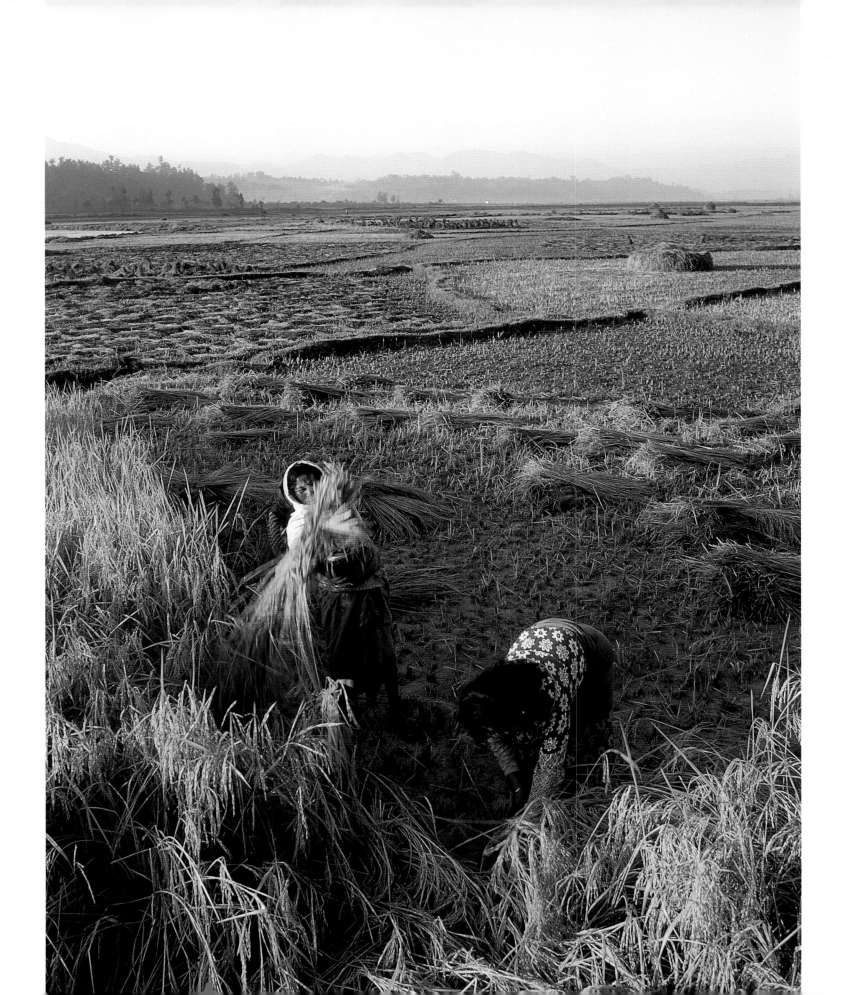

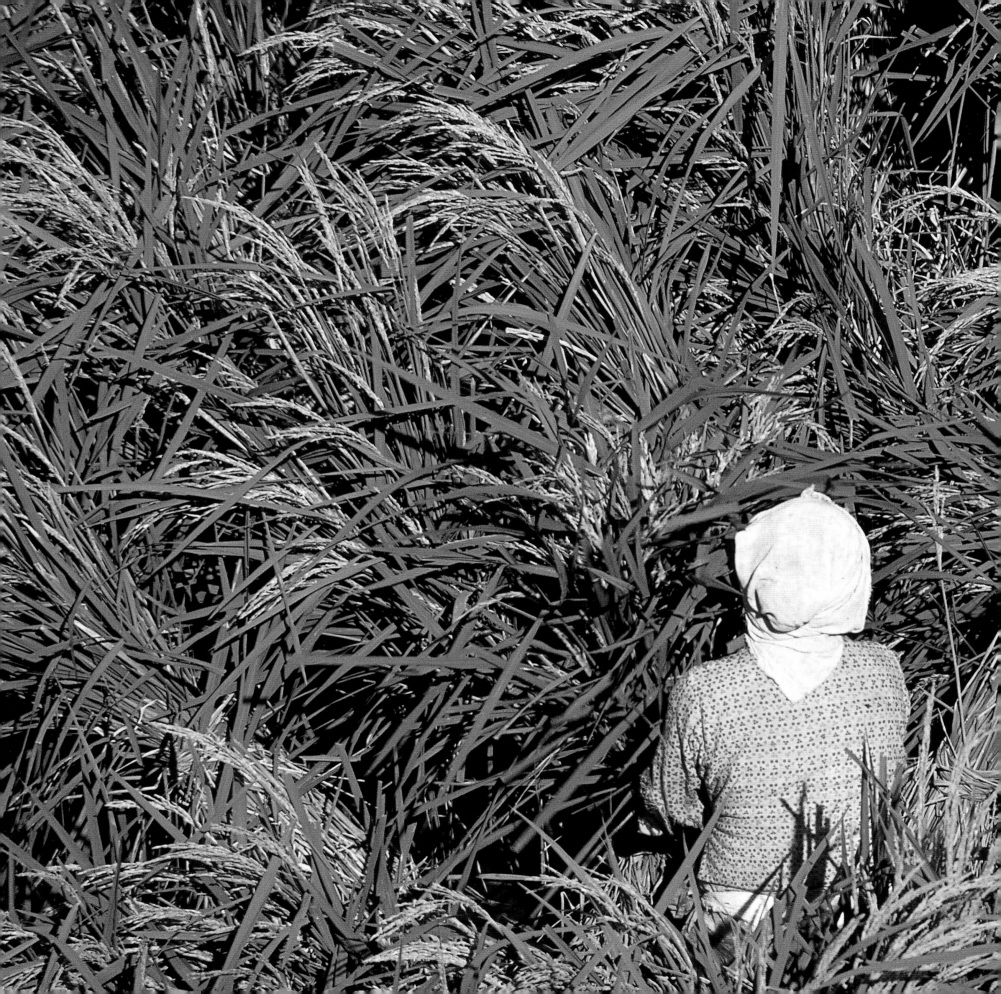

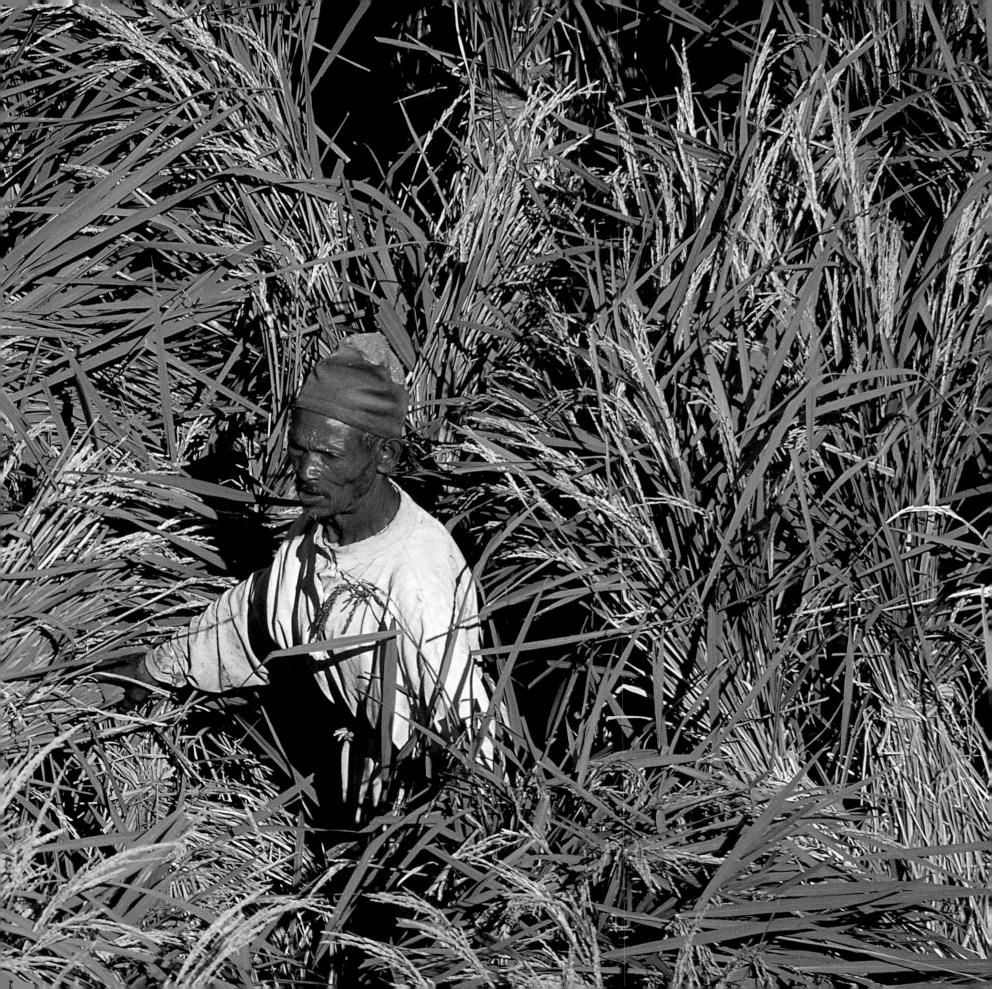

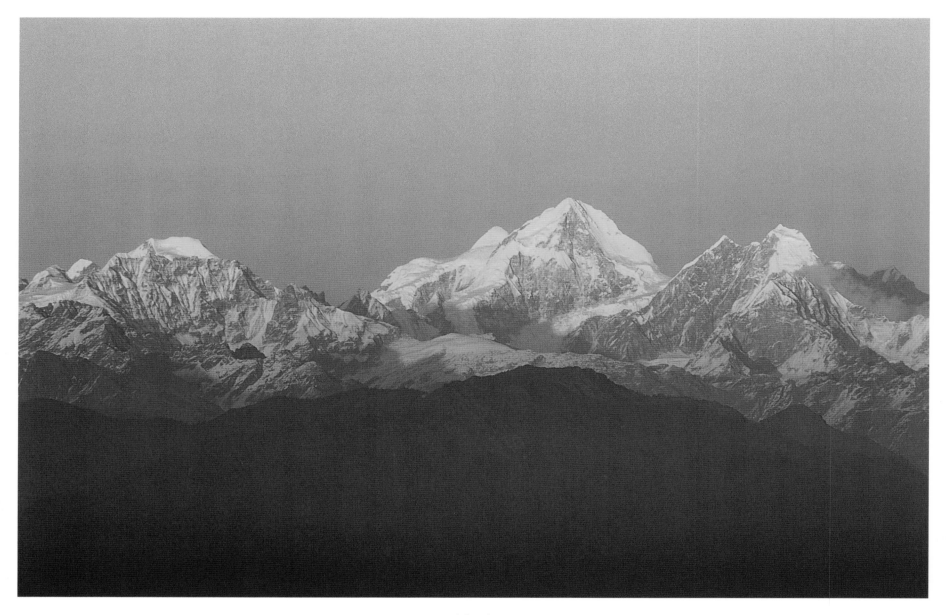

(Above)
The hilltop viewpoint of Nagarkot on the Valley's eastern rim offers stunning mountain panoramas at sunrise and sunset. Nepal has eight of the world's
ten highest peaks, a dry fact on paper, but the actual sight of them looming to the north always manages to catch the breath with a brief flutter of surprise.

(Facing page)
Startlingly tall Himalayan peaks tower over the Valley, forming a stern barrier to the north. Twice the height of the Alps, the Himalayas weld the
Indian subcontinent to Asia in a giant arc extending over 3,800 kilometres. To ancient Hindus, the Himalayas were literally the "Abode of Snow,"
and the dwelling place of the gods. Nepal's Central Himalaya consists of a number of smaller mountain chains
or himals divided by rivers and lower ridges.

(Previous spread)
Life in much of the Valley, as in the majority of Nepal, is based on farming. Some 80 percent of the population practices farming,
and agriculture contributes to around half of national production – one of the world's highest rates.

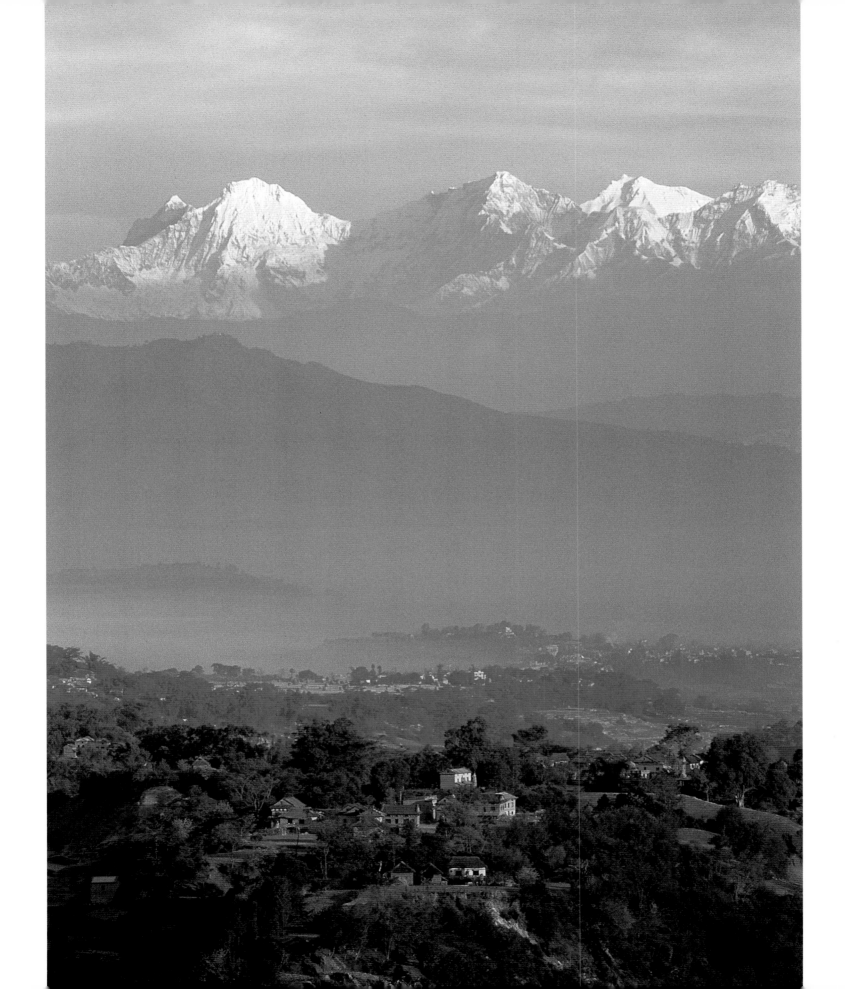

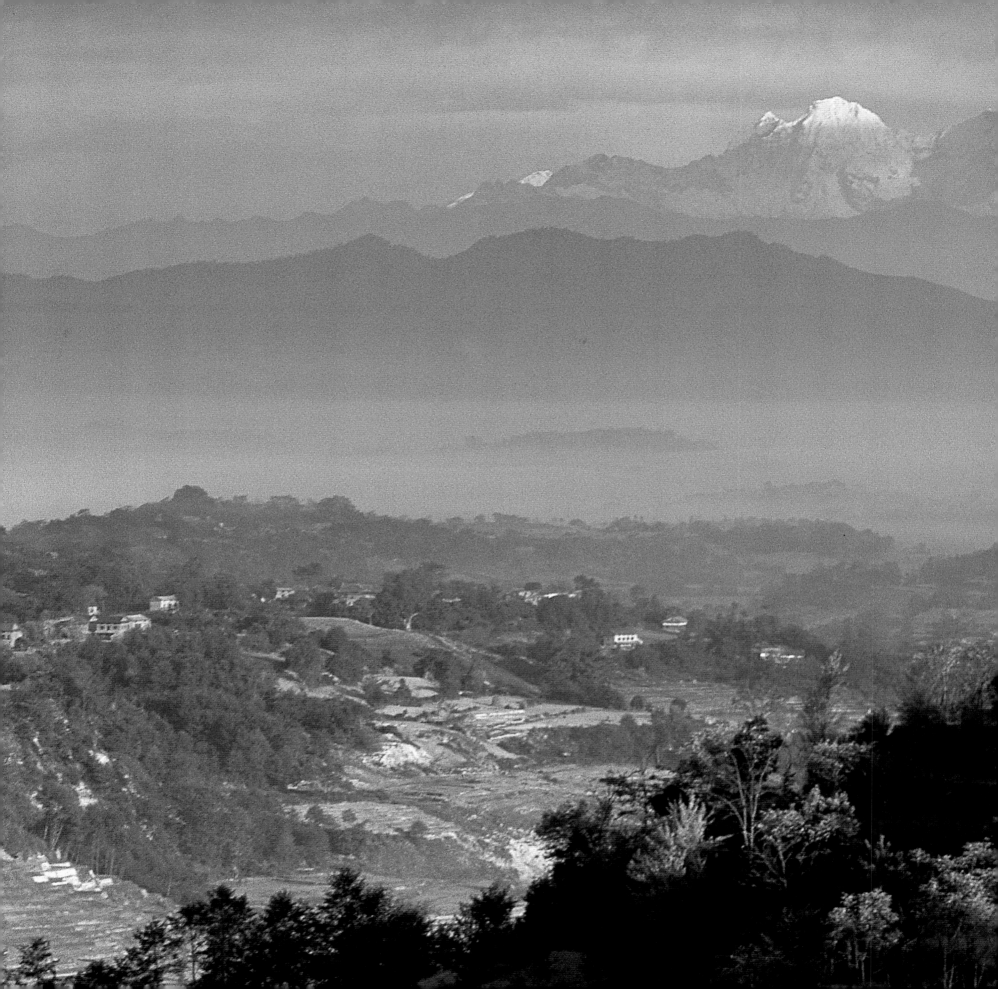

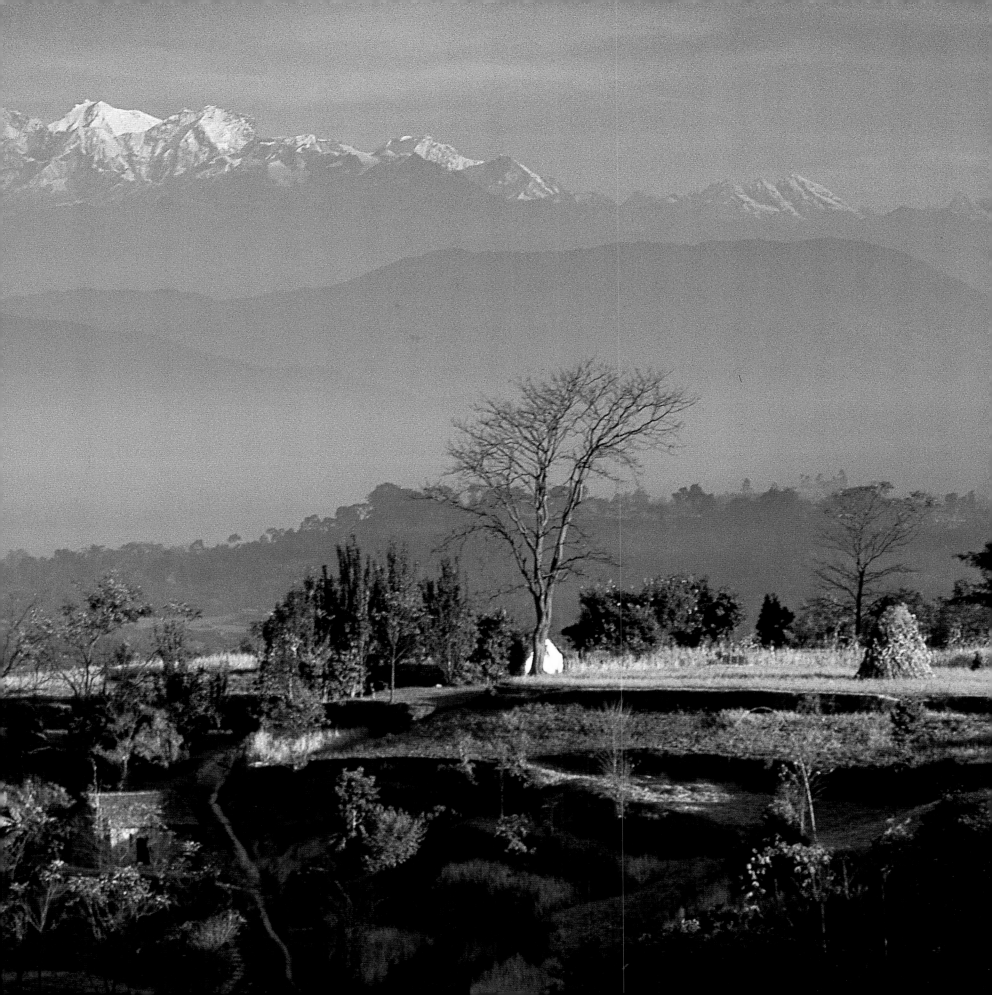

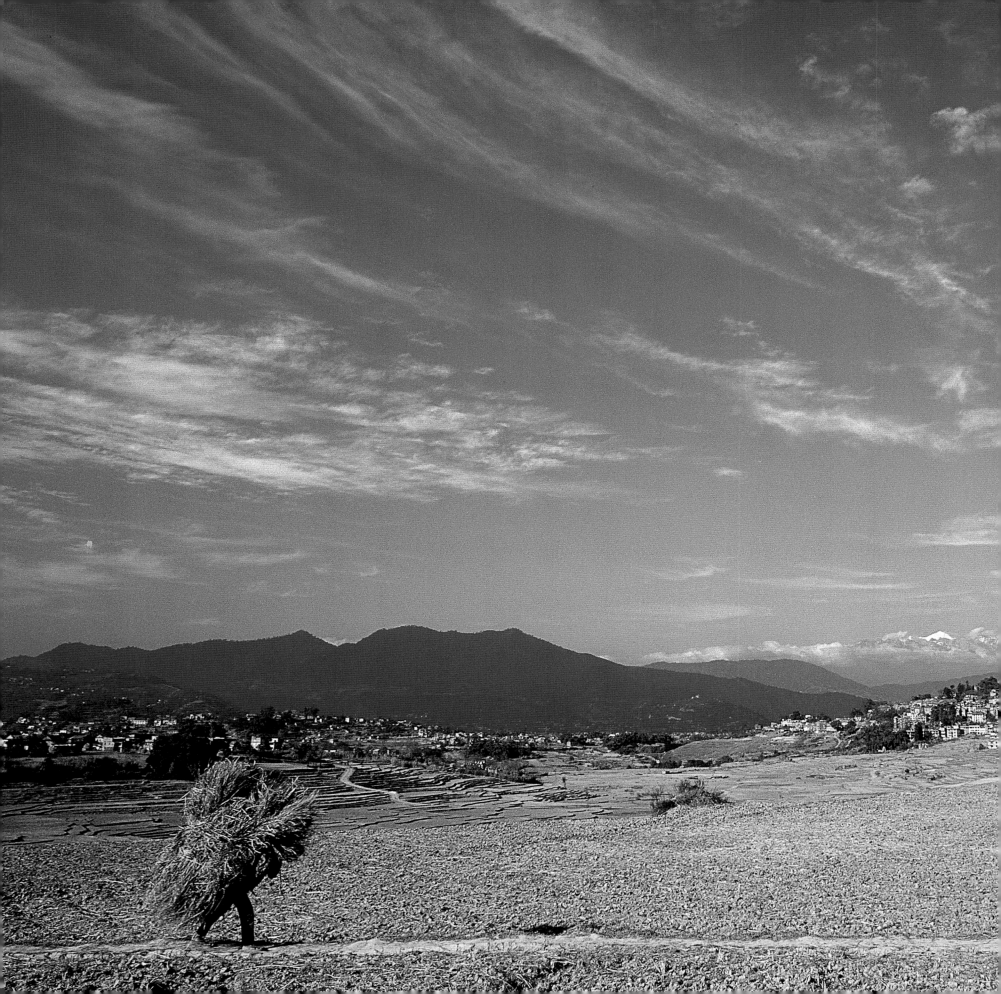

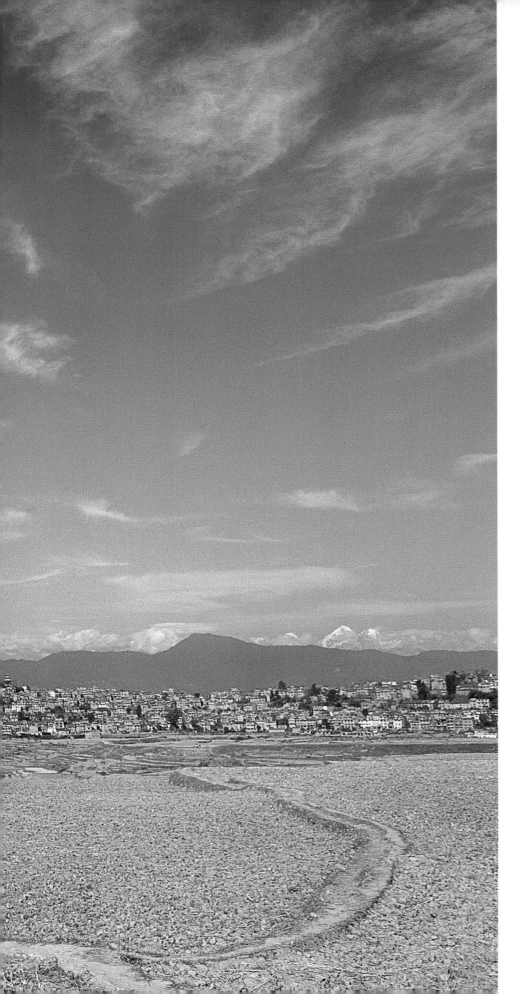

(Above)
An elderly kisaan or farmer gazes across the Valley from the southern slope of Shivapuri. The streams running off this forested mountain constitute the Valley's main water source, protected by the Shivapuri Watershed and Wildlife Reserve.

(Left)
A walking haystack – a man carries a bundle of straw across fallow fields south of Kirtipur.

(Previous spread)
A morning landscape of the Valley beneath the Himalayas. No-one knows the origins of human habitation in the Valley, although a handful of Neolithic artefacts have come to light. The first historical inscription, etched on a stone pillar at the temple of Changu Narayan, bears a date corresponding to A.D. 464, but long, long before that humans had settled in the Valley, drawn by its rich soil, abundant water, and gentle climate.

137

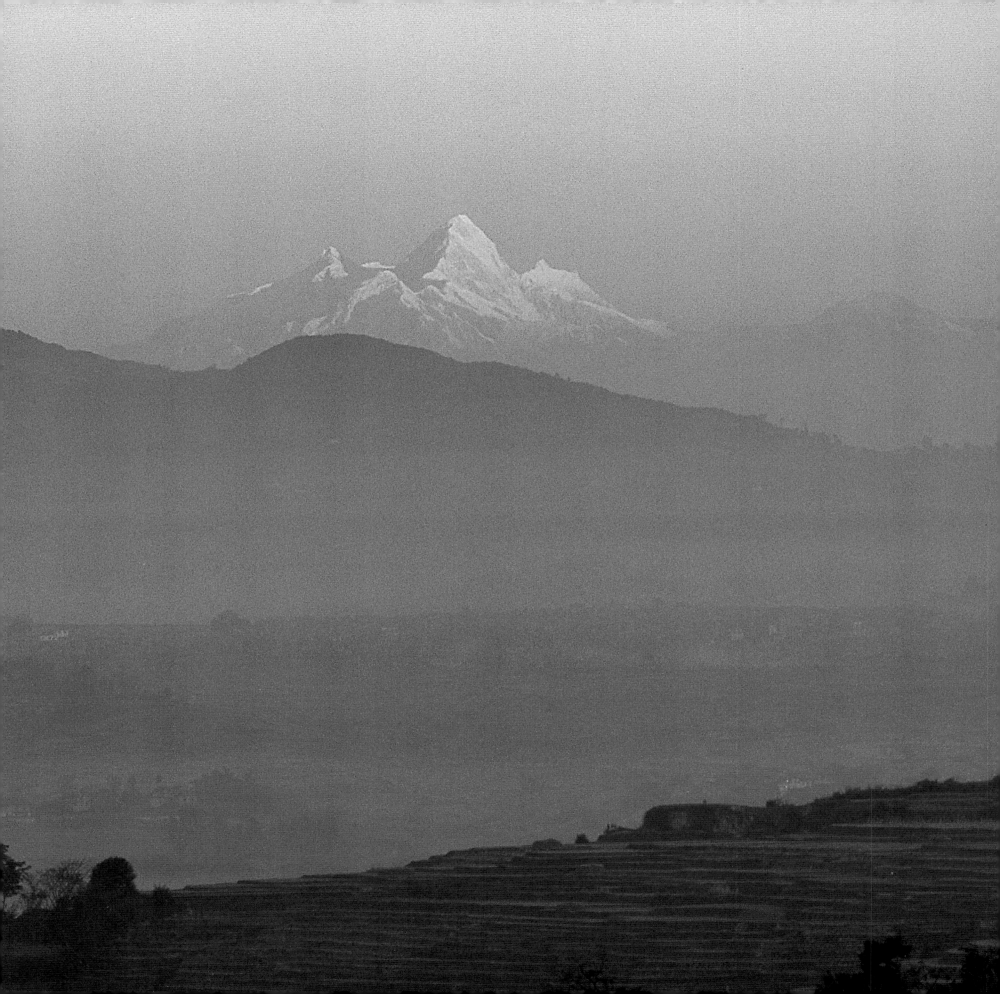

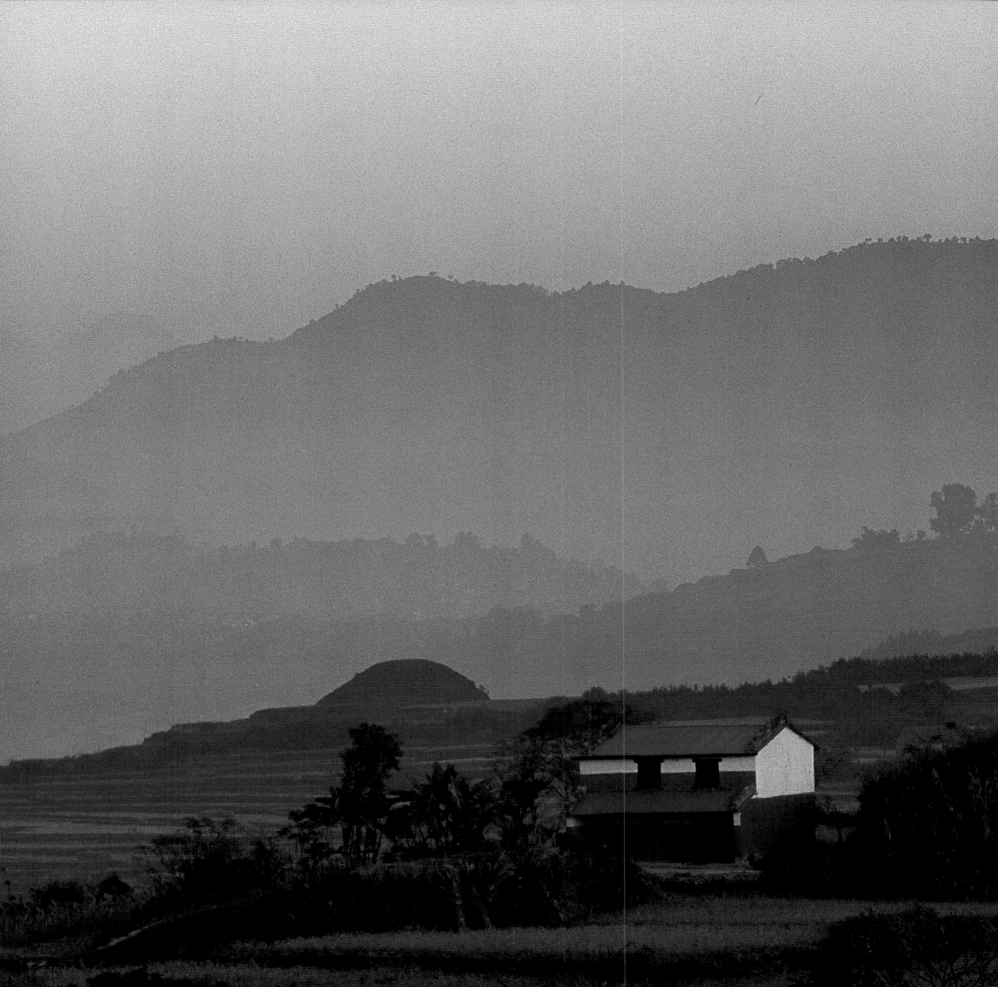

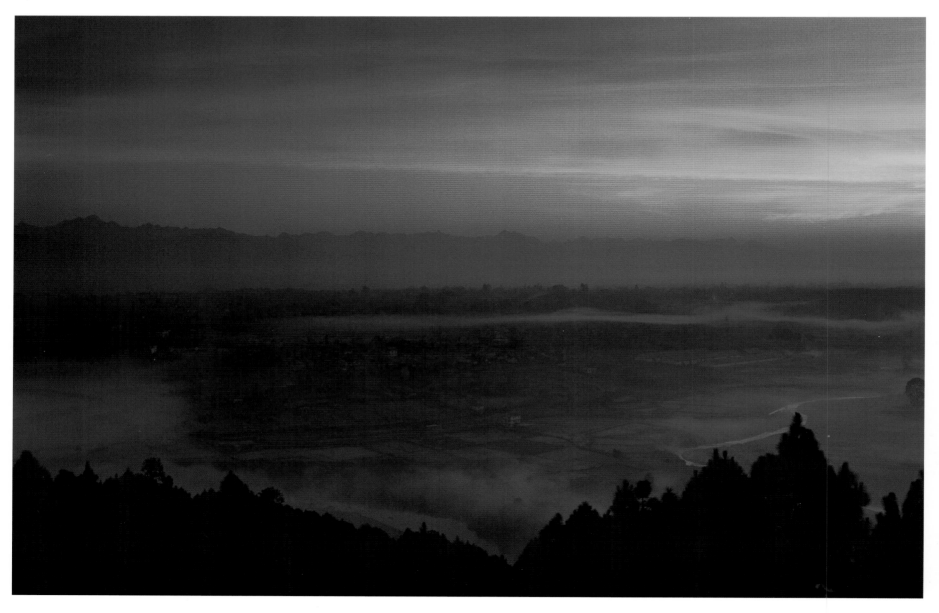

(Above)
A sea of mist set aflame by the rising sun, the Valley serves as a crucible for a great traditional culture, as well as
a special sanctuary for both Hindus and Buddhists. With nearly 3,000 monuments packed into some 570 square kilometres,
the Valley's magnificent natural and cultural heritage makes it an international treasure. In the words of a UNESCO proclama-
tion making the Valley a World Heritage Site, it is "a refuge of beauty and spiritual repose."

(Previous spread)
Dusk falls on the Kathmandu Valley as the setting sun illuminates a Himalayan peak. While the city of Kathmandu faces a
host of pressures typical of third-world urban centres, the Valley's countryside remains
remarkably unchanged, still in tune with its ancient cultural traditions and historic roots.

GLOSSARY

NEPALI AND TIBETAN TERMS

avatar incarnation or manifestation of a deity

bahal Newari Buddhist monastery complex

baksheesh a tip; often a tip given in advance to expedite service-more bluntly, a bribe

bhajan religious hymn

Bhotia, Bhotiya, Bhotey, general term for Tibetan-influenced people of the northern border regions

bodhisattva a buddha-to-be who has renounced individual enlightenment to help other beings

chaitya a Buddhist monument, a miniature version of a stupa

chang (Tib.) home-made beer, usually brewed from barley

chautara shady trailside resting place with a low wall to support porters' loads

chorten (Tib.) a small stupa, sometimes with a passage through the middle so that people can walk through it

chowk a square or courtyard

dal bhat The national dish of Nepal: lentils (dal) and cooked rice (bhat), served with curried vegetables

dhara water tap

doko wicker basket used for carrying loads

dorje (Tib.) see vajra

dyochem (Newari) 'god's house', a special shrine

gainey a minstrel caste

ghat flight of stone steps lining river banks, used for laundry, bathing and cremation

gompa (Tib.) Tibetan Buddhist monastery

guthi traditional Newari social association

hiti sunken fountain typical of the Kathmandu Valley

jatra festival

khukri Curved Nepali knife

kora (Tib.) circumambulation

Kumari young virgin Buddhist girl worshipped as a manifestation of the Hindu goddess Durga

ladoo a milk-based sweet

lama (Tib.) guru; religious teacher

Licchavi a ruling dynasty of the Kathmandu Valley (AD 300-879)

linga symbol related to Shiva and the phallus

makara sea serpents of Hindu mythology

mandala mystic diagram depicting the order of the universe

mani wall prayer wall: heap of flat stones engraved with mantra and religious images, found in mountainous Buddhist regions

mantra mystic formula of Sanskrit syllables

math Hindu monastery

mela fair, often associated with a religious festival

momo (Tib.) meat-stuffed dumplings

naga serpent deities: guardians of wealth associated with rain

pati open rest-house providing shelter to travellers

puja ritual offering and prayer

rakshi (Tib. arak) potent alcoholic beverage distilled from grain

sal hardwood tree *(Shorea robusta)* famed for its fine-grained wood

samsara the cycle of delusion created by the unenlightened mind

sadhu Hindu ascetic or holy man

shikhara a tapered tower surmounting a temple

shikar the hunt

sindhur red powder used as religious offering

sirdar organizer of a trek or expedition

stupa Buddhist monument: a hemispheric mound topped by a conical spire

tantra school of mysticism developed in medieval India which has influenced both Hinduism and Buddhism

tempo three-wheeled motor vehicle serving as an inexpensive public taxi

thangka (Tib.) scroll painting depicting religious subjects

tika auspicious mark on the forehead, made as part of worship

tol neighbourhood or quarter of a city

tongba drink made from hot water mixed with fermented mash

torana semicircular carved tympanum mounted over temple doors and windows

topi Nepali men's cap, brimless and slightly lopsided

tsampa (Tib.) roasted barley flour, a highland staple

yaksha graceful nymph of Hindu mythology

vajra Buddhist ritual implement representing the absolute aspect of reality

HINDU AND BUDDHIST DEITIES

Ajima Newari grandmother goddesses; indigenous deities often placated with blood sacrifice

Annapurna goddess of the harvest, a manifestation of **Lakshmi**

Ashta Matrika 'Eight Mothers', each representing a different aspect of Durga

Avalokitesvara compassionate Bodhisattva who grew eleven heads and 1,000 arms in order to help suffering beings; see **Lokesvara**

Bhagwati another name for the goddess **Durga**

Bhairab fierce manifestation of **Shiva**

Bhimsen patron god of traders: a minor figure in the Mahabharata

Buddha an enlightened being; more particularly the historical Buddha, Siddhartha Gautama

Bunga Dyo local name for **Machhendranath**

Chandeswari fierce goddess associated with Durga, slayer of the demon Chand

Devi another name for the goddess **Durga** or **Parvati**

Durga The Great Goddess, appearing in many different manifestations, most popularly as the defeater of the evil buffalo demon Mahisasura.

Ganesh elephant-headed god of luck, son of **Shiva** and **Parvati**

Ganga goddess associated with the sacred River Ganges, usually appearing with Jamuna, the personification of another sacred Indian river

Garuda winged man, the mount of **Vishnu**

Goraknath 12th-century yogi deified as an aspect of **Shiva**

Guru Rinpoche *see* **Padmasambhava**

Guyheswari the Secret Goddess, a name for **Shiva's** spouse Sati

Hanuman the Monkey King, a prominent figure in the Ramayana, worshipped as a protector

Indra Vedic deity honoured as King of the Gods

Kali the 'Black One', hideous goddess personifying death

Krishna blue-complexioned god of love, an incarnation of **Vishnu**

Kumari young virgin worshipped as an incarnation of **Durga**

Lakshmi goddess of wealth and abundance, consort of **Vishnu**

Lokesvara (Lokeswar, Karunamaya) 'Lord of the World', beloved bodhisattva and god of compassion

Machhendranath rainmaking patron deity of the Kathmandu Valley, worshipped primarily by Buddhist Newars

Mai indigenous deities transformed into 'Mother Goddesses', usually associated with a particular locality

Manjushri bodhisattva and embodiment of wisdom and learning

Nandi mount of Shiva, depicted as a kneeling bull

Narasimha incarnation of Vishnu, half man, half lion

Padmapani lotus-holding bodhisattva; see **Lokesvara**

Padmasambhava Indian tantric responsible for the introduction of Buddhism into Tibet

Pancha Buddha five Buddhas, each associated with a different element, colour, direction and aspect of enlightenment

Parvati consort of **Shiva** and a goddess in her own right

Pashupati (nath) Lord of the Beasts, benevolent form of **Shiva**

Saraswati goddess of learning and culture

Shiva important Hindu deity, the transformer and destroyer

Sitala goddess of smallpox and protector of children; Newari Buddhists worship her as Harati

Taleju tantric goddess imported from India and made patron of the Malla dynasty; related to **Durga**

Tara (Tib. **Dolma**) female bodhisattva representing mercy and compassion, appearing in 21 emenations, the most important being the White and Green Taras

Vajra Yogini Tantric Buddhist deity, a fierce protector goddess

Vishnu an important Hindu god worshipped as the Preserver and appearing in 10 principal incarnations

RECOMMENDED READING

Travel and Description

Crossette, Barbara. *So Close to Heaven: The Vanishing Buddhist Kingdoms of the Himalayas* (Knopf, 1995). Chapter 8 deals with Buddhist Nepal, but this entire book, written by a former *New York Times* India correspondent, provides insights into modern Tibetan Buddhist culture.

Greenwald, Jeff. *Shopping for Buddhas* (Harper & Row, 1990). Amusing personal account of Western consumers in hot pursuit of Eastern spirituality.

Herzog, Maurice. *Annapurna* (Jonathan Cape, 1952). The story of the first successful ascent of an 8,000-metre peak (the team's first problem was *finding* the mountain). That adventure pales in comparison to the harrowing saga of the long and painful return journey (most of Herzog's fingers and toes were severely frostbitten and had to be amputated along the trail). A gripping story, told with enormous dignity.

Iyer, Pico. *Video Night in Kathmandu* (Knopf, 1988). A romp through the Eastern tourism scene. The chapter on Kathmandu is not the strongest, but the book captures the bizarre mutations that occur when East meets West.

Matthiessen, Peter. *The Snow Leopard* (Viking, 1978). A luminous modern masterpiece that has probably inspired more visits to Nepal than any other book. Matthiessen accompanied zoologist George Schaller on a trip to the remote Himalayan region of Dolpo in search of the rare snow leopard. This is at once a description of the trek, and of the author's inner journey.

Peissel, Michel. *Mustang: a Lost Tibetan Kingdom* (Collins and Harvill Press, 1968). The adventurous Tibetan-speaking author became one of the few Westerners to penetrate the restricted region of Mustang with his 1964 visit.

Pye-Smith, Charlie. *Travels in Nepal* (Aurum Press, 1988). Blending good travel writing with keen observations on various projects and issues, this book is a palatable way of diving into the complexities of development in Nepal.

Snellgrove, David L. *Himalayan Pilgrimage* (Oxford, 1961). Account of the Buddhist scholar's 1956 journey through Dolpo, the Kali Gandaki and Manang. Fascinating insights into how it was, permeated with dry humour.

Thapa, Manjushree. *Mustang Bhot in Fragments* (Himal Books, 1992). Daughter of a Nepali diplomat, Thapa grew up in America and returned to Nepal as both insider and outsider. This slim volume records her observations on two visits to the newly-opened Mustang region.

Tilman, H. W. *Nepal Himalaya* (Cambridge University Press, 1952). Reprinted in *The Seven Mountain-Travel Books* (The Mountaineers 1983). Tilman was an old hand by the time he went on this 1949 excursion, the first reconnaissance of the Langtang, Annapurna and Everest regions, but his sense of humour is as wry and sharp as ever.

Tucci, Giuseppe. *Journey to Mustang* (Reprinted by Ratna Pustak Bhandar, 1977). Essential reading for the trek to Muktinath: the celebrated Tibetologist's 1952 journey up the Kali Gandaki–his observant eye missing nothing along the way. The book is filled with both cultural insights and compassion.

People

Avedon, John. *In Exile From the Land of Snows* (Alfred A. Knopf, 1984). The heartbreaking story of Tibetans in exile, and the single best introduction to the Tibetan issue.

Chorlton, Windsor. *Cloud-dwellers of the Himalayas: the Bhotia.* (Time-Life Books, 1982). Superb photo essays and chapters documenting life in the remote valley of Nar-Phu, north of Manang. The life and customs described here apply to many Bhotia peoples.

Coburn, Broughton. *Nepali Aama: Portrait of a Nepalese Hill Woman* (Moon Publications, 1990). Black-and-white photos and quotes create a lovely, insightful documentary of an old and very spunky Gurung woman with whom the author lived as a Peace Corps volunteer.

Downs, Hugh R. *Rhythms of a Himalayan Village* (Harper & Row, 1980). A sensitive look at life in the Sherpa region of Solu, blending black-and-white photos, narrative and quotations.

Fisher, James F. *Sherpas: Reflections on Change in Himalayan Nepal* (Oxford University Press, 1990). Thoughts on changing Sherpa culture by an observer who first visited Khumbu in the early 1960s. Notable for the extent it allows Sherpas to speak for themselves.

Fürer-Haimendorf, Christoph von. *Himalayan Traders* (John Murray, 1975). Broad examination of Tibetan-oriented trading communities across the Nepal Himalaya and how their lives have changed with the advent of modern times.

Macfarlane, Alan, and Indra Bahadur Gurung. *Gurungs of Nepal* (Ratna Pustak Bhandar, 1990). This slim volume on modern Gurung life makes good reading for trekking in the Annapurna region.

History and Culture

Anderson, Mary M. *The Festivals of Nepal* (Unwin Hyman, 1971). The standard classic, though somewhat outdated. Engagingly written descriptions of major and minor festivals of the Kathmandu Valley.

Bista, Dor Bahadur. *Fatalism and Development: Nepal's Struggle for Modernisation* (Longman, 1990). A provocative examination of how the 'culture of fatalism' embedded in the Hindu caste hierarchy has hampered Nepal's development. The author's jaundiced look at the dominant culture has been severely censured by Brahmin Chetri critics; the only way he can get away with it is being a Chetri himself, and a respected anthropologist.

Farwell, Byron. *The Gurkhas* (Allen Lane, 1984). The history of the fearless Nepalese mercenaries who are often called the world's finest infantrymen.

Goodman, Jim. *Guide to Enjoying Nepalese Festivals* (Pilgrim Book House, 1993). Excellent summary of festivals in the Kathmandu Valley, with handy notations on what occurs when and where.

Landon, Percival. *Nepal* (Constable, 1928). Detailed two-volume set examining the history of the Valley, interesting for period notes but marred by the author's obsequious attitude towards his Rana hosts.

Levy, Robert I. *Mesocosm: Hinduism and the Organization of a Traditional Newar City in Nepal* (University of California, 1990). An incredibly complex, detailed study of the traditional Newari society of Bhaktapur, with special emphasis on spatial relations.

Sever, Adrian. *Nepal Under the Ranas* (Oxford University Press, 1993). Comprehensive, balanced survey of 104 years of Rana rule, well-written and illustrated with rare historic photographs.

Slusser, Mary. *Nepal Mandala: A Cultural Study of the Kathmandu Valley* (Princeton University Press, 1982). Massive (and expensive) two-volume study of the Valley's Newari culture and its unique blending of Buddhist and Brahmanical traditions, both serious and fascinating.

Whelpton, John. *Jang Bahadur in Europe.* (Sahayogi Press, 1983). An entertaining account of the Prime Minister's 1850 visit to England and France, including a translation of a narrative written by a member of the party.

Religion

Anderson, Walt. Open Secrets: *A Western Guide to Tibetan Buddhism* (Viking, 1979). A very accessible introduction to Tibetan Buddhism, emphasizing its psychological aspects.

O'Flaherty, Wendy Doniger (editor). *Hindu Myths* (Penguin, 1975). Wide selection of the essential Hindu myths which permeate Nepalese art and religion.

Sogyal Rinpoche. *The Tibetan Book of Living and Dying* (Harper, San Francisco, 1992). A lucid and inspiring account of Tibetan Buddhism by an Oxford-educated lama.

Stutley, Margaret. Hinduism: *The Eternal Law* (The Aquarian Press, 1985). Basic introduction to Hindu literature, deities and beliefs.

Art

Aran, Lydia. *The Art of Nepal* (Sahayogi Prakashan, 1978). A remarkably relevant study of Nepalese art, focusing on the Kathmandu Valley and doubling as a study of religious iconography.

Bernier, Ronald. *The Nepalese Pagoda-Origins and Style* (S. Chand, 1979). This scholarly yet readable examination of the complex symbolism embedded in Nepalese temples adds much depth to Valley sightseeing.

Macdonald, Alexander W., and Anne Vergati Stahl. *Newar Art: Nepalese during the Malla Period* (Vikas, 1979). Architecture and paintings of the Kathmandu Valley examined in the context of classical Newari culture.

Pal, Pratapaditya. *Art of Nepal* (University of California Press, 1985). Catalogue of the Los Angeles County Museum's marvellous collection of Nepalese art.

Natural History

Cameron, Ian. *Mountains of the Gods* (Century, 1984). An illustrated survey of the Himalaya, its history, geology, ecology and peoples.

Fleming, Dr Robert L., Jr. and Lain Singh Bangdel. **Birds of Nepal** (Nature Himalayas, 1976). The standard classic, with colour illustrations of 1,000 individuals of 753 species accompanied by lucid descriptions for easy identification.

Gurung, K.K. *Heart of the Jungle: The Wildlife of Chitwan Nepal* (André Deutsch,

1983). Well-written account of the natural history of Chitwan National Park.

Hillard, Darla. *Vanishing Tracks: Four Years Among the Snow Leopards of Nepal* (William Morrow, 1989). Enjoyable story of the first study of the endangered snow leopard, focusing on the cultures as well as the environment of the Western Nepal Himalaya.

Mishra, Hemanta R., and Margaret Jeffries. *Royal Chitwan National Park: Wildife Heritage of Nepal* (The Mountaineers, 1991). A thorough guidebook to the flora, fauna and people of Chitwan.

Trekking and Rafting

Bezruchka, Stephen. *A Guide to Trekking in Nepal.* (The Mountaineers, 1985). The classic trekkers' guide: thorough, sincere and responsible, with detailed trail descriptions of 40 different routes and in-depth sections on culture, language and health.

Duff, Jim and Peter Gormley. *The Himalayan First Aid Manual* (World Expeditions, 1992). Handy pocket-sized guide to doctoring yourself and others on the trail. Available at the HRA office in Kathmandu.

Hayes, John L. *Trekking North of Pokhara* (Roger Lascelles, 1993). A brief essential guide to the most popular trekking region in Nepal.

Knowles, Peter and David Allardice. *White Water Nepal: A Rivers Guidebook for Rafting and Kayaking* (Rivers Publishing, 1992). The first guide to river rafting, written by experienced rafters. It's helpful in choosing a reliable commercial operator and in planning trips to remote areas.

McGuiness, Jamie. *Trekking in the Everest Region* (Trailblazer, 1993). Up-to-date, detailed guide to the Everest region; perfect if this is the only region you plan to visit.

Uchida, Ryohei. *Trekking Mount Everest* (Chronicle Books, 1991). A souvenir rather than a guidebook, lavishly illustrated with colour photographs.

Fiction

Han Suyin. *The Mountain is Young* (Jonathan Cape, 1958). Purple prose from the author of A Many-Splendoured Thing: a shy, sensitive Englishwoman, a 'wayward writer in search of herself', finds love in the Kathmandu of the early 1960s.

Robinson, Kim Stanley. *Escape from Kathmandu* (Tor, New York, 1989). An amusing romp through Everest, Yetis, trekking, lamas, Ranas, and other Nepal clichés.

Literature

Hutt, Michael James (translator and editor). *Himalayan Voices* (University of California, 1991). An eye-opening introduction to the riches of modern Nepali literature, both poetry and short stories.

Lienhard, Siegfried. *Songs of Nepal* (University of Hawaii Press, 1984). Anthology of Newari folksongs and hymns providing fascinating insights into culture and legends.

Rubin, David. *Nepali Visions, Nepali Dreams* (Columbia University Press, 1980). The translated poems of Lakshmi Prasad Devkota, considered Nepal's finest poet.

Photographic Studies

Gilman, Peter (editor). *Everest: The Best Writing and Pictures from 70 Years of Human Endeavour* (Little, Brown & Co., 1993). Magnificent photographs with a nice mix of essays excerpted from accounts of various encounters with the world's highest peak.

Kelly, Thomas L., and Patricia Roberts. *Kathmandu: City on the Edge of the World* (Abbeville Press), 1988. An in-depth look at the Valley's history, culture, festivals and people.

Valli, Eric, and Diane Summers. *Dolpo: Hidden Land of the Himalayas* (Aperture Foundation, 1987). Insightful, capturing the rhythms of life in a remote region.

—. *Honey Hunters of Nepal* (Thames & Hudson, 1988). Spectacular large-format book documenting the age-old honey extraction methods of the Gurungs of Central Nepal, who climb up sheer cliffs on rope ladders to boldly steal the honey from swarming bees.

Language

Clark, T. W. *Introduction to Nepali* (Ratna Pustak Bhandar, 1989). Formal, wide-ranging survey of grammar and vocabulary: one of the best books, and everything is in Romanized Nepali, which means you don't have to read the Devanagari script to learn the language.

Karki, Tika B., and Chij Shrestha. *Basic Course in Spoken Nepali* (Published by the authors, 1979). Peace Corps volunteers learn from this simple, situationally based book very good for hammering in the basics.

Meerdonk, M. *Basic Gurkhali Dictionary* (Straits Times Press, 1959). Handy pocket-sized volume with Nepali-English and English-Nepali.

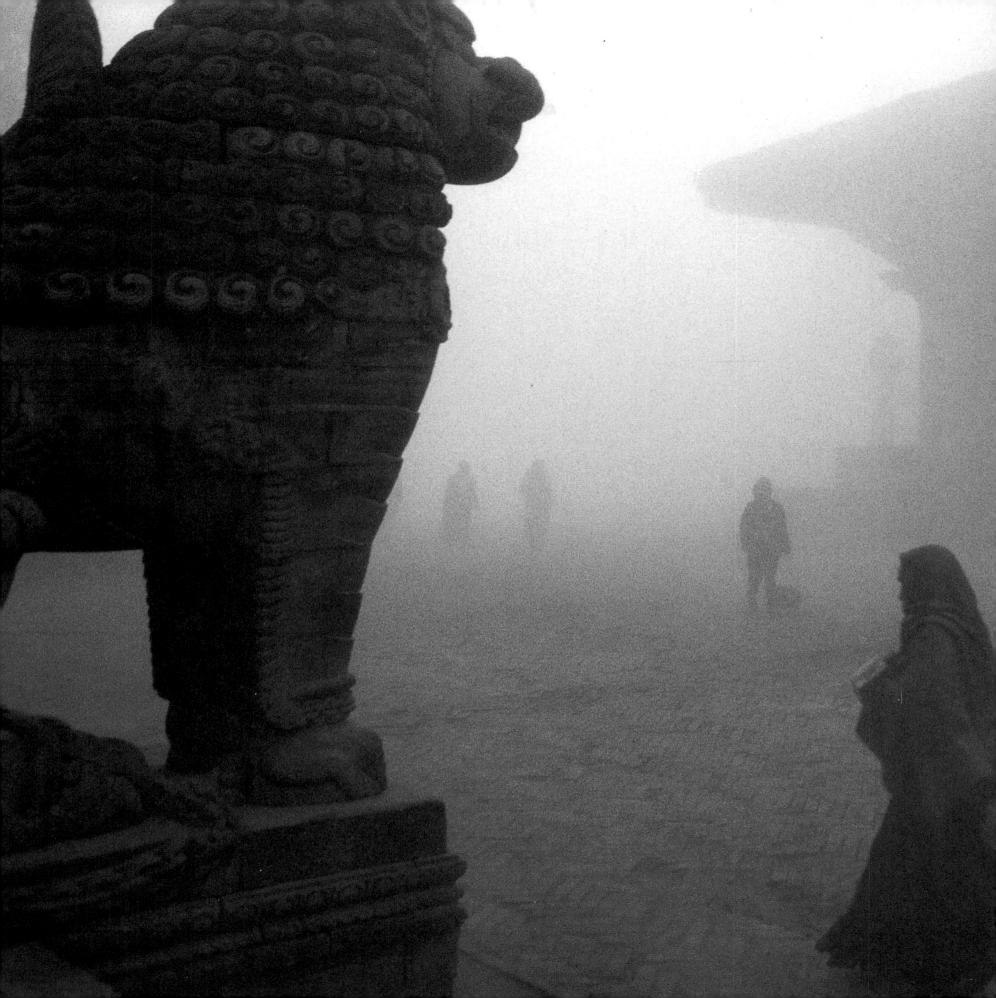